art *of the* forties

art
of the
forties

Edited by **Riva Castleman**

With an essay by **Guy Davenport**

The Museum of Modern Art, New York

Published on the occasion of the exhibition
Art of the Forties, organized by Riva Castleman,
Deputy Director for Curatorial Affairs and
Director, Department of Prints and Illustrated Books,
The Museum of Modern Art, New York,
February 24–April 30, 1991.

The exhibition is supported in part
by a grant from The Bohen Foundation.

Library of Congress Catalog Card Number 90-063249
ISBN 0-87070-188-6 (clothbound)
ISBN 0-87070-189-4 (paperbound)
ISBN 0-8109-6089-3 (Abrams/trade edition)

Printed in the United States of America

Edited by Harriet Schoenholz Bee
Designed by Lisa Govan, The Sarabande Press
Production by Vicki Drake
Composition by The Sarabande Press, New York
Printed by Litho Specialties, Inc., Saint Paul, Minnesota
Bound by Midwest Editions, Inc., Minneapolis, Minnesota

Published by The Museum of Modern Art
11 West 53 Street, New York, New York 10019

Clothbound edition distributed in the United States and
Canada by Harry N. Abrams, Inc., New York
A Times Mirror Company

Clothbound edition distributed outside the United States
and Canada by Thames and Hudson Ltd., London

Cover: Fernand Léger. Studies I and V for a Cinematic
Mural. (1939–40). Gouache, pencil, and pen and ink on
cardboard, each approx. 20 × 15″ (50.7 × 38 cm).
The Museum of Modern Art, New York.
Given anonymously

Contents

Foreword

On many occasions during its more than sixty years of existence The Museum of Modern Art has presented exhibitions drawn solely from its collection. Most often, these exhibitions have focused on works in one of the several mediums represented in the collection, demonstrating the depth of the Museum's holdings by showing works which are not consistently on view for space or conservation reasons. Only rarely in the past few decades has the Museum drawn on its holdings to present surveys which encompassed all the mediums in which it collects. *Art of the Forties* exemplifies this kind of exhibition, including painting and sculpture, drawings, prints and illustrated books, architecture and design, photography, and film. As it surveys the art of this critical decade, it also illustrates the extraordinary richness and range of the Museum's collection.

The variety of material produced in the turbulent decade of the forties and drawn from the Museum's collection presents a revealing panorama of the creative climate of the Western world during World War II and the first years of the cold war. The Museum's curators collaboratively selected the exhibition, and they included some objects that have long remained in storage, representing viewpoints which lost favor during the ensuing decades but might now be productively reexamined in the context of the period.

With the rapid political changes taking place in Central and Eastern Europe in late 1989, it seemed timely to look back and review the decade when that part of the world took the form it kept for half of this century. Riva Castleman, Deputy Director for Curatorial Affairs and Chair of the Curatorial Exhibition Committee, had the idea that it would be

stimulating and instructive to study the Museum's collection of works from the forties from a current perspective. As a prelude to the more prolonged analysis the material requires, she and her colleagues decided to put on exhibition a selection of works that might activate both general and scholarly interest. With them she coordinated the selection process, chose and compiled the material for this book, and, as organizer of the exhibition, wrote its introduction. For conceiving this project and for realizing it with imagination and expertise, Riva Castleman deserves our warm appreciation.

The exhibition has been generously supported by a grant from The Bohen Foundation, for which The Museum of Modern Art is deeply grateful.

Early in the formulation of *Art of the Forties* it was decided not to narrow the scope of a reappraisal of the period by restricting the text of this book solely to art history. We are very fortunate to have as our author Guy Davenport, Alumni Distinguished Professor of English at the University of Kentucky, and a widely published essayist and writer of fiction, whose interest in the art of the period was demonstrated in his writings. He has provided an admirably insightful essay, recalling and illuminating some of the significant cultural issues of the period.

At the end of the forties, an exhibition at the Museum titled *Modern Art in Your Life* attempted to show the relationships of the painting and sculpture of the time to architecture, interior design, and people's daily activities. Throughout the forties, the Museum actively sought to pursue an informative and life-enhancing role. In those years preceding the television era, many Museum exhibitions travelled to hundreds of communities, large and small, cultivating interest in the arts and, during the war, inspiring patriotism. Some of this history is included in a general chronology of the period in this volume.

It is our hope that *Art of the Forties* will stimulate reevaluation of the period, and the result may well be to alter some too easily assumed attitudes about its arts. We also hope that an exhibition like this one will invite appreciation of the great wealth and diversity of our collection and redirect to it some of the attention diverted to temporary loan exhibitions.

Richard E. Oldenburg
Director
The Museum of Modern Art

Introduction

Riva Castleman

The incentive to revive some past period is often as opportunistic as it is imperative. Nostalgia, as a motivator, is no match for the need to recall a historical moment that has embedded within it a spirit lacking in the present. Sometimes an unexpected or unthinkable event occurs which completes a series of past events with such finality that one must strain to remember what it was that so obscured them and their meaning for so long.

In the beginning of the present decade, the events that changed the political and social status quo of Central Europe forced the recollection of a decade, fifty years before, which produced conditions that, until now, seemed virtually unchangeable. Nations the world over are in the process of recalling their moments of pain and glory as they commemorate their World War II experiences and review the impact of the prodigious technical developments of the forties. This one decade, long avoided, is finally to be reviewed, digested, and understood in the new light of the 1990s, its consummate legacy.

In reviving memories of the forties, a selection of artworks from the collection of The Museum of Modern Art opens this review to a universe of interpretation. Longtime associations within stylistic frameworks have sequestered many of the works of the forties so that their former relationships within the time period of their development have been obscured. Many studies have been made that define the accomplishments of the Surrealist exiles in America, set out the diverse meanings of Abstract Expressionism, explain the formation of the CoBrA group and the Italian concrete art movement, and detail the vicissitudes of the *tachistes* in France. Most museum collections show the works of these and

other artists in such contexts, as if they were totally unreflexive. When conjoined with architecture, design, film, and photography, which had equivalent stylistic variations, the clarity of the customary arbitrary divisions is dispersed somewhat and the added dimension of occurrence within a specific time encroaches.

The decade of the forties was filled with cataclysmic changes in every possible area. In the arts, the displacement not only of European artists but of great quantities of artworks was extremely influential in both hemispheres. Before the fall of France in October 1940 the Nazis had confiscated large quantities of "degenerate" art (predominantly paintings by the German Expressionists and other avant-garde artists of the twentieth century), which did not represent the Aryan ideal, selling it at auction or destroying it. Throughout the war, Nazi connoisseurs appropriated major works from museums and from Jewish collections. The desperate circumstances in which many Europeans found themselves led to the forced sale of their treasures from the early thirties onward. Many of the artworks found their way into the international art market where the likeliest buyers were Americans. Even though there was a minor economic depression after the war, there could be no comparison between the wealth of the United States, totally untouched by bombs and ethnic annihilation, and the other victorious nations. The Museum of Modern Art was able to sponsor some of the European refugee artists, show and occasionally purchase the works of many more, as well as acquire along with other American museums some of the art that no longer was deemed acceptable under the Nazi regime. With a well-established base in international collecting, The Museum of Modern Art, through its founding director, Alfred H. Barr, Jr., brought into its collection many works that, had circumstances been different, would never have been available nor, possibly, publicly known. It was fortunate, too, that the Museum had moved into its own new building in 1939 so that it actually was a museum in every sense, with sufficient space to house an expanding collection.

While the older works that entered the collection, in part because of the exigencies of the war, gave the Museum added prestige, the acquisition of contemporary work was a continuing and fundamental obligation. For example, a representative group of artworks from Latin American countries was sought out and paid for from a fund that was established in 1942. Design competitions produced furniture, posters, and objects (some of whose materials were developed for military uses) that were added to the collection.

The war also forced the return to the United States of several American expatriates who had sought the cultural freedom of Europe earlier in the century. One of them, Peggy Guggenheim, had collected and sold modern art in Europe, so it followed that at Art of This Century, her gallery in New York, she would not only exhibit her own avant-garde collection but take on the paintings of some young American artists as well. Unlike the dealers who had fled Europe and reestablished their galleries in New York and the few Americans who opened galleries in the forties, both groups primarily interested in European artists, Guggenheim was a speculator in life. Without the constraints of economic require-ments or social acceptance she made her gallery the cradle of Abstract Expressionism, the first important art movement to develop in America. It was from there that the Museum

acquired a work by Jackson Pollock in 1944, the year after it was painted, his first to enter any museum collection.

With the end of the war, galleries in New York and Paris were founded with new art in mind, while several of the older European-oriented galleries in New York took an interest in both Americans and Europeans. From these sources as well as the many personal friendships between artists and curators that grew from exhibitions of the newest work, the collection of the Museum burgeoned. And, in addition to the established museums of modern art in New York and San Francisco, Paris soon had its Musée d'Art Moderne and Boston and London their Institutes of Contemporary Art.

The strange environment of a world at war provided many situations that would not normally be thought of as nurturing or encouraging. Nevertheless, the atmosphere did disrupt a long string of expected behavior and motivated thoughts that, albeit essentially negative, had substantial impact on most subsequent creative activity. Jean-Paul Sartre's philosophy of Existentialism, which he set forth in texts (not translated into English until the fifties), in public lectures in Paris and across the United States, and in plays that were translated and seen by English-speaking audiences, became the prevalent doctrine of the postwar era. The popular interpretation of its message was promising and seemed to be directed to those who had grown to maturity during the depressed years of the thirties. It provided artists with an alternative to following the frequently restrictive Surrealist dogma. The idea that a person's actions are what determine his or her existence gave primacy to the conscious life and responsibility to those who persisted in living it. Sartre's encouragement of Wols, who illustrated some of his poems, and Alberto Giacometti, whose prewar Surrealist sculptures gave way to the agonizingly spare and elongated figures he developed in the forties, provided the public with visual examples of his ideas. While it was still valid to speak of subconsciously motivated creativity, those motivations were controllable by and passed through their activator or liberator. In consequence, the new art in France was dubbed *l'art informel* while, in America, it was called "Action" painting.

In the arts of photography and film, the war and its aftermath had other consequences, for as they documented and offered insight into the incomprehensibility of life and death in war many chances were given and taken that extended the development and influence of these mediums. The Museum's collection reflects the nature of photography at a time when many photographers contended with the dramatic reality of wartime events and still others sought a fresh sense of reality in formal ideas. In filmmaking, war actions of both the Axis and the Allies were translated into patriotic epics, mysteries provided needed diversion, and tales of honesty and goodness gave reassurance. The expansion of communications was a major element in differentiating the forties from any previous decade, and photographers and filmmakers were among its best conduits. They, too, experienced the influences of Surrealism in its last blossoming and Existentialism in its full bloom. In France and Italy filmmakers were the first to mine the everyday conditions of the postwar years and radically transform their art. Because the Hollywood film industry had not then recognized the need to preserve its works and generally prevented anything but commercial access to them, they

are less visible in film collections, including the Museum's, than those of the new and initially independent foreign film enterprises.

During the war The Museum of Modern Art contracted with the United States government to provide services that would help the war effort. This contract was fulfilled by the production of a series of exhibitions, mostly using photographic panels, extolling the various American systems in order to inspire Americans to support them in war and confirm that a moral right was on their side. In retrospect these exhibitions, the high point of which was *Road to Victory*, organized in 1942 by Edward Steichen and with captions by his brother-in-law Carl Sandburg, somewhat changed the Museum's relationship to the public. Hundreds of exhibitions had been prepared and sent to large and small communities throughout the country in the thirties, but while the Museum had been striving to obtain serious attention for modern art, there was always a difficulty in attracting those who paid no attention to art at all. During the war, therefore, the Museum developed into something of a social center (there was even a G.I. canteen) as part of its Armed Services Program, devoting an estimated one-third of its staff time to the war effort. Although it continued to emphasize good design in objects (labels stating the Museum's approval appeared on household items in department stores all over the United States), it also pointed out which materials were needed for the war and should not be bought. Occupational therapy, too, was the subject of exhibitions as well as offered in the War Veterans' Art Center (1944–48) which became the People's Art Center (the Museum's progressive art school from 1949 to 1970).

Little was collected in the field of architecture (architectural drawings were documents that architects kept, not sold) until decades later, but major architectural exhibitions were held, and one was even sent by the Museum to neutral Sweden in the middle of the war. Because architecture, itself, was uncollectible, models and photographs of buildings were made to illustrate the best work. Therefore, the Museum does not have in its collection any materials that would document, for example, bunker construction during the war or the mammoth Pentagon in Washington, but it does have models of houses by Charles Eames, Buckminster Fuller, and Ludwig Mies van der Rohe. The inventions necessitated by the war, the new technologies that have forever changed our world, are documented in items of bent plywood, pliable plastic, and brushed aluminum, and by objects related to war (airplane parts) and peace (streamlined racing car).

No single collection, public or private, could contain an example of every sort of visual expression that was given permanent form during any one period. The forties was an age of opportunity for the Museum, but all opportunities that would have made its collection more comprehensive were neither given nor taken. Many key members of the staff and board of trustees went to fight the war. Alfred Barr was asked to resign in 1943 because some of the trustees felt he was incapable of administering the larger institution and should focus on his talent as a writer (nevertheless, he was retained until his retirement in 1967 under a series of titles that allowed him to oversee most of the Museum's collecting). Changes in the Museum's staff during and after the war recast its aesthetic attitudes, and partly for that reason the collection has a wider range of taste than it might have had. More than one-third of the works of the forties that are

illustrated in this volume were acquired in the forties (that percentage would rise if works dated 1948–49 but acquired between 1950 and 1951 were added). There were, in all, 6,525 acquisitions made in that decade, not including the many items taken into the study collections of photographs, posters, and objects, nor works in the Film Library. Within these groups what was then considered unexceptional now enhances the presentation of a decade studied from the perspective of today.

The forties was a period of old ideas and values held onto for reasons of security in the face of disbelief, disgust, and destruction. Through fantasy, references to simpler times, and then willingness to face reality, those who survived cast away that past. As at the end of World War I and within a few years thereafter, when Dadaism, destroyer of old values, sent artists looking beyond reality (*sur réalité*), so World War II drove them to penetrate reality. Peace brought with it the realization that the whole world could be destroyed by the technology that World War II produced. In the forties artists were not yet inured to the threat of total nuclear destruction and were able to function within this provocative environment. Now, fifty years later, the protagonists of the war that followed the war have begun to settle the peace that never followed the peace.

Civilization and
Its Opposite
in the
Nineteen-forties

Guy Davenport

In July 1942 Pavel Tchelitchew, a Russian exile, who like hundreds of European artists, scholars, and scientists had found refuge in the United States, had just finished a large painting called *Hide-and-Seek* (page 37). It was a culmination of his work up to that time, and was exhibited in a retrospective show of his paintings and drawings at The Museum of Modern Art in 1942. James Thrall Soby's monograph *Tchelitchew*, of the same year, served both as the show's catalog and as the first study of the artist.

Hide-and-Seek is a system of visual puns. Like its close analogue James Joyce's *Finnegans Wake*, which was published in 1939, it is, as we can now say, with our new knowledge of Mandelbrot sets and microcircuitry, a pattern of such intricate resolution that a coherent interpretation, despite the pioneer attempts of Parker Tyler's *The Divine Comedy of Pavel Tchelitchew* (1967) and Benjamin Ivry's unpublished Johns Hopkins thesis, has yet to appear. Its dominant themes, however, are clear. Children playing hide-and-seek are deployed in the branches of an ancient tree, which is also a hand and a foot. In a cyclical progression of the seasons that alludes to Arcimboldo (in principle but not in technique) Tchelitchew has constructed a poetic statement that is at once beguilingly magical, Proustian, Rilkean, and boldly biological. Its vivid sexuality in conjunction with a lyric innocence has disturbed people. It has remained an enigma.

Once they are in the world, paintings have their destinies. Looking back to the forties we have the advantage of perspective. We can say that Max Ernst's *Europe after the Rain*, of 1940–42 (Fig. 1), is exact in its foresight, and that Pablo Picasso's *Guernica* (Fig. 2) was not so

much a response to a tragic event in 1937 as a preparation of our eyes for violence that is still raging. We can also see a history that was invisible at the time.

Within two weeks of Tchelitchew's finishing *Hide-and-Seek*, this happened: the murder of 192 children at Treblinka, on August 6, 1942. These were orphans in the care of the brilliant Polish pediatrician and humanitarian Janusz Korczak and his chief administrator Stefa Wilczynska. The orphanage, in Warsaw, was "a children's republic," a successfully modern experiment in the upbringing and education of abandoned children. Korczak's theories are known all over the world, from American orphanages to kibbutzim. (The most recent, and best, account of his life and work is in Betty Jean Lifton's *The King of Children: A Biography of Janusz Korczak*, of 1988; and Korczak's novel *King Matt the First*, of 1923, was translated by Richard Lourie in 1986.)

On the day of their death by asphyxiation at Treblinka, Korczak's orphans were ordered into the street while they were having breakfast. Korczak understood what was about to happen, and asked permission to march the children in an orderly fashion to the cattle cars which would take them to Treblinka. Korczak carried the youngest child, five-year-old Romcia, in one arm, and led another small child, perhaps Szymonek Jakubowicz, by the hand. Stefa came behind with (in Lifton's words) "the tattered remnants of the generations of moral soldiers he had raised in his children's republic." King Matt's flag—the standard of the orphanage—brought up the rear, carried by the oldest boy, who was fifteen. They marched out of the ghetto to the rail head where the trains left twice daily, packed with wearers of the blue Star of David on white armbands. Up to this point there are witnesses to this event. We know that Poles along the way shouted, "Good riddance, Jews!" There is hearsay that Korczak himself was offered his freedom by the SS as the train was being loaded. He was an officer in the Polish army and had a reputation as a pediatrician. He refused.

At Treblinka they were packed into sheds into which the exhaust pipes of three-quarter-ton army trucks emitted carbon monoxide. The corpses were bulldozed into pits.

Fig. 1. Max Ernst. *Europe after the Rain*. 1940–42. Oil on canvas, 21⁹/₁₆ × 58³/₁₆″. Wadsworth Atheneum, Hartford. Ella Gallup Sumner and Mary Catlin Sumner Collection

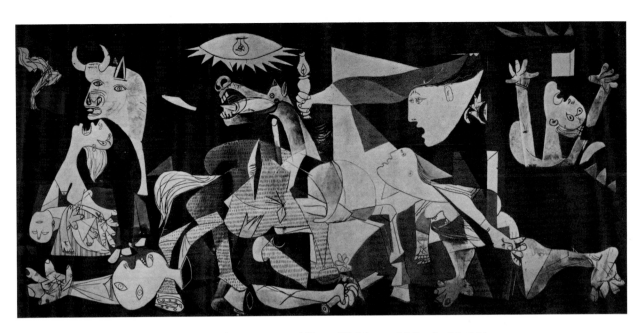

Fig. 2. Pablo Picasso. *Guernica.* 1937. Oil on canvas, 11′6″ × 25′8″. Museo del Prado, Madrid

Tchelitchew's tree crowded with happy, phantom children is a hymn to innocence. Into the sheds at Treblinka 192 children were packed by jackboots. Francisco Goya could—and in effect did—depict the latter. What happened in the sheds at Treblinka on August 6, 1942, requires the art of Sophocles, Dante, or Shakespeare. We have no art that can speak for the Holocaust. Tchelitchew was speaking for what the Holocaust went a tragic long way toward obliterating. Among the many assaults of National Socialism on civilized art and thought was its insult to the imagination—its identification of whole schools of painting, music, and writing as decadent. Tchelitchew fell into that category. He was, in the parlance of fashion, a neoromantic. He was a surrealist.

His true fellow spirit was James Joyce (one can locate abundant similarities in their work, such as the giant whose head is the promontory at Howth and whose toes are tombstones on the other side of Dublin, and children at play figure throughout *Finnegans Wake*), but there is no influence either way. Joyce, another victim of the Nazis, was dying in Switzerland when *Hide-and-Seek* was being painted; and Tchelitchew's English was incompetent. A closer analogue is Jean Cocteau's Tchelitchevian *Léone* of 1942–44. It is contemporary with *Hide-and-Seek*, and is as enigmatic. Its subject is equally distributed in a microcircuitry. Had Cocteau seen Tchelitchew's work when he wrote of a sleeping heroic figure who is also a landscape, with nesting birds, and whose genitals are a bird (referring to the Greek *pteros*, winged *phallos*, and the Italian *uccelli*—male genitalia with feet and wings—which Leonardo's mischievous assistants drew on his manuscripts)? Not since the High Renaissance, when paintings were layered as allegories, symbols, myths, and political homilies had European art been so avid and skillful in implicated meaning.

The imagery of heroic innocence in T. S. Eliot is thoroughly Tchelitchevian, as we see in *The Waste Land* (1922), part three, "The Fire Sermon":

But at my back from time to time I hear
The sound of horns and motors, which shall bring
Sweeney to Mrs. Porter in the spring.
O the moon shone bright on Mrs. Porter
And on her daughter
They wash their feet in soda water
Et O ces voix d'enfants, chantant dans la coupole!

These lines are transparencies overlaid. Sorted out, they are Andrew Marvell's *To his Coy Mistress* (1650), John Day's *The Parliament of Bees* (1607?), a popular song ("Little Red Wing"), an obscene Australian marching song, and Paul Verlaine's *Parsifal* (1888). An image of Actaeon and Diana from Ovid, a favorite Renaissance subject, underlies modern vulgarities.

Verlaine's part in Eliot's montage alerts us to his curious kinship to Tchelitchew. The line which ends Verlaine's sonnet (*And O voices of boys from the choir*) is about the magic power of the knight Parsifal's virginity. Verlaine's meditation on the theme of heroic innocence is broken in on by real voices.

In his *Four Quartets* (1943) Eliot symbolizes a sequestered but recoverable innocence with unseen children hidden in gardens and in trees, for example, in "Burnt Norton":

> Other echoes
> Inhabit the garden. Shall we follow?
> Quick, said the bird, find them, find them,
> Round the corner. Through the first gate,
> Into our first world, shall we follow
> The deception of the thrush? Into our first world.
> There they were, dignified, invisible,
> Moving without pressure, over the dead leaves,
> In the autumn heat, through the vibrant air.
> And the bird called, in response to
> The unheard music hidden in the shrubbery. . . .

Eliot made this passage out of Rudyard Kipling's story *They* (1904), in which ghost children live in an English country house and garden. This placing of children at a slight distance, or hidden in trees, belongs to the iconography of our time, and may be a resuscitation of angels and putti, or even of elves and daimons.

The *Four Quartets* are in one sense Eliot's emulation, and rivalry, of Rainer Maria Rilke's *Duino Elegies* (1921). Both are the greatest poems of our century about time, mortality, and our tragic incomprehension of existence. Both negate time for an eternal present containing the past and the future. The evocation of the existential (momentum, entropy, and a vitality unaccounted for by either) at the end of "Little Gidding," as throughout the *Four Quartets*, and as in Rilke, finds in children a symbol of fate:

At the source of the longest river
The voice of the hidden waterfall
And the children in the apple tree
Not known, because not looked for
But heard, half-heard, in the stillness. . . .

In Ezra Pound's *Pisan Cantos* — a text of the forties — the figure of an Italian girl becomes the poem's image of Fortuna, or Fate. Thomas Mann and Hermann Hesse had placed daimons in the form of lovely children throughout their oeuvres, as had Hermann Broch in *The Death of Vergil* — another forties text (translated beautifully by Jean Starr Untermeyer when Broch was in exile in the United States). The more we look at the child as a symbol of fate in our time — in *The Little Prince* (1943) of Antoine de Saint-Exupéry, in Korczak's *King Matt*, in Balthus's daydreaming adolescents (or his *Mitsou*, a novel-in-drawings, of 1921, instigated and provided with a preface by Rilke), in Eudora Welty and Carson McCullers — the more we see that these are symbols of vulnerability, of a frail and unprotected innocence. History and art have the same story to tell; their dialects are sometimes so different that it takes a while to see that Tchelitchew's *Hide-and-Seek* is, in a leap of intuition 6,000 miles distant, about the afternoon of August 6, 1942, when Stefa Wilczynska, Janusz Korczak, and 192 orphans were killed by Germans and Poles at Treblinka.

On another sixth of August, three years later, an American airplane destroyed Hiroshima with an atomic bomb. It imploded with a blinding solar brightness. Above this thermonuclear hell rose a biblical pillar of fire and smoke the shape of which looked to a British observer like a titanic mushroom. His simile, quoted by *The New York Times*, entered the language.

This mushroom cloud, with streaks of fire that give it the appearance of a skull, can be seen in the upper right of another of Tchelitchew's paintings, the large *Phenomena*, completed in 1938 (Fig. 3). This crowded canvas is technically a Temptation of St. Anthony by way of genre and is teratologically exact in its depiction of genetic mishaps. Its mushroom cloud is an illusion: Tchelitchew meant it for an apocalyptic image, much as Albrecht Dürer might have employed it. It is the same kind of coincidence as Jules Verne's rocket to the moon from "Tampa Town," only 120 miles west of the John F. Kennedy Space Center at Cape Canaveral in "southern" Florida. The arts are rich in lucky prophecies. But the atomic explosion seen on television in *Finnegans Wake* is deliberate prognostication:

Lok! A shaft of shivery in the act, anilancinant. Cold's sleuth! Vayuns! Where did thots come from? It is infinitesimally fevers, resty fever, risy fever, a coranto of aria, sleeper awakening . . . a flash from a future. . . .

Tom.

It is perfect degrees excelsius. A jaladaew still stilleth. Cloud lay but mackeral are. Anemone activescent the torporature is returning to mornal. . . . Telle whish.

Fig. 3. Pavel Tchelitchew. *Phenomena*. 1936–38. Oil on canvas, 6′7″ × 8′10½″. Whereabouts unknown

Joyce combined, as part of the world's-end scenario in the last chapter of the *Wake*, an inevitable atomic bomb and the inevitable presence of television in Dublin pubs.

The Hiroshima bomb is the center of the decade. Before it, a war that began in 1939; after it, a cold war.

New York in the early forties was an outpost of the war in Europe. We can now look at some of the symmetries. Jacques Lipchitz got to New York in 1941, with his wife and the clothes on his back, and survived. Max Jacob did not, and died at Drancy. We are talking about neighbors in Paris. Bertolt Brecht escaped; Walter Benjamin almost escaped. He got as far as the Spanish border, where he could only solve the dilemma he was in — he had given up his passport to the French before he knew that a new Nazi agreement with Franco did not allow him to enter Spain — by shooting himself. Two legal systems had literally deprived him of a space on which to stand. He was Franz Kafka's subtlest explicator, and a philosopher who studied the psychology of tyranny.

There is no assessment possible of American civilization without taking into constant account the immigration of people and ideas that have come in steadily since 1620. These donations from outside follow a pattern that is by now practically a folklore motif. One of the greatest American physiologists, Samuel James Meltzer (1851–1920) was born in Panevėžys,

Lithuania, and destined to be a Talmudist. He arrived in New York in 1883, by way of a medical school in Berlin. He was invited to join the faculty of Rockefeller Institute for Medical Research in 1902. Practically everything done to you in a hospital (insertion of nasal tube into stomach, injection, oxygen tent, insulin, and dialysis, to name a few) he invented, or opened the way to its future discovery.

Multiply Dr. Meltzer by many thousands to understand American culture. In the forties we can point to William Carlos Williams whose mother was more comfortable speaking Spanish than English; to Louis Zukofsky, whose parents spoke very little English. If we drop back a hundred years, we can say the same thing about John James Audubon and James Joseph Sylvester; drop back fifty, Charles Proteus Steinmetz. In the New York of the forties, W. H. Auden was already thoroughly American, while losing nothing of his Englishness. Constantin Brancusi, a visitor in 1939 on Long Island, refused to look at Manhattan ("so ugly, so ugly").

Before the *Wehrmacht* flattened Poland, many Europeans had already begun to arrive in America. Ludwig Mies van der Rohe, the last director of the Bauhaus, came in 1938, following Walter Gropius and Marcel Breuer. William Lescaze had arrived as early as 1920, bringing the International Style (and a knowledge of Arthur Rimbaud and Guillaume Apollinaire to the great profit of Hart Crane). The family of architectural styles that we call modern, with its ramifications into machine and interior design, began in Europe as a spirit and all too often came to the United States as a fashion.

The Schröder House, which Gerrit Rietveld had designed and built in Utrecht in 1924, for example, was the expression of a social and political ideal. Its continuous space defined a frankness and honesty in family life which was a dimension of Dutch liberalization. It is a democratic house but in an extremely utopian sense. It asked of its inhabitants that they appreciate its Shaker clarity and Spartan—or Japanese—reduction, functionalism, and essentiality. It is a house for the neat-minded, the orderly, the idealistic. Its style, de Stijl, one of the most influential of the twentieth century, is a Dutch shaping of a spirit that arose in Russia among some of the most inventive and original artists of our time: Vladimir Tatlin, Kasimir Malevich, El Lissitzky, Alexander Rodchenko, Varvara Stepanova, and many others. From these elate Russians, who were intimately cooperative with a brilliant genera- tion of poets (Osip Mandelstam, Nikolai Gumilev, Vladimir Mayakovsky, Anna Akhmatova), theoreticians (Victor Shklovsky, Mikhail Bakhtin), architects (Konstantin Melnikov), filmmakers, playwrights, and avant-garde publishers, the Bauhaus and de Stijl took their central philosophical tenet: that art must disappear as an autonomous aesthetic and reappear as an integral part of all design. Art was to be a habitation, an icon of a new religion; it was to be everything made.

A work by Piet Mondrian is an example of the pure design which Plato allowed in his ideal republic. Dramatically balanced lines on a white field are a paradigm of moral virtue and a well-ordered mind. Stoicism, which taught a calm control of the self, had at last come full circle to join the expression of the self in art. So abstract painting is and isn't painting; it is part of a wall, which is part of a house, which is a machine for living.

The Spartans had decreed that the city-state was a work of philosophy. This beautiful idea has proved to be fatally attractive to many people, with wildly varying results. It worked splendidly for the Shakers and other religious communities; it proved to be disastrous in the hands of Lenin and Hitler. The most rigorous plan for communities of like-minded people to bring the art of living to perfection was that of Charles Fourier (1772–1837), whose ideas inspired Marx and Lenin, our own New England transcendentalists, and many American communities on the frontier. His radical idea was to retribalize humanity into small agricultural communities, or *harmonies*—pure little democracies in which everyone was friend (and lover) of everyone else.

Le Corbusier's Unité d'Habitation in Marseilles, begun in 1945, was designed with Fourier's harmony in mind. So was the Bauhaus and its American counterpart, Black Mountain College, near Asheville, North Carolina. The Bauhaus and Black Mountain must surely have had the highest ratio of geniuses among its alumni and faculty to the short lifespan of each, of any schools in history. And both were dedicated to the Russian idea that all the arts are integral, none independent. Inside practically all the arts of the forties was this armature of idealism as the inner structure of a progressive and healthy society. László Moholy-Nagy brought the idea to Chicago's Institute of Design, Gropius to Harvard, Buckminster Fuller and Charles Olson to Black Mountain. It was inherent in the founding of The Museum of Modern Art.

That a museum might be a community school was the invention of Charles Willson Peale, of Philadelphia. In 1786 he expanded his portrait gallery of Revolutionary heroes into a natural history museum, complete with a mammoth skeleton. With Jean Jacques Rousseau as its tutelary genius, it was laid out as an orderly display of the world's flora and fauna for Democratic Man to learn from on a Sunday afternoon, together with his wife and children. From its inception The Museum of Modern Art set out to educate with its permanent holdings and by recurring shows of painting, sculpture, architecture, film, and photography. Never before had a museum been in a cooperative and reciprocal relationship with its subject, or able and willing to be both critic and importer, teacher and curator. In the forties The Museum of Modern Art came of age; it became a vital and vigorously influential part of modern art, doing for art what James Laughlin's publishing house New Directions was doing for contemporary writing.

Like many of the guiding principles of the modernist avant-garde, this concept of art as integral is thoroughly archaic. In the forties French thought was diligently exploring in two complementary spaces: anthropology and Surrealism. Claude Lévi-Strauss and his structuralist circle were reassessing a century of ethnological research, trying to find out what human nature is (and thus carrying on the quests of Rousseau and Fourier), how it came to culture from barbarity, how it tamed itself. Surrealism defies definition, but is always recognizable whether as a canvas by Giorgio de Chirico or a play by Eugène Ionesco. Since its tactics are to disclose the illogical and the absurd through imaginative juxtaposition, it is technically a satiric art. Yet it differs widely from satire in that it is essentially poetic. Surrealism is the metaphysical poetry of satire.

From its beginnings, Surrealism has worked with anthropology in a common enterprise that we can regard as a critical commentary on civilization in our time. French anthropology, inspired to some extent by Guillaume Apollinaire's and Paul Guillaume's appreciation of African and South Seas sculpture as art of the highest order, worthy of being placed in the Louvre beside Donatello and Auguste Rodin, began to study so-called primitive art as the door to the primitive mind.

In a symmetrical balance of assertions, Surrealism said that civilization in the twentieth century is absurd and self-destructive; anthropology, that mankind in its deep past and in surviving primitive societies is wise and has an orderly and wonderfully imaginative mind. Sigmund Freud had told us that we are neurotic. Psychiatry was one of the disciplines that arrived in the forties with the influx of European immigrant refugees. Kafka's books began to be known in English translation. Not until the sixties would the United States be in a position to read French thought of the forties, or to realize who had been here among us. Lévi-Strauss was here; Max Ernst was here. There is a time lag of about half a century in Atlantic crossings for ideas, despite attempts to speed things up. The Museum of Modern Art had a show of facsimiles of prehistoric art collected by the German anthropologist Leo Frobenius in 1937. This was seminal, but it took years for the seed to germinate.

Both anthropology and modern art had prepared us for the significance of a discovery of the deep past in 1940. The autumn of 1940 was tragic, however, and we had to wait until after the war even to know about the event. On the twelfth of September, just outside Montignac in the Dordogne, when country roads and highways were bumper-to-bumper with automobiles fleeing from the Germans (Paris had capitulated in June), two boys, Jacques Marsal and Marcel Ravidat, were playing in the woods around the Lascaux estate. It was a Thursday, and Thursdays were then the day off during the week for French schools. Marsal's dog, Robot, disappeared in the woods; only his frantic barking could be heard.

Robot had fallen into a deep hole opened by the uprooting of a tree in a windstorm the winter before. The boys went down the hole to rescue Robot, and suspected, once they explored around in the dark, that they had discovered a cave of the kind they knew all about from school, for Montignac is at the heart of French prehistory, and children had been discovering caves in the region since 1880. The Begouïn brothers had found Tuc d'Audubert and Trois Frères just before World War I. Many of the caves around Les Éyzies-de-Tayac were the discoveries of the curiosity of children. And it was a little girl who first noticed the painted ceiling at Altamira in northern Spain (her father had been studying its floor for years; she, on her first visit, looked up).

The cave into which Robot fell was Lascaux, on the walls of which were the most extensively painted paleolithic murals to have survived. It had been sealed for 17,000 years. Its polychrome horses and bulls have become as familiar to us as the ceiling of the Sistine Chapel. By unlikely coincidence, Abbé Henri Breuil, the greatest of French archaeologists and prehistorians, was only a few miles away, as the boys' schoolteacher Léon Laval happened to know, so that this momentous discovery was shared in a few days by the scholar most able to appreciate its significance.

Its significance had already been intuited by Picasso, who early in his career had seen the painted bulls at Altamira, and whose *Guernica*, with its bull and horse, is a continuation of a theme at Lascaux (which has a bison pierced by a spear, rhyming with Picasso's dying horse). Lascaux became an ammo cache for the Maquis until 1944.

Every epoch chooses its own past, and cannot know how it will be remembered. The forties did not know that Joyce would emerge as the century's greatest writer, or that Eudora Welty and Samuel Beckett, just beginning their careers in the forties, would be the masters of English prose at the century's end. Many diligent figures were still largely unheard of: Jean-Paul Sartre, Albert Camus, Simone de Beauvoir, Balthus, Buckminster Fuller, Joseph Cornell, Mark Rothko. Later they would all be far better known.

Conversely, we now pay scant attention to Peter Blume, Paul Cadmus, John Steuart Curry, or to the sculpture portraits of Isamu Noguchi. Civilizations ripen into cultures; the process is very long, and must be measured in thousands rather than hundreds of years. It can be argued that we have not yet reached anything like a civilization, and are a very long way from having an American culture. We therefore have no use for a national memory. Foreigners know our history better than we do.

The way in which the art of a decade encodes the spirit of the age is rarely direct. In the art of the forties what strikes us first is the diversity of styles and subjects. In the second half of the decade abstraction took over, brought from several European avant-gardes (those of Robert Delaunay, Piet Mondrian, Vasily Kandinsky, František Kupka, and Francis Picabia), and yet Mark Rothko and Jackson Pollock at their best bear no resemblance to European models. Fernand Léger said that he'd never painted better than in his exile here in the forties. His sense of accomplishment could as well belong to Mondrian, Stuart Davis, and Robert Motherwell. Form had accomplished again what it periodically longs for: it became a metaphor for its subject, and therefore the subject itself. Form did not displace its subject; it absorbed it. The verticals and horizontals of Jan Vermeer are discernable in a Mondrian, even though it was, variously, a tree and a ginger jar he was abstracting. Nature is full of Jackson Pollocks: autumn leaves, vegetable tangles, and random litter of all sorts. Magnifications of stone and even of colonies of bacilli all look like Pollocks. The same can be said of Motherwell's silhouetted boulders and slats; or of beltline advertising and Stuart Davis. These similarities need not be offered to rationalize abstractions. We will always come back around to the hieroglyphic deployment of paint. Claude Monet was getting wonderfully close to Pollock in the last lily-pond canvases at Giverny, and Paul Cézanne was as desirous of painting a landscape in which nothing could be discerned but the brushstrokes as Henry David Thoreau was of writing "a sentence which no intellect can understand."

Popular feeling and intellect had been so manipulated from World War I onward into the century, frequently violently, insultingly, and crudely that the arts felt the need to redefine themselves. The forties experienced a crisis in all the arts. Orson Welles was saying with *Citizen Kane* and *The Magnificent Ambersons*, "*This* is how to make a film." Ionesco and Jean

Dubuffet returned their arts to their most elemental expression, to the basic needs of the drama—actors saying something about anything—and to drawing as untutored as children's on a sidewalk.

Picasso turned sixty in 1941, the year his illustrations of Buffon's Natural History were published (deluxe reprints of classic texts were safer for French publishers under Nazi occupation); and he ended the decade with his lithograph *The Dove* (page 86), which became a universal symbol on posters and in Communist propaganda. An iconographic study of Picasso's animals will disclose a coherent vocabulary and grammar (bull and horse, goat and sheep). Into this symbolic family he introduced the owl in the forties, making it a major motif of his poetry and sculpture at Vallauris after the war: Athene's bird, daimon of the Acropolis.

Picasso was at Royan, near Bordeaux, at the beginning of the forties. He returned to Paris, to the studio at 7, rue des Grands-Augustins where he had painted the *Guernica*. Picasso was not alone in barricading himself in a prodigiously creative solitude during the occupation. Georges Braque, too, found new energies and directions, achieving his finest canvases since the Cubist period. Always strict and spare in composition and color, in the forties he evolved a classicism of his own devising, as did Béla Bartók and Charles Ives. The decade is rich in examples of artists finding that true mastery of a form lies in doing variations on a set of rules. E. E. Cummings's sonnets in his two books of the forties, *50 Poems* and *1x1*, are the most inventive sonnets in English since Gerard Manley Hopkins, and the most daring modernization of a traditional form since Stéphane Mallarmé's.

The still life is the sonnet of painters. The Cubist still life, as Gertrude Stein saw (and imitated in prose), was the focus of the modernist moment in painting. If Braque and Picasso renewed their art in the forties by finding isolation an occasion to fulfill and perfect, the then eighty-year-old Henri Matisse experienced a miracle of creative energy. At the beginning of the occupation, he moved to Nice, ill with gastric problems requiring dangerous surgery. His wife and daughter, both in the Resistance, were in the hands of the Gestapo. One son was in New York (Matisse refused to join him, asking what would happen to France if all her artists and writers were to leave), one was in Paris, his fate unknown.

In Nice, and later in Vence, he lived in hotel suites which he filled with a jungle of plants and an aviary of doves. (Picasso's Dove of Peace was actually one of Matisse's flock.) Too weak to paint, he began "sculpting" with paper, pasting up the collages of *Jazz* (page 73), the Vence chapel, and the murals. It is as if in the midst of the hell of war Matisse felt that his response should be to orchestrate all that he knew of color harmony and the beauty of lines and masses. With an art one learns in kindergarten Matisse brought the most sensually happy career of the century to a finale as unpredictable as it was triumphant.

Gertrude Stein died in 1946. It was through her writing and her salon that we first heard of Picasso, Braque, and Matisse. We owe the shaping of modernism as a movement to her charming intelligence and brave discoveries. She thought of The Museum of Modern Art as an oxymoron: How could art be modern if it was in a museum? She did not consider that there could be a museum that paralleled her salon. For her, modern painting had for its geography a few Parisian neighborhoods. She was known in the forties for *The Autobiography*

of Alice B. Toklas (1933) and for her last, popular works, *Wars I Have Seen* (1945) and *Brewsie and Willie* (1946).

Paul Klee, the comic Mozart of modernism, died in 1940, in his sixty-first year. With an energy as unfailing as Picasso's and a philosophical wit as lively as Ernst's, he gave us an oeuvre of such skill and complexity that he will probably be fully appreciated only in the next century. Quite early in modernism there occurred an overflow of poetry into painting. There is a pressure of words just under the surface of a de Chirico, for example, as if a poem had had to abandon the verbal and redefine itself in paint. This is most evident in Ernst, a great deal of whose work began as illustrations to texts and kept the sense of being texts. To see this quality better, note that few of Picasso's works suggest or can generate a text, nor do Matisse's. Klee, however, is one of the great poets of the century, close to Marianne Moore and Wallace Stevens, to Christopher Middleton and Jules Supervielle. Klee's titles, like Joseph Cornell's and Max Ernst's, are part of the work.

In André Malraux's imaginary "museum without walls" one might cause a considerable amount of cultural static by hanging a Grant Wood — *Parson Weems' Fable*, a work firmly located in a text (*The Life of George Washington with Curious Anecdotes Equally Honourable to Himself and Exemplary to His Young Countrymen*) — beside a Mark Rothko such as an untitled painting of c. 1948 (page 121). *Parson Weems' Fable* (Fig. 4) was finished in 1939; Rothko's work was not yet, in the forties, what we think of when we hear his name: stacked rectangles of color. Wood died in 1942, after only a dozen years of painting in the style we know him by (and that not consistently). Rothko maintained his characteristic nonreferential style for thirty years.

Both Wood and Rothko (a Latvian Jew who came to the United States in 1913, at the age of ten) were American painters working in deep heritages from Europe. Aristotelian,

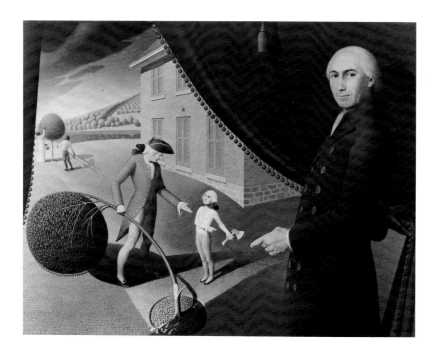

Fig. 4. Grant Wood. *Parson Weems' Fable*. 1939. Oil on canvas, 38³/₈ × 50¹/₈". Amon Carter Museum, Fort Worth

dramatic, and ironic, Wood had to work in a society that missed his every subtlety. Platonic, contemplative, and lyric, Rothko worked above comment and beyond criticism. Abstract Expressionism was so obviously a matter of pure spirit, that Americans, always eager for the transcendent and willing victims of the ineffable, embraced it.

Parson Weems' Fable is of its period: World War II awoke a cherishing of the American past that was variously vulgar, patriotic, and vernacular. We can separate Wood's painting from marketable nostalgia and calendar art easily enough. As his fellow hometown intellectual Garrison Keillor has sung, "His trees are perfectly round." That is, Malevich would have admired this painting. Little George Washington's head is a quotation from a three-cent postage stamp, a witticism from Dada. The composition is that of Charles Willson Peale's *The Artist in His Museum* in the Pennsylvania Academy of the Fine Arts. Wood's original title *Glad Am I, George* relates to a specific text: "I can't tell a lie, Pa." . . . /"Run to my arms, you dearest boy, . . . glad am I, George, that you killed my tree, for you have paid me for it a thousand fold." Wood's parson holds back the curtain to show us Squire Washington and little George. "Look!" say his eyes. He does not mind in the least that in the space he shows us we can also see two black slaves harvesting cherries. The *Mayflower*'s next voyage, after the one that landed English protestants at Plymouth, was to Africa for a cargo of slaves. In the forties the bigotry of segregation was intact.

We can keep looking at Wood's painting, noting that the kind of historical rhyme it makes parallels the ideogrammatic method of Pound's *Cantos*; that the cherry was an ambiguous allusion (the cherry trees in Washington were a gift from Japan); that Wood's satire is civilized and gentle on the surface but resonantly troubling in its implications. The painting is a lie (myth, if you will) about telling the truth. It is a slyly sincere painting about hypocrisy. It is rich in information (architecture, costume, horticulture), some of which is false (the cherry had not yet been introduced into the country).

It is Grant Wood's inability to remain mute that has cast him out of the modernist aesthetic. Charles Sheeler is mute, so that his elegant subjugation of matter to style moves him close enough to abstraction. He can be tolerated, like Charles Burchfield, whose muteness gives way to song from time to time.

What does this mean, our refuge in the wordless, our skittishness at anecdote, fable, sense? Is it our transcendental heritage? Through what naiveté was the *Guernica* consistently denounced as ugly, enigmatic, politically wrong-sided, and technically inept on its tour of the United States before it hung for nearly fifty years in The Museum of Modern Art? Stubbornly, people refused to read it for what it was: civilization violated by brutality. The decade of the forties began an American awareness of this problem that is still crucial, still controversial. Forty years later American critics were still trying to dismiss Wood, still trying to criminalize Balthus as a painter of salacities. We cannot blame abstraction as a dominant style for this hostility toward the pictorial; we can, however, say that an abstract art devoid of ideas is also unthreatening and placid.

There was a public forties in the history of the arts, and there was a secret forties. If modern painting began with Picasso and Braque developing the implications in Cézanne's late work, it began again in St. Petersburg and Moscow with Tatlin and Malevich. Malevich died in 1935. Tatlin lived on until 1953, perilously camouflaged within the Soviet system, his painting banned, the movement in which he was such a force interdicted and largely dispersed (Marc Chagall and Kandinsky escaped; Velimir Khlebnikov, Mandelstam, and Mayakovsky died). Tatlin eked out his years teaching ceramics and designing an air bicycle. He never joined the Communist Party.

The Nazi concentration camps were not publicly acknowledged in the American press until the fall of Germany and we saw their horror in Margaret Bourke-White's photographs. French art went underground, or was unexhibited, or was maintained just beyond German focus, as with Sartre's plays. Gertrude Stein and Alice B. Toklas sat out the occupation at Bilignin, and once had to reply to a German officer that no, they did not know of two Jewish old maids rumored to be in the neighborhood.

Our century, ironically, will have to be listed with the most virulent in the pathology of bigotry. The United States banned Joyce's *Ulysses* (1922) for the first dozen years of its existence, and in the forties Henry Miller's works and D. H. Lawrence's *Lady Chatterley's Lover* (1928) were illegal. Tarzan in comic books was not allowed to have a navel. A list of proscribed artists and writers—Mircea Eliade in Romania, Jean Genet in France, Alexander Solzhenitsyn in Russia—would almost coincide with a roster of genius.

By November 1945 Ezra Pound was serving the first of thirteen years in St. Elizabeths Hospital for the Criminally Insane in Washington. His case is symptomatic of the ambiguity inherent in constitutional liberty and in the liberal spirit as it was cultivated in the forties. Pound's crime was treason, "giving aid and comfort to the enemy in time of war." He was also the most influential, perhaps the greatest American poet of the twentieth century. His position at the center of English writing in our time is hard to contest, and Eliot, Joyce, William Butler Yeats, and many others have insisted on his primacy. He was the mentor of Eliot, William Carlos Williams, Louis Zukofsky, and Charles Olson, among others.

His crime was to broadcast violent and obscene opinions about the imminent war, damning international bankers, armaments manufacturers, and Roosevelt; praising Mussolini and fascist Italy; praising Hitler. As the broadcasts were all recorded months before their airing, the timing of Pound's alleged treason was ambiguous, and the case was never tried. And that was not the only ambiguity. Pound's mind had suffered a breakdown during his incarceration at Pisa, where he had surrendered to the American army in May 1945. It was here that he wrote *The Pisan Cantos* for which the Library of Congress awarded him the first Bollingen Prize in 1948. (The liberal outcry at this award was so strong that the Library was prohibited by Congress from giving out a poetry prize until 1990.) Pound was, even to the layman's eye, paranoid schizophrenic, a feature of which was an overt anti-semitism. As with all schizophrenia, logic was not in the formula. Despite his obsessive bigotry, Pound had Jewish friends, many of long standing, such as Zukofsky (who, while deploring his anti-semitism, bore him no resentment) or his psychiatrist Dr. Jerome Kavka.

Pound's Jews were the imaginary ones of paranoia; Roosevelt was a Jew in his scheme.

At St. Elizabeths we can locate, in the forties, one of the strangest cultural activities of all history. In a ward for catatonics, or in good weather on the beautiful grounds of the prison hospital (St. Elizabeths began as an arboretum, hence the congeniality of the grounds), one could find the visitors T. S. Eliot (on one occasion lifting his legs to allow the imaginary vacuum cleaner of an inmate to do its work around his chair, Pound having demonstrated how this was to be done), Marianne Moore, H. L. Mencken, E. E. Cummings, or Archibald MacLeish. One could also find the young Hugh Kenner, then a graduate student at Yale, Herbert Marshall McLuhan, Charles Olson, and James Laughlin. There were young painters and poets, scholars and translators; and in with them were the half-baked and the fanatic. Pound and his wife Dorothy (née Shakespear, daughter of Yeats's mistress Olivia) welcomed them all, for these visits were limited to four hours a day; the rest of Pound's time was spent among the mindless.

From Pound at St. Elizabeths came such a spray of energies that we have not yet charted them all. Olson, rector at Black Mountain College, and a student of Pound, taught Robert Creeley, Robert Duncan, Jonathan Williams, Denise Levertov, Fielding Dawson, and many another, who were thus Pound's pupils at one remove. Pound, appalled at American ignorance, was a diligent teacher. On the grounds at St. Elizabeths one learned about Louis Agassiz, Leo Frobenius, Alexander Del Mar, Basil Bunting, Arthur Rimbaud, Guido Cavalcanti, Confucius, Mencius, Raphael Pumpelly, and on and on. He was making up for the periodic and convulsive self-erasure of the American mind.

One of the themes of Pound's later poetry is precisely this discontinuity of culture. He saw it as a desensitization of the spirit, and paranoidly saw it as deliberate. It was worse than deliberate: it was simple dullness. Or, to say this another way, it was the absence of a culture. How do you appreciate Grant Wood when you are unaware of the necessity of the fine arts to any culture?

A friend of mine, and agemate, was dared by her circle in a college dormitory to do an outrageously brave thing: to call St. Elizabeths (this is *res gestae*, forties) one evening and ask to speak to Ezra Pound. She called. An attendant answered and said he would fetch the patient to the phone. After a while, she heard the voice of Ezra Pound. "Start a renaissance!" it said, and hung up.

Renaissance: a re-beginning, a finding of lost things, a taking up of dropped continuities. Pound's *Cantos* begin with the word *And*. William Carlos Williams's *Paterson* (the very title implies *pater*, father in Latin, plus the English *son*) begins with a colon, a punctuation mark indicating that what follows is a logical derivation from what precedes. One of the axioms in Buckminster Fuller's *Synergetics: Explorations in the Geometry of Thinking* (1975) is that we instinctively take a step back when we want to take a step forward.

How long will the United States be re-beginning? It has become a habit by this time, with corporate amnesia gaining ground. It is clear that we must re-invent the city (and perhaps we are, in malls). Neighborhoods and city streets are gone. Our renaissances tend to bleed to death. The late forties brought us a new kind of urban housing: freestanding

highrise structures set at a distance from each other to provide light and air, after such Corbusian models as Ville Radieuse (1930). Like the tenement housing they were intended to replace, these proved to be instant slums and places of terror, danger, and loneliness: anti-neighborhoods. At the same time Mies van der Rohe gave us a new vocabulary of glass and steel, but his most revolutionary built house—all glass—turned out to be elegant but uninhabitable, and now belongs to an Englishman who, helped by electric fans and open doors, lives in it for one week in the year. There are regular complaints that the modern in design and architecture is inhuman, without coziness, without comfort. A number of Le Corbusier's dwellings have been betrayed by their inhabitants. Two of his buildings were used for years as cow sheds. Today, many professors of architecture teaching modernist or postmodernist styles themselves live in comfortable Victorian houses.

The forties were undeniably a renaissance, of sorts. Our universities were again enriched (as before in the 1840s) with European scholars of the first rank. (The index to Laura Fermi's *Illustrious Immigrants: The Intellectual Migration from Europe, 1930/1941* runs to 1,400 names.) We were a new Netherlands, traditional refuge of the persecuted. (In all candor, however, it ought to be said that we refused many—Nijinsky for one, because he was insane—interned some, and erected barriers against others.) Even so, we had the makings of a renaissance in both the sciences and the arts.

Prehistoric painting is without regard for the horizontal or the vertical: one of the horses in Lascaux is jauntily upside down, drawn by some remote ancestor of Marc Chagall. With history came uprights on horizons. The Greek and Roman love of long rectangles enclosing bas-reliefs decided for Western painting that its finiteness would be concise and rational, bounded like property, like walls and floors. This convention is still a kind of law. The old Picasso superstitiously crammed his figures into rectangles. In modern painting there are two artists for whom the frame was the basis and essence of their work. One was a native of New York, Joseph Cornell, of Utopia Parkway, Flushing; the other Piet Mondrian, who came to New York in 1940 for the last four years of his life. He died in Murray Hill Hospital, of pneumonia, in 1944, even more than Lipchitz or Bartók the archetypal refugee. He was Dutch, had been trapped in Paris by World War I, and had a great fear of bombs. He lived in Paris for twenty-one years, and was sixty-six when he fled it for London in 1938, a very wrong choice, as it turned out. Where he lived little mattered to a man whose life was contemplative, unmarried, philosophically quiet. To achieve the perfect arrangement of the horizontals and verticals and spare areas of the primary colors to which the most severe reductionism in the history of art limited his canvases, he sat for hours, occasionally rising to move a line (tape thumbtacked to the stretcher) a smidgin of a centimeter left or right. When the composition was correct, he painted it in. Only in art books are these Platonic visions elegantly neat; the originals are dirty whites and messy lines; any sign painter could have been neater. But the material realization does not matter; these are pure ideas. Brancusi said of Mondrian, "Ah! That great realist!" What Mondrian saw out of his studio window in Paris were train tracks, straight lines crossing their ties at right angles. He grew up in the Netherlands, where the horizon is a spirit level in all directions.

It is charming that New York mellowed Mondrian into a last development something like Matisse's at Vence, allowing color and a giddy liveliness. Mondrian had always loved dancing, and shared with Ludwig Wittgenstein a connoisseurship of gaudily emphatic femininity; for Mondrian, Mae West; for Wittgenstein, Carmen Miranda and Betty Hutton. Someday a scholar will give us a treatise on music and painting (Burchfield and Sibelius, Chagall and the elate processional music of the Hasidim, Klee and Mozart). Mondrian's *Broadway Boogie Woogie* (page 51) is contemporary with Matisse's *Jazz* suite (page 73).

If Mondrian ended in the realm of pure essence, Joseph Cornell worked in a space explored by Picasso and Tatlin in 1913, and which has had other occupants: Kurt Schwitters, for instance, and many folk artists; and in nature, the magpie and the bowerbird.

He called his works shadow boxes and montages. Their ancestry involves many influences. In 1911 two high-spirited Englishmen, Edward Verrall Lucas and George Morrow, cut up a mail-order catalog, pasted it in various whimsical combinations, wrote captions in the style of schoolboy humor, and all unknowingly invented Dada, Max Ernst, and René Magritte. Ernst saw in *What a Life!*—Lucas's and Morrow's *Urtext* of Surrealism— that the deliciously absurd is not the only effect of absurdly combined commercial illustrations. All advertising ages into sinister indictments of our culture. So Ernst made two of the most eerily Freudian novels out of Victorian illustrations to fiction, *La Femme 100 têtes* (1929) and *Une Semaine de bonté* (1934).

Joseph Cornell developed this method of quotation into a theater of lyric magic. He was as much a scavenger as the folk artists who decorate a wastebasket with magazine pages, or the makers of patchwork quilts. He accumulated a garage full of boxes containing celluloid parrots, stationery letterheads, broken dolls, handbills, watch springs, clay pipes, marbles, window screens, candy wrappers, wine glasses—the vernacular artifacts of our culture. Like Schwitters, the anticipatory archaeologist, he saw in trash the signature of our nature.

Cornell was an erudite man. One might guess that he was an eccentric out of Beckett, a grazer of garbage heaps. He had a poetic sensibility and a metaphysical wit the equal, often the rival, of de Chirico and Ernst. He is still considered a peripheral figure in American art, as his complex allusiveness can be dismissed as childish trivia. He therefore belongs to the secret history of the forties. He was a genius with an imagination as vigorous as Emily Dickinson's. Like her, he was a recluse, and like her he could transform the quotidian and the overlooked into beguiling mysteries. One quality in Cornell, rare in modern art, is his domesticity: his boxes are friendly, strangely familiar when first seen, as if we had known them before. They remind us of old museum displays, of drawers in which we have irrationally kept party favors, photographs, our favorite spinning top, an envelope with foreign postage stamps.

With Mondrian and Cornell we come back to the crisis in interpretation that so troubles modernist painting and writing. The new, which arrived with such promise and excitement in the forties, has remained enigmatic, a kingdom of the imagination that amounts to a riddle

of a generation. What does *Hide-and-Seek* mean? Who can accurately read Joyce and Mallarmé? What is the difference between a Pollock and spilt paint?

A cliché we hear often enough is that modern art is a break-up, a disintegration, and Cubism and abstract painting are offered as evidence. Exactly the opposite is true: the modern is an integration, a new beginning. It is in part a renaissance that reaches back to the archaic and that in several European cities, New York, Asheville, and Chicago brought together some of the most creative minds of the century, disseminating energies and ideas which are still enriching the world. In another fifty years we will know more about the forties; it takes the perspective of one century to know another. We are just now seeing the significance of Zukofsky, who was writing *A* in the forties but was unknown except to a few; of Olson and the Black Mountain poets; of the real political history of the time, as archives are opened. We will have new readings of *Hide-and-Seek* and of Cornell. Yet in a century the violence of the forties will still not have lost its pain and ugliness, and it will still seem wonderful that out of the human spirit so much art could be made in a world where the artist was far more often the victim rather than the honored benefactor of the people.

Plates

The works of art on the following pages are in the collection of The Museum of Modern Art unless otherwise noted, and have been drawn from the Museum's departments of Painting and Sculpture, Drawings, Prints and Illustrated Books, Architecture and Design, Photography, and Film. In the captions, titles appear in italics. Dates enclosed in parentheses do not appear on the works. For drawings, prints, and illustrated books, the support is paper, unless otherwise noted. Dimensions are given in feet and inches, height preceding width, and followed by depth in the case of sculptures, constructions, and design objects; composition or plate size is given for prints and page size for illustrated books; sheet size is given for other works on paper. More complete data on these works appear in the List of Plate Illustrations, beginning on page 126.

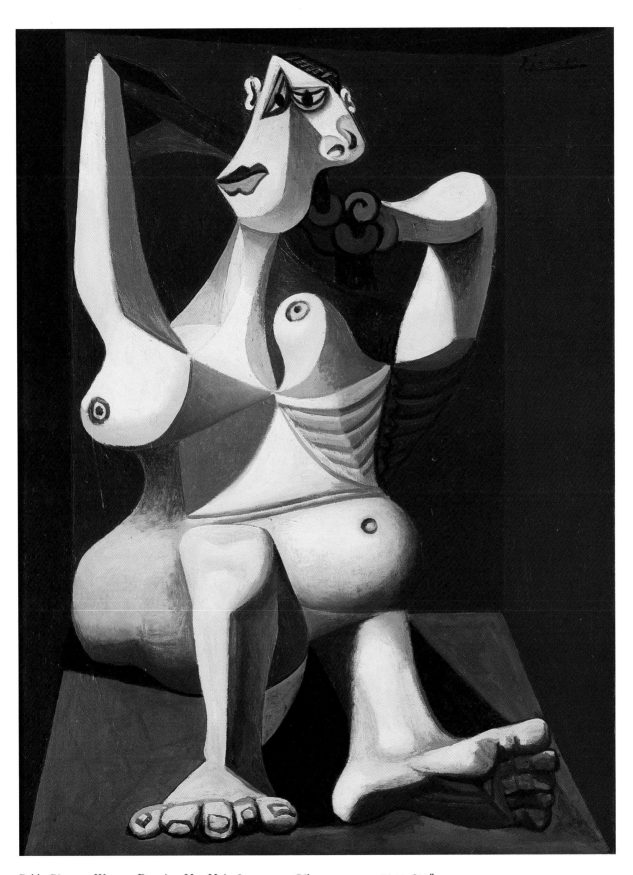

Pablo Picasso. *Woman Dressing Her Hair*. June 1940. Oil on canvas, 51¼ × 38¼"

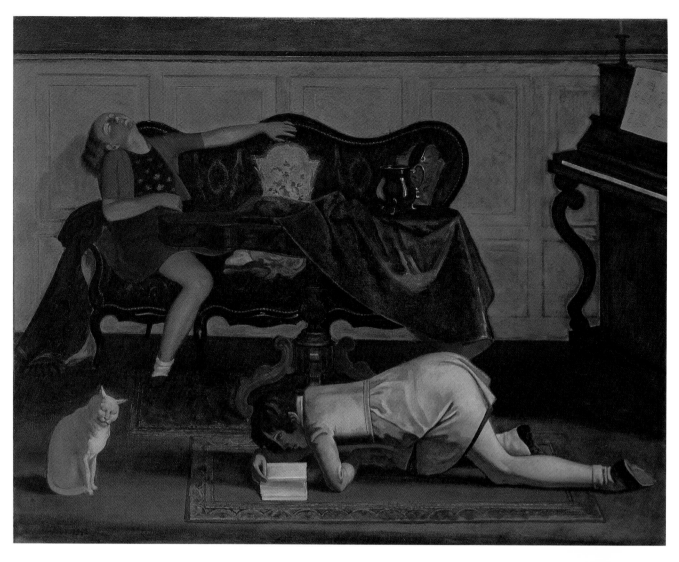

Balthus. *The Living Room*. 1942. Oil on canvas, 45¼ × 57⅞″

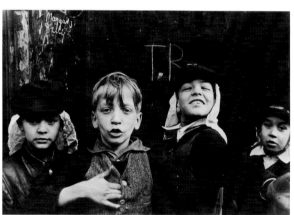

Helen Levitt. Untitled. (c. 1940). Photograph: gelatin-silver print, 6⅝ × 9¾″

Joseph Cornell. Untitled (*Bébé Marie*). (early 1940s). Papered and painted wood box, with painted corrugated cardboard floor, containing doll in cloth dress and straw hat with cloth flowers, dried flowers, and twigs, flecked with paint, 23½ × 12⅜ × 5¼″

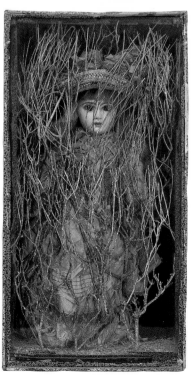

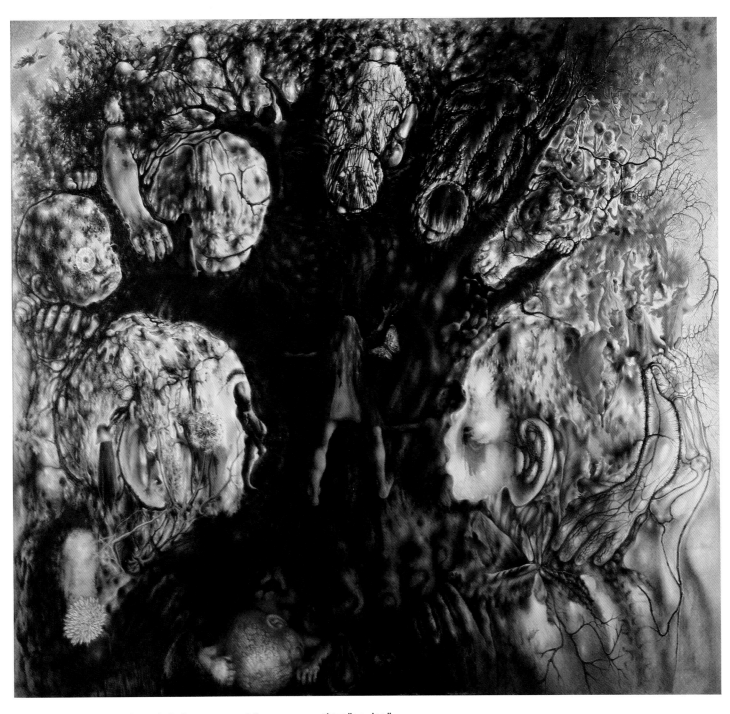

Pavel Tchelitchew. *Hide-and-Seek*. 1940–42. Oil on canvas, 6′6½″ × 7′¾″

Jacques Lipchitz. *Rape of Europa IV*. 1941.
Chalk, gouache, brush and ink, 26 × 20″

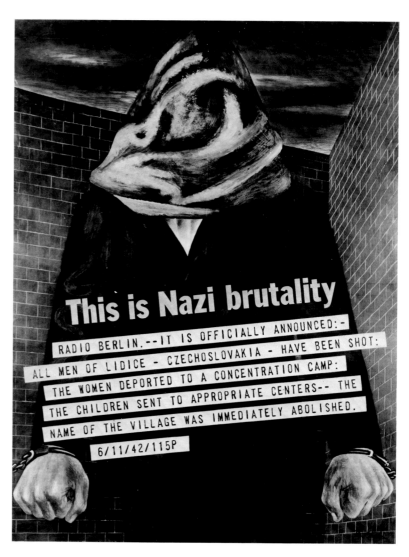

Ben Shahn. *This Is Nazi Brutality*. (1943).
Poster: offset lithograph, 38¼ × 27⅞″

Jackson Pollock. *Bird.* (1941). Oil and sand on canvas, $27^{3}/_{4} \times 24^{1}/_{4}''$

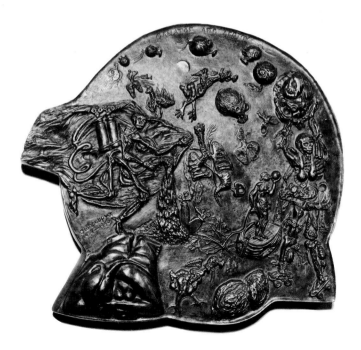

David Smith. *Death by Gas*, from the Medals for Dishonor series. 1939–40. Bronze medallion, $11^{3}/_{8}''$ diam., irreg.

José Clemente Orozco. *Dive Bomber and Tank*. 1940. Fresco, 9 × 18′, on six panels, each 9 × 3′

Jackson Pollock. Untitled. (c. 1938–41). Screenprint with hand additions, 17 × 21¹³/₁₆″, slightly irreg.

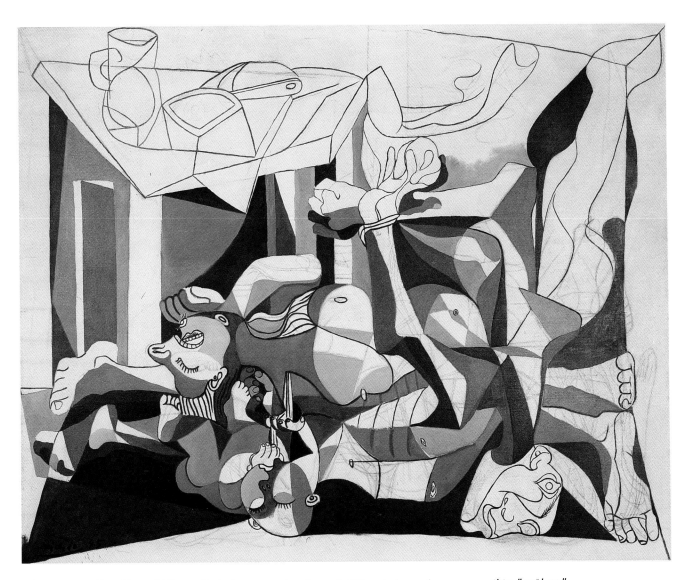

Pablo Picasso. *The Charnel House*. Paris (1944–45; dated 1945). Oil and charcoal on canvas, 6′6⅝″ × 8′2½″

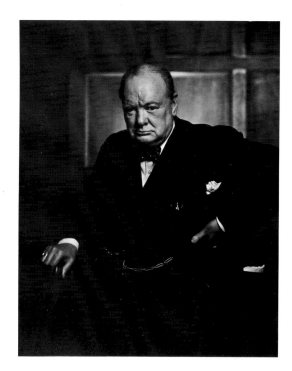

Yousuf Karsh. *Winston Churchill*. 1941.
Photograph: gelatin-silver print, 19³/₄ × 15³/₄″

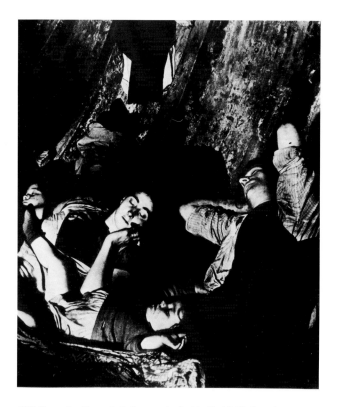

Bill Brandt. *Crowded Improvised Air-Raid Shelter in
a Liverpool Street Tube Tunnel.* (1940). Photograph:
gelatin-silver print, 24¹/₈ × 20¹/₂″

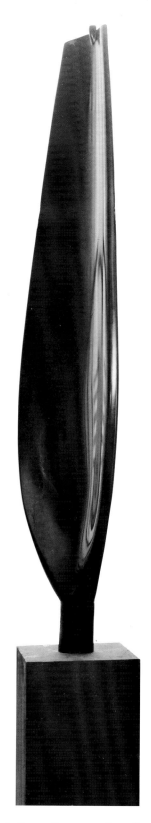

St. Regis Paper Company. Propeller Blade.
(c. 1943). Panelyte, 62¹/₄ × 14¹/₂ × 3¹/₂″

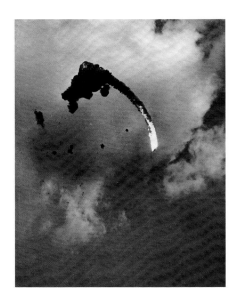

Unknown photographer. *Gunners of the U.S.S. Hornet Score a Direct Hit on Japanese Bomber—18 March 1945.* (1945). Photograph: gelatin-silver print, 13$^{1}/_{2}$ × 10$^{3}/_{4}$"

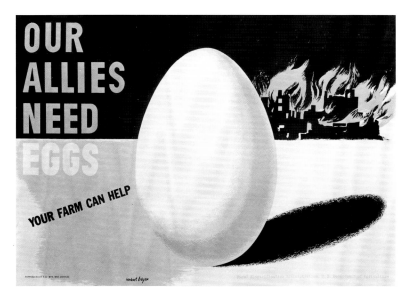

Herbert Bayer. *Our Allies Need Eggs.* (1942). Poster: screenprint, 20$^{1}/_{4}$ × 30"

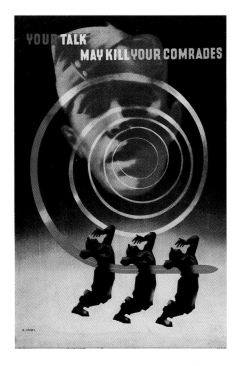

Abram Games. *Your Talk May Kill Your Comrades.* (1943). Poster: offset lithograph, 29 × 18$^{3}/_{4}$"

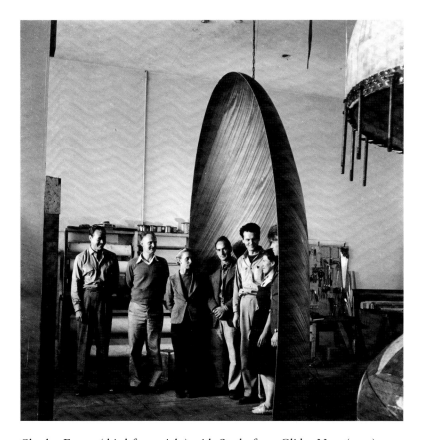

Charles Eames (third from right) with Study for a Glider Nose (1943) and colleagues Norman Bruns, William Francis, Marion Overby, Harry Bertoia, Ray Eames, and Gregory Ain. Photograph, 1943

Ansel Adams. *Mt. Williamson, Sierra Nevada, from Manzanar, California*. 1944. Photograph: gelatin-silver print, 15⅛ × 18¾″

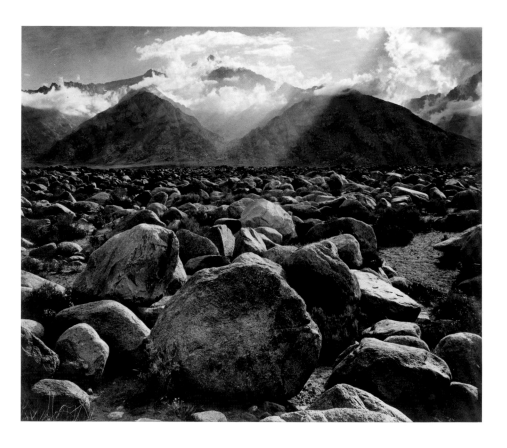

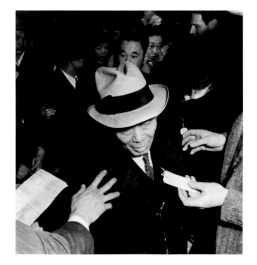

Dorothea Lange. *San Francisco*. (c. 1942). Photograph: gelatin-silver print, 9½ × 9⅜″

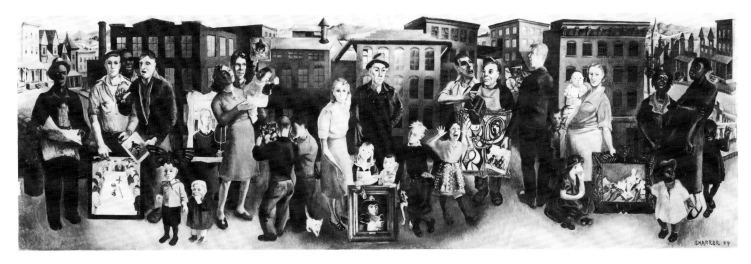

Honoré Sharrer. *Workers and Paintings*. (1943; dated 1944). Oil on composition board, 11⅝ × 37"

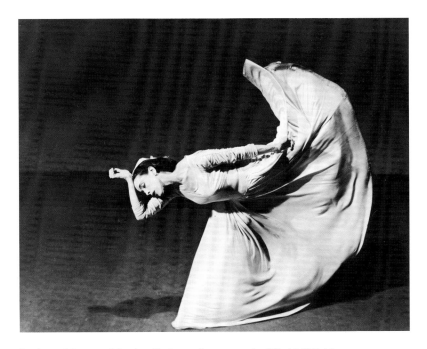

Barbara Morgan. *Martha Graham, Letter to the World (Kick)*.
1940. Photograph: gelatin-silver print, 14½ × 18¼"

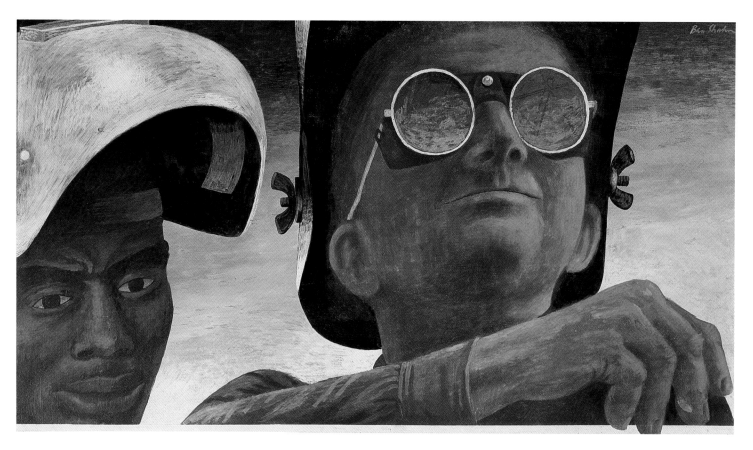

Ben Shahn. *Welders*. (1943). Tempera on cardboard mounted on composition board, 22 × 39³/₄″

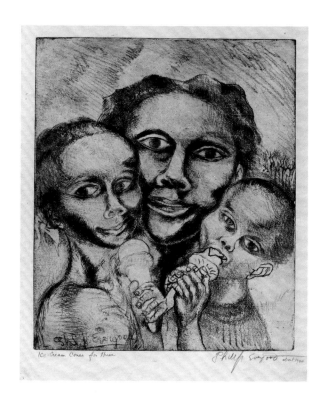

Philip Evergood. *Ice-Cream Cones for Three*. (c. 1940). Etching, 11³/₄ × 10″

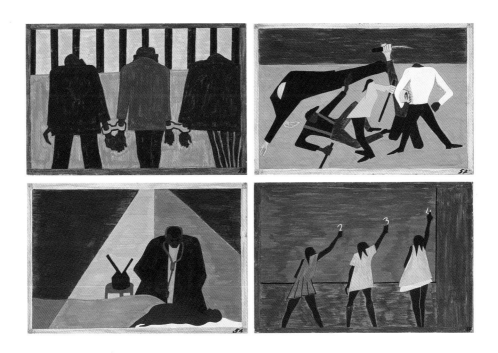

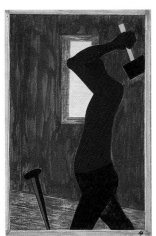

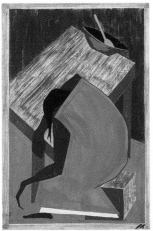

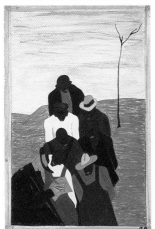

Jacob Lawrence. *The Migration of the Negro.*
(1940–41). Eight from a series of 60 works:
tempera on gesso on composition board, each
18 × 12″, vert. or horiz. The works are numbered
clockwise from the upper left, as follows:
22, 52, 58, 56; and 4, 16, 46, 28.

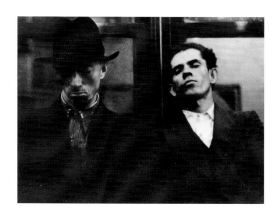

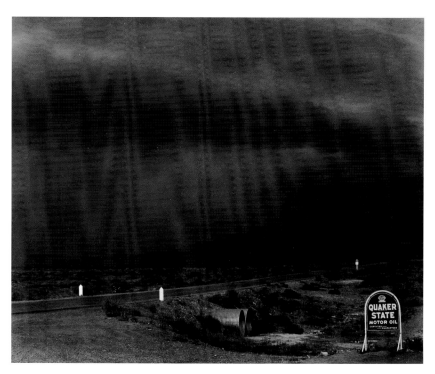

Walker Evans. *Subway Portrait*. (1938–41).
Photograph: gelatin-silver print, 3'³/₁₆ × 5'¹/₄"

Edward Weston. *Quaker State Oil, Arizona*. (1941).
Photograph: gelatin-silver print, 7⁵/₈ × 9⁵/₈"

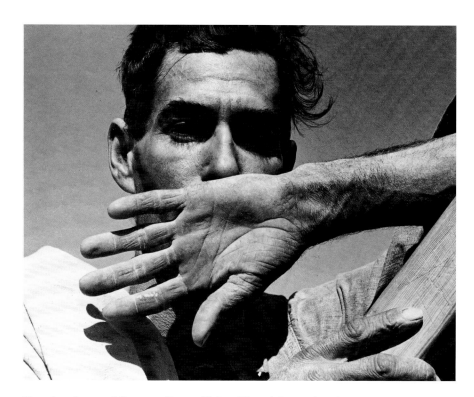

Dorothea Lange. *Migratory Cotton Picker, Eloy, Arizona*. (1940).
Photograph: gelatin-silver print, 10¹/₂ × 13¹/₂"

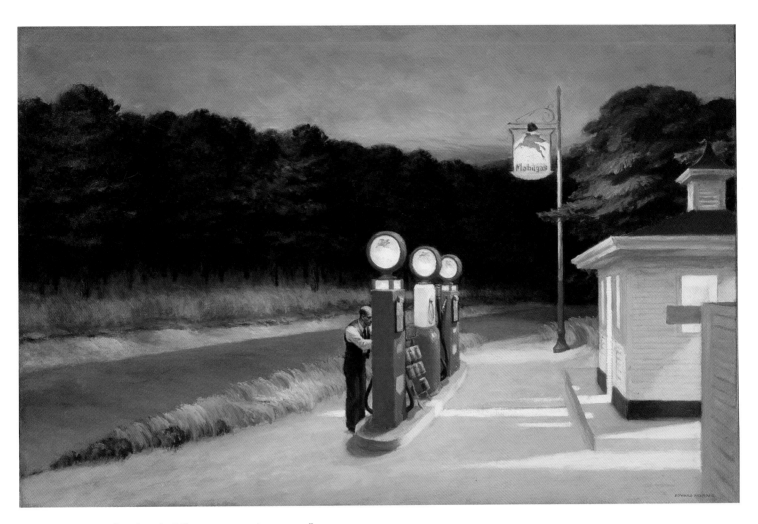

Edward Hopper. *Gas*. (1940). Oil on canvas, 26¼ × 40¼″

Harry Callahan. *Chicago*. (c. 1949). Photograph: gelatin-silver print, 6⅝ × 8⅜″

Paul Strand. *Church*. (1944). Photograph: gelatin-silver print, 9½ × 7⅝″

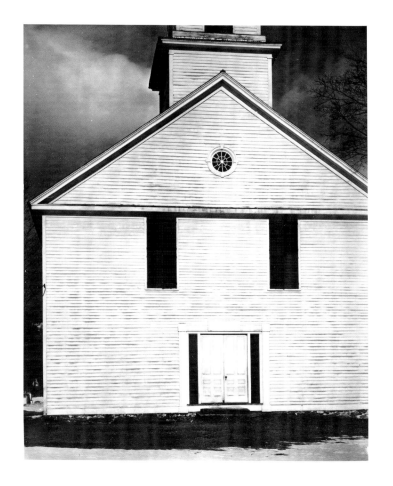

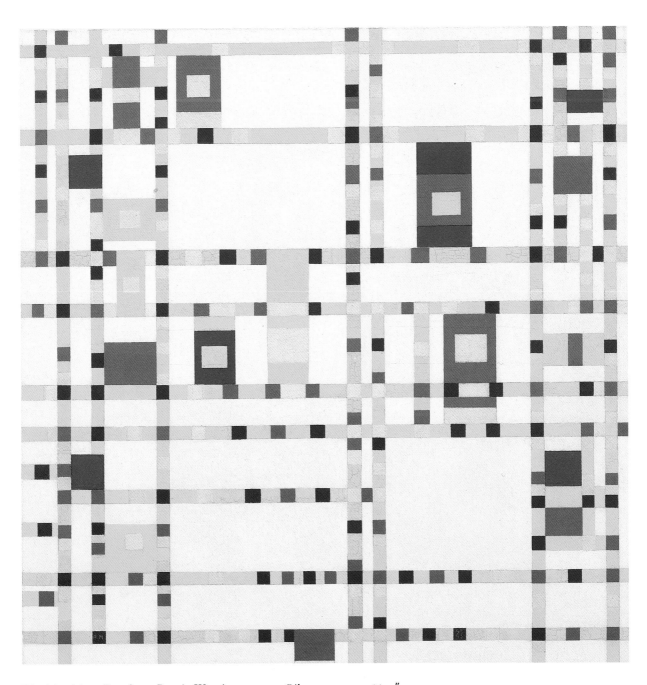

Piet Mondrian. *Broadway Boogie Woogie*. 1942–43. Oil on canvas, 50×50″

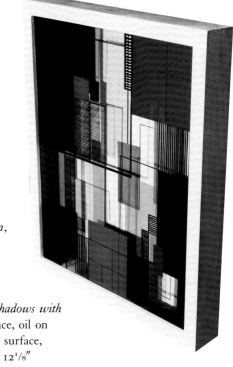

Left: Josef Albers. *Ascension*, from the series *Graphic Tectonic*. 1942. Lithograph, 17³/₁₆ × 8¹/₈″, irreg.

Right: Irene Rice Pereira. *Shadows with Painting*. (1940). Outer surface, oil on glass, 1¹/₄″ in front of inner surface, gouache on cardboard, 15 × 12¹/₈″

Jean Gorin. *Counterpoint Number 31*. 1948. Painted wood relief, 22³/₄ × 35¹/₄ × 3³/₄″

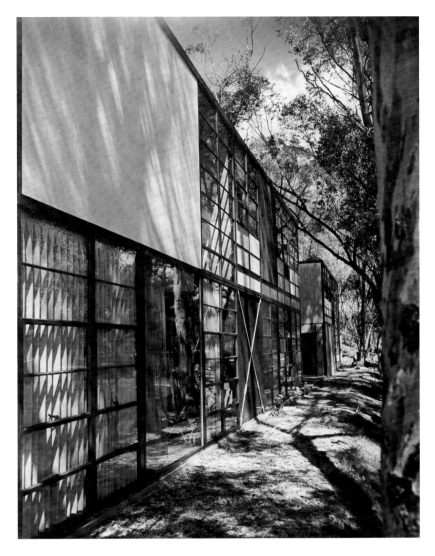

Charles Eames. Eames House, Santa Monica, California. (1949)

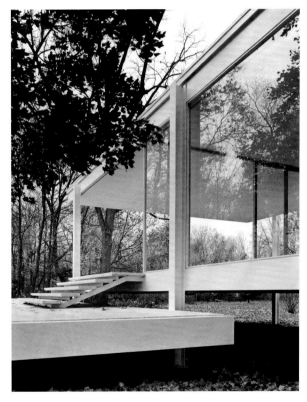

Ludwig Mies van der Rohe. Farnsworth House,
Plano, Illinois. (1946–51)

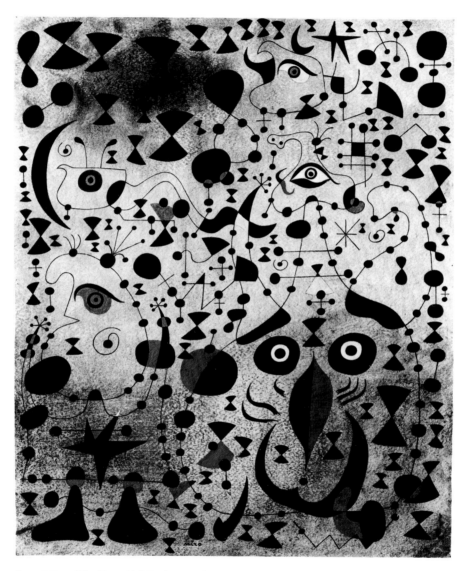

Joan Miró. *The Beautiful Bird Revealing the Unknown to a Pair of Lovers*.
1941. Gouache and oil wash, 18 × 15″

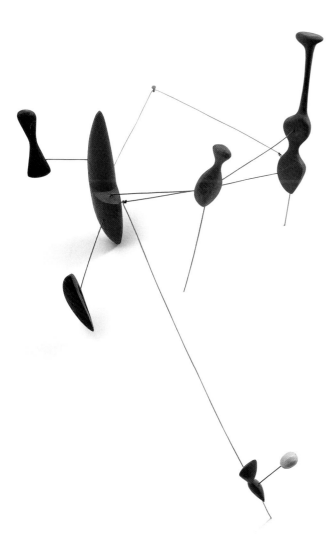

Alexander Calder. *Constellation with Red Object.* (1943). Painted wood and steel wire construction, 24¹/₂ × 15¹/₄ × 9¹/₂″

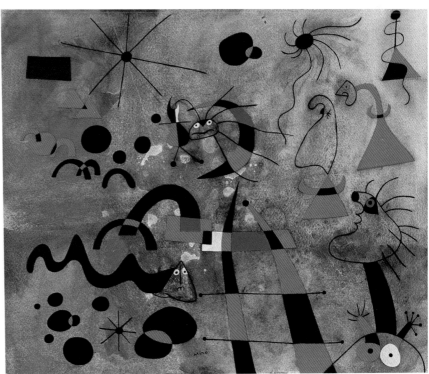

Joan Miró. *The Escape Ladder.* (1940). Gouache, watercolor, and brush and ink, 15³/₄ × 18³/₄″

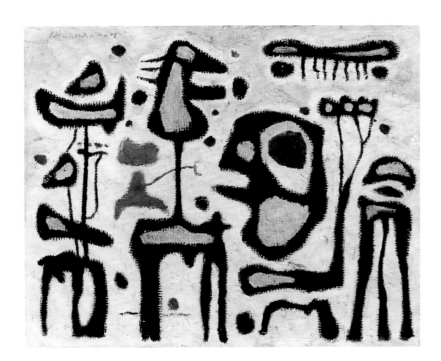

Willi Baumeister. *African Play, IV*. 1942.
Oil on composition board, 14¹/₈ × 18¹/₈"

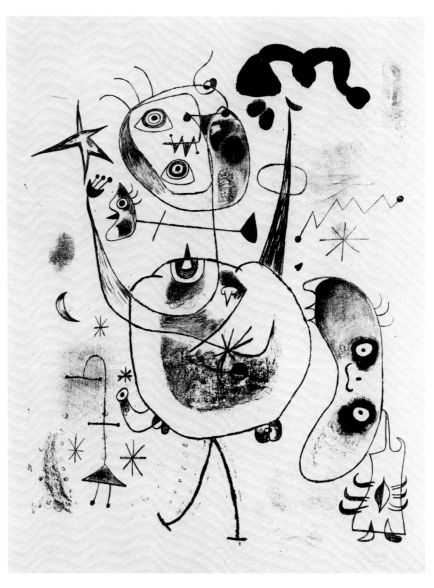

Joan Miró. Plate XXIII, from the
Barcelona Series. 1944. Transfer
lithograph, 24³/₈ × 18⁹/₁₆"

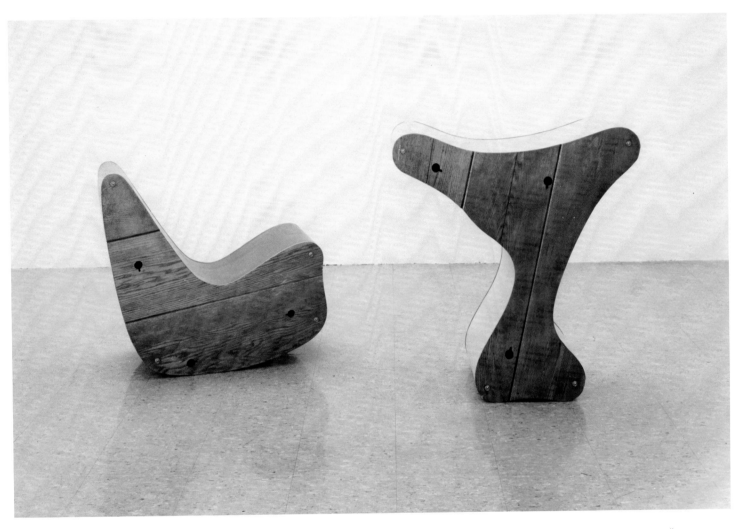

Frederick J. Kiesler. Multi-use Rocker and Multi-use Chair. (1942). Oak and linoleum, 29¹/₄ × 15⁵/₈ × 30³/₄″ and 33³/₈ × 15⁵/₈ × 35″

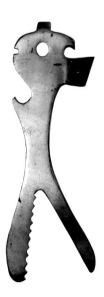

Barcalo Manufacturing Company. Seven-in-one Tool.
(1940). Metal, bronze finish, 6¹/₄ × 2¹/₂″

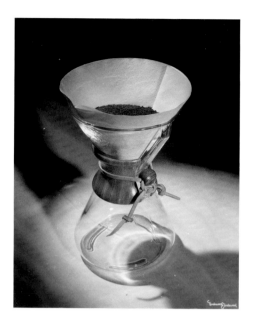

Peter Schlumbohm. "Chemex" Coffee Maker
(quart size). (1941). Borosilicate glass, wood
collar handle, rawhide string, 9¹/₂″ h. ×
6¹/₈″ diam. Photograph, 1944

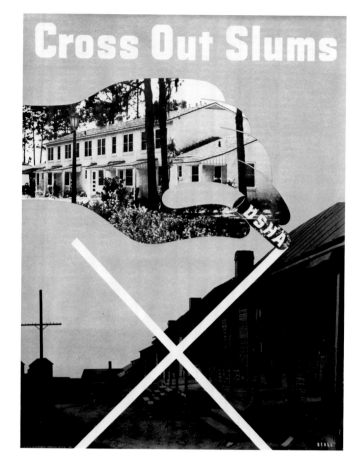

Lester Beall. *Cross Out Slums*. 1941. Poster:
offset lithograph, 39¹/₂ × 29¹/₈″

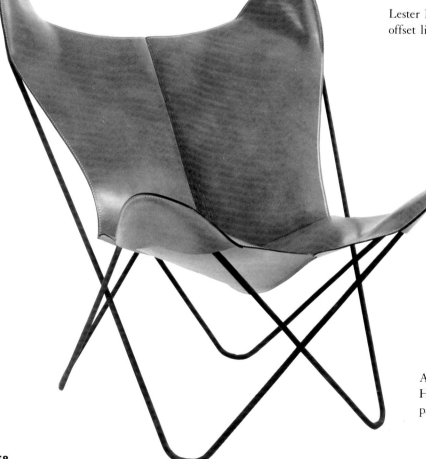

Antonio Bonet, Juan Kurchan, and Jorge Ferrari-
Hardoy. "B.K.F." Chair. (1939–40). Leather seat,
painted wrought-iron rod frame, 34³/₄ × 31 × 37″

André Breton. Untitled, from the portfolio *VVV*. 1943. Collage of paper, thread, and sequins with ink, 17¹⁵⁄₁₆ × 13¹⁵⁄₁₆″

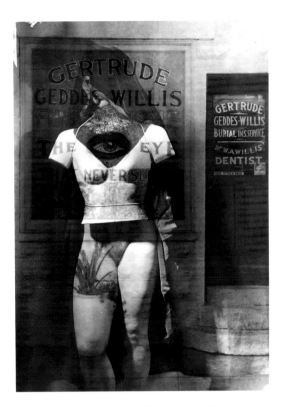

Clarence John Laughlin. *The Eye that Never Sleeps*. 1946. Photograph: gelatin-silver print, 12³⁄₈ × 8³⁄₄″

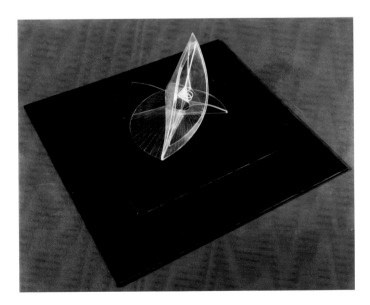

Naum Gabo. *Spiral Theme*. (1941). Construction in plastic, 5¹⁄₂ × 13¹⁄₄ × 9³⁄₈″ on base 24″ square

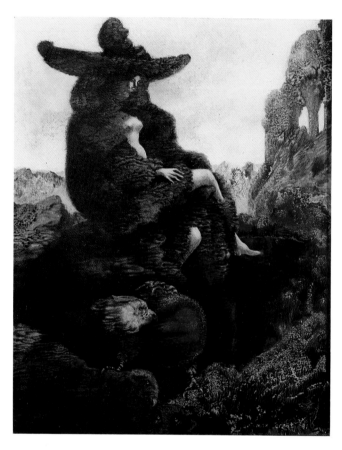

Max Ernst. *Alice in 1941*. 1941. Oil on paper,
mounted on canvas, 15³/₄ × 12³/₄″

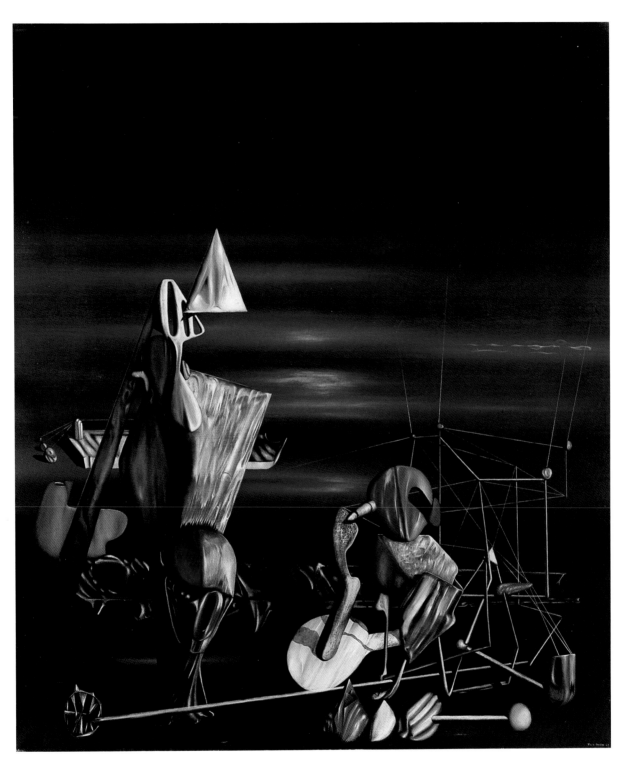

Yves Tanguy. *Slowly Toward the North.* 1942. Oil on canvas, 42 × 36″

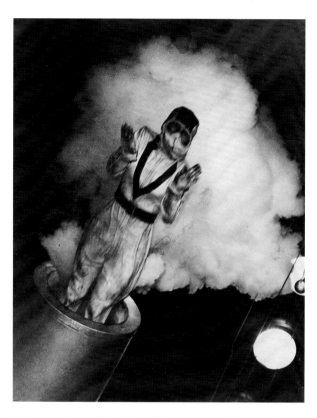

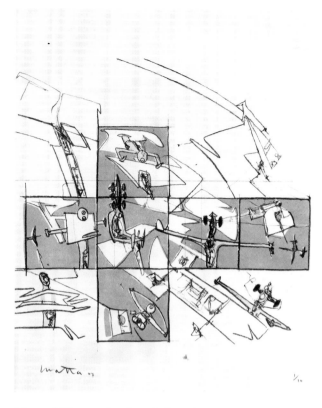

Matta. *I Want to See It to Believe It*, plate V from the
Brunidor Portfolio, No. 1. 1947. Lithograph, 12¹/₈ × 12⁷/₈″

Weegee. *Woman Shot from Cannon*. 1943. Photograph:
gelatin-silver print, 13⁷/₈ × 11¹/₄″

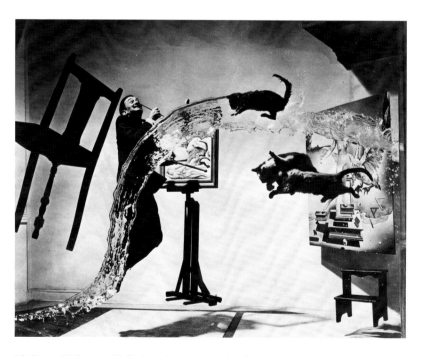

Philippe Halsman. *Dali Atomicus*. (c. 1948). Photograph:
gelatin-silver print, 10³/₁₆ × 13¹/₈″

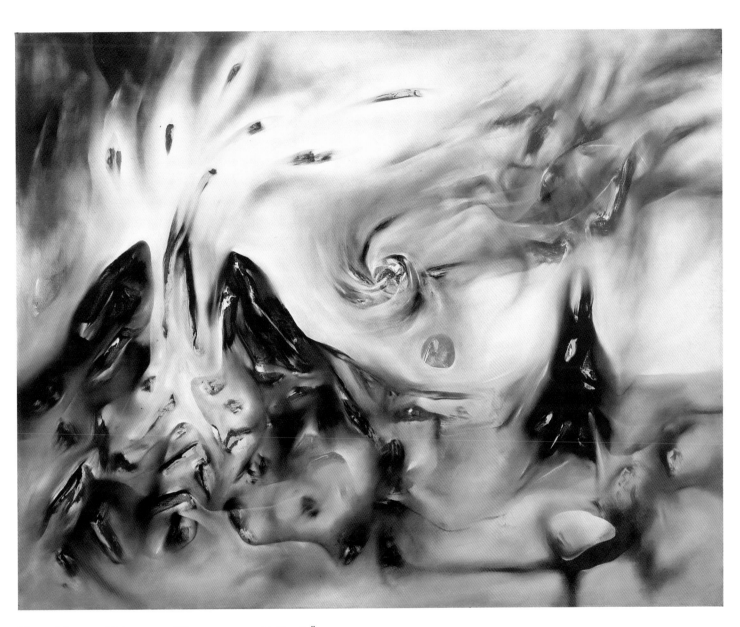

Matta. *Listen to Living.* 1941. Oil on canvas, 29¹/₂ × 37³/₈″

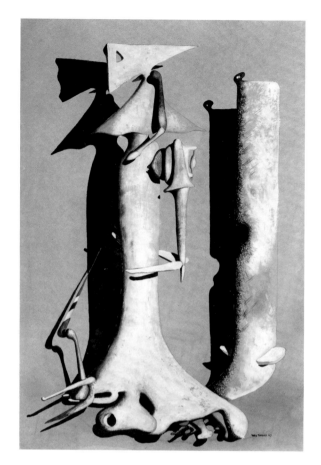

Yves Tanguy. Untitled. 1947. Gouache,
brush and ink, and pencil, 13⁵/₈ × 9⁷/₈″

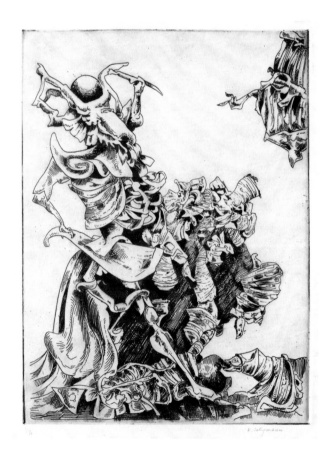

Kurt Seligmann. *Acteon*, plate VI from the *Brunidor
Portfolio, No. 1*. 1947. Etching, 11³/₄ × 8¹³/₁₆″

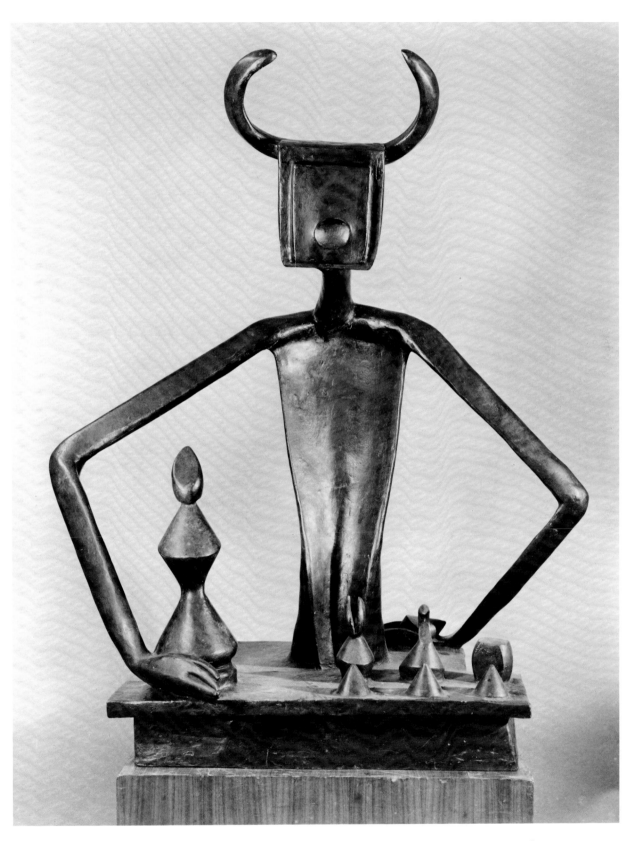

Max Ernst. *The King Playing with the Queen*. (1944; cast 1954). Bronze, 38½″ h., at base 18¾ × 20½″

Stanley William Hayter. *Death by Water*.
1948. Engraving, 13¹³/₁₆ × 23¹³/₁₆″

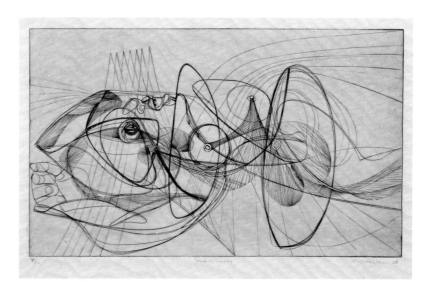

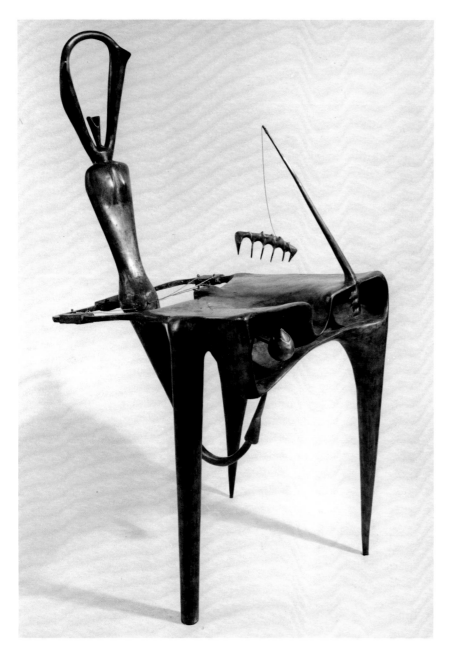

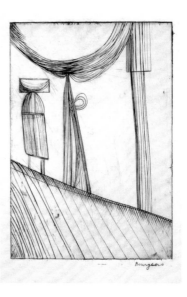

Louise Bourgeois. *Difficult Climb*.
(1945–50). Engraving, 6¹⁵/₁₆ × 4⁷/₈″

David Hare. *Magician's Game*. (1944; cast 1946).
Bronze, 40¹/₄ × 18¹/₂ × 25¹/₄″

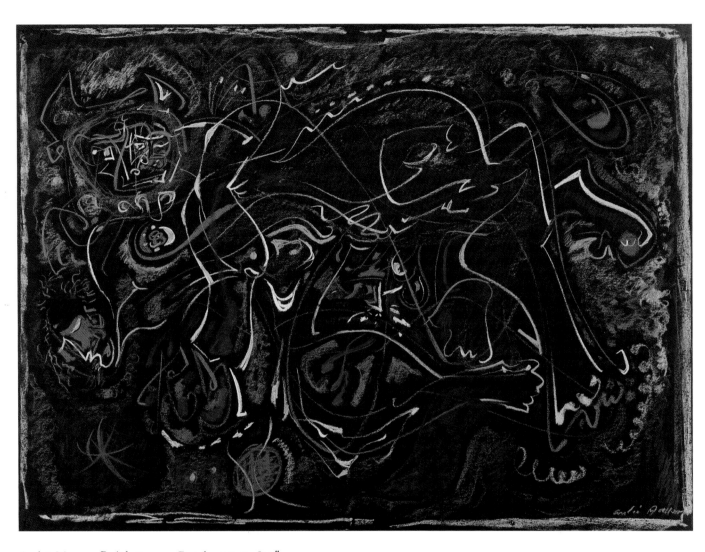

André Masson. *Pasiphaë.* 1945. Pastel, 27¹/₂ × 38¹/₈″

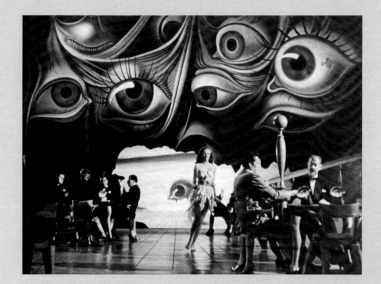

Gregory Peck and Michael Chekhov in *Spellbound*. (1945). Directed by Alfred Hitchcock

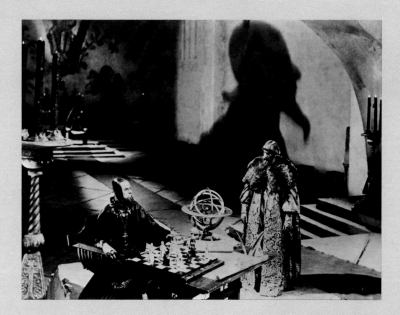

Nikolai Cherkassov in *Ivan the Terrible*, Part I. (1944). Directed by Sergei Eisenstein

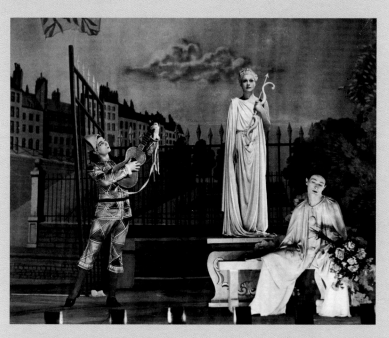

Pierre Brasseur, Arletty, and Jean-Louis Barrault in *Children of Paradise*. (1945). Directed by Marcel Carné

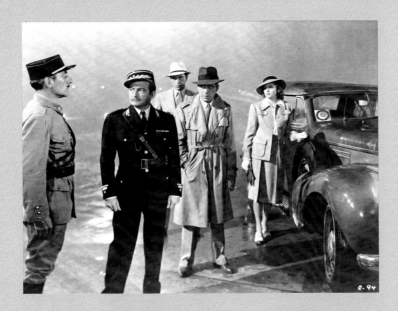

Claude Rains, Paul Henreid, Humphrey Bogart, and Ingrid Bergman in *Casablanca*. (1942). Directed by Michael Curtiz

Orson Welles and Ray Collins in *Citizen Kane*. (1941). Directed by Orson Welles

Jack Bittner in *Dreams That Money Can Buy*. (1947). Directed by Hans Richter

Paul Klee. *Lady Apart*. 1940. Tempera on paper
mounted on cardboard, 25^{1}/$_{2}$ × 19^{5}/$_{8}$"

Frida Kahlo. *Self-Portrait with Cropped Hair*.
1940. Oil on canvas, 15³/₄ × 11″

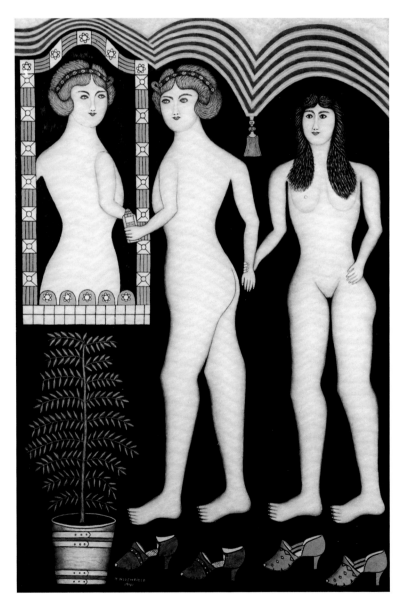

Morris Hirshfield. *Inseparable Friends*.
1941. Oil on canvas, 60¹/₈ × 40¹/₈″

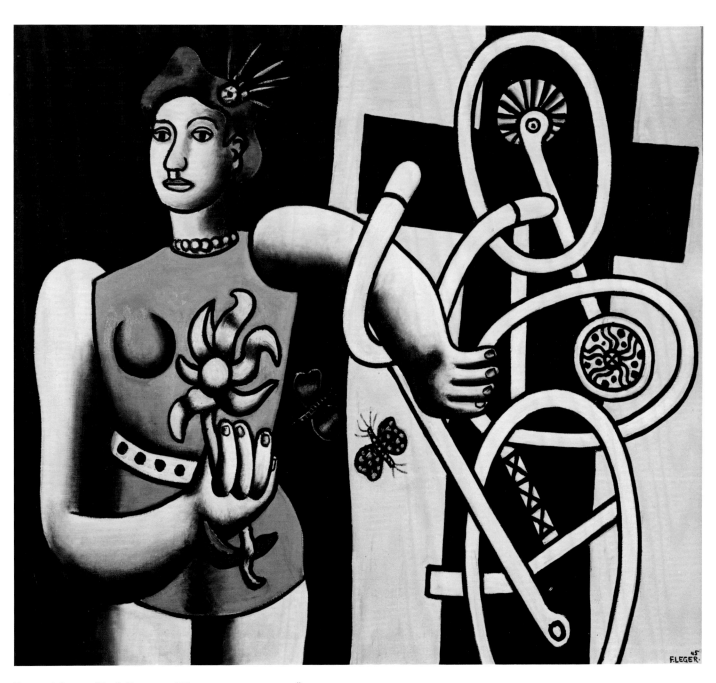

Fernand Léger. *Big Julie*. 1945. Oil on canvas, 44 × 50¹⁄₈″

Ces pages ne servent donc que d'accompa- gnement à mes couleurs, comme des asters aident dans la compo- sition d'un bouquet de

18

Henri Matisse. *Le Cirque*, from *Jazz*. 1947. Pochoir, 16⅝ × 25⅝″

Henri Matisse. *Monsieur Loyal*, from *Jazz*. 1947. Pochoir, 16⅝ × 25⅝″

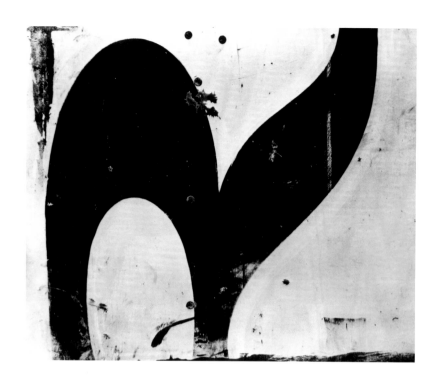

Aaron Siskind. *Chicago*. 1949. Photograph: gelatin-silver print, 14 × 17¹³⁄₁₆″

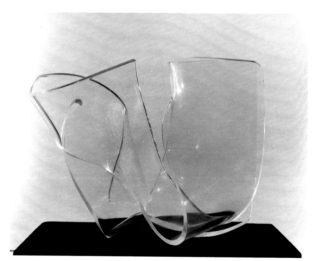

László Moholy-Nagy. *Double Loop*. 1946. Plexiglass, 16¹⁄₄ × 22¹⁄₄ × 17¹⁄₂″

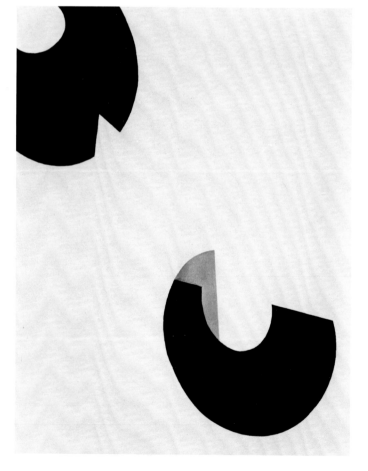

A. E. Gallatin. *Forms and Red*. 1949. Oil on canvas, 30 × 23″

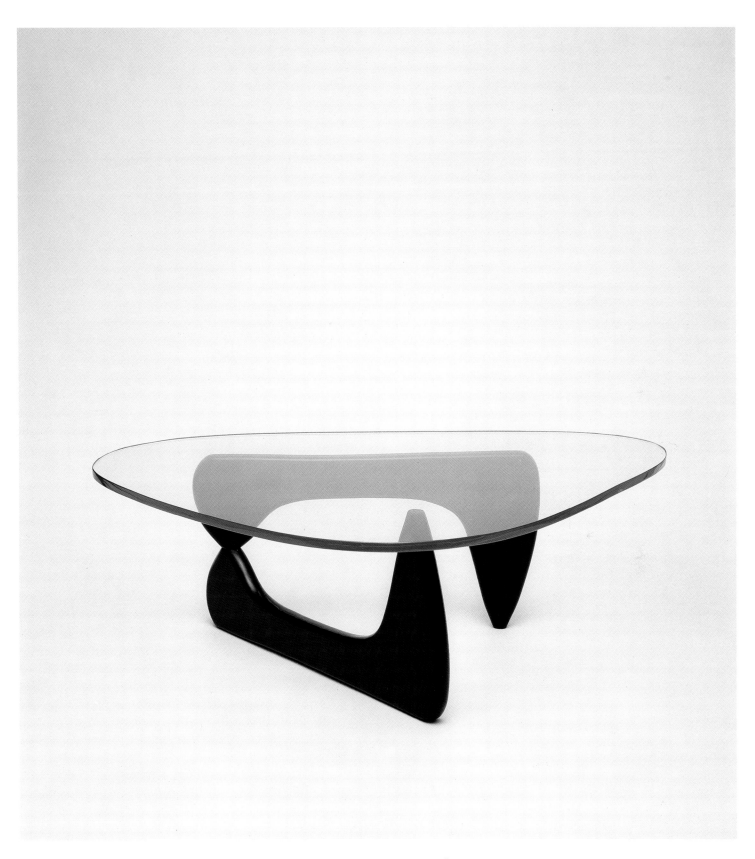

Isamu Noguchi. Table. (1944). Ebonized birch (base) and glass (top), $15^5/8 \times 50 \times 36''$

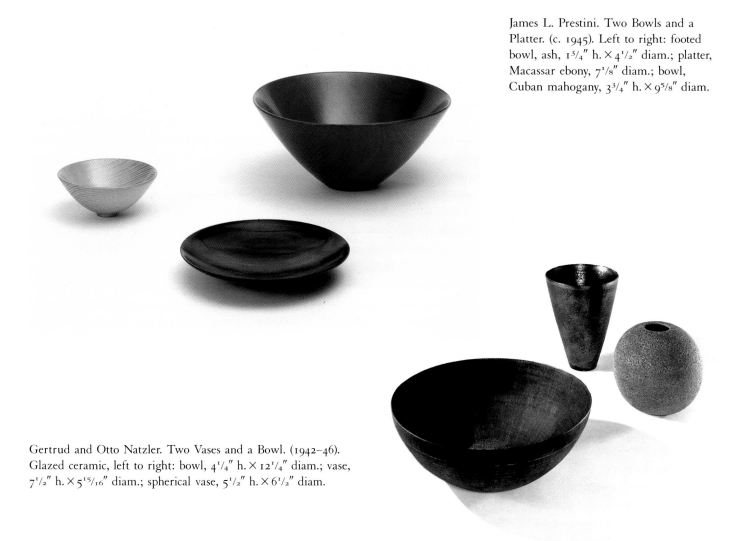

James L. Prestini. Two Bowls and a Platter. (c. 1945). Left to right: footed bowl, ash, 1³/₄″ h. × 4¹/₂″ diam.; platter, Macassar ebony, 7¹/₈″ diam.; bowl, Cuban mahogany, 3³/₄″ h. × 9⁵/₈″ diam.

Gertrud and Otto Natzler. Two Vases and a Bowl. (1942–46). Glazed ceramic, left to right: bowl, 4¹/₄″ h. × 12¹/₄″ diam.; vase, 7¹/₂″ h. × 5¹⁵/₁₆″ diam.; spherical vase, 5¹/₂″ h. × 6¹/₂″ diam.

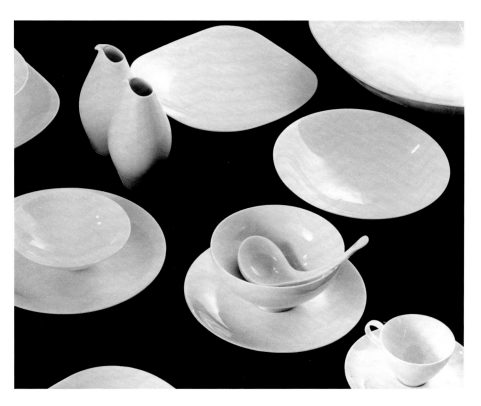

Eva Zeisel. "Museum" Dinner Service. (c. 1942–45). Glazed porcelain, various dimensions. Photograph, 1946

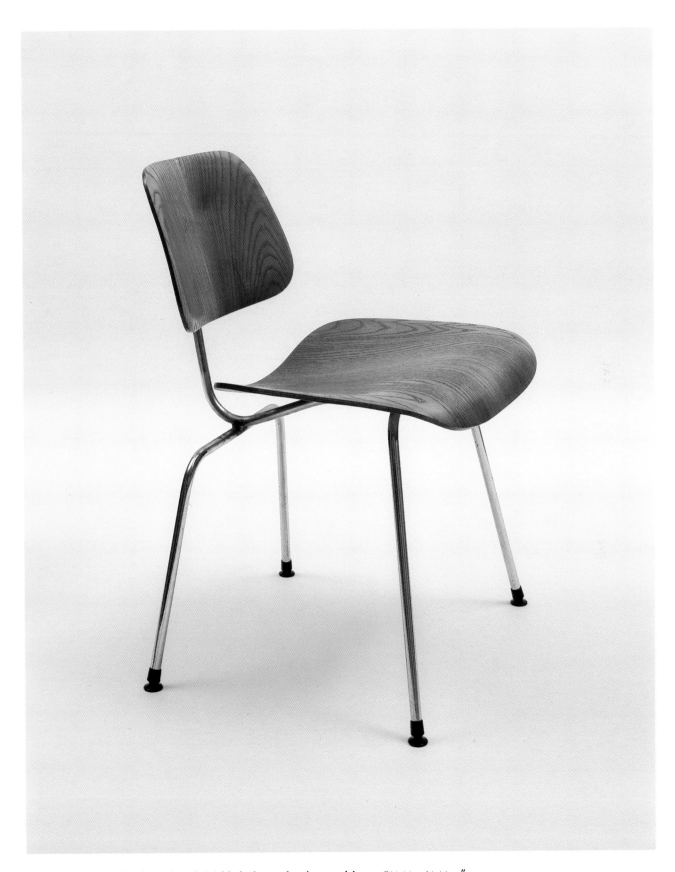

Charles Eames. Side Chair. (1946). Molded plywood, ash, metal legs, $28^{3}/_{4} \times 19^{1}/_{2} \times 20''$

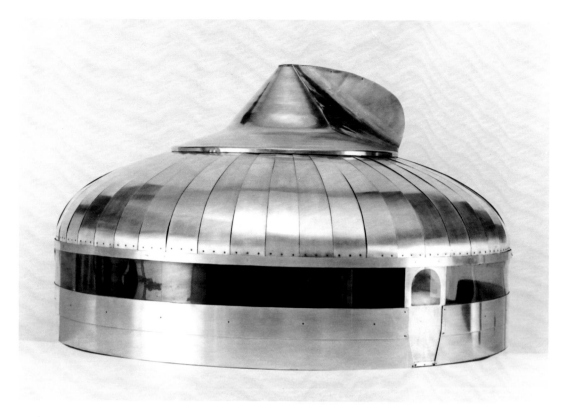

Buckminster Fuller. Wichita House (Dymaxion Dwelling Machine). (1944–46).
Model: aluminum and various mediums, 21¼″ h. × 36″ diam.

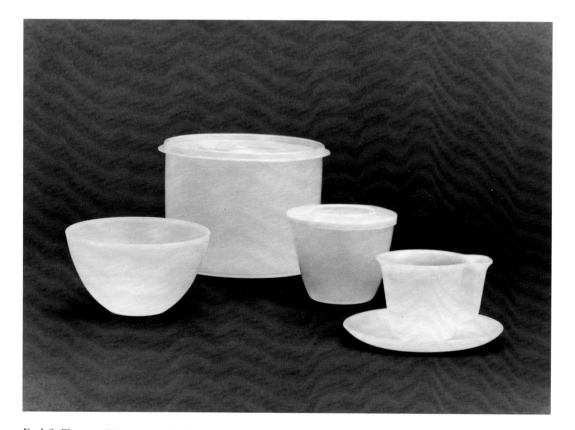

Nathan George Horwitt.
Wristwatch Face. (1947).
Analogue watch, white gold,
enameled dial, 1⁵/₁₆″ diam.

Earl S. Tupper. "Tupperware." (c. 1945). Flexible plastic, left to right: bowl, 2⁷/₈″ h. × 5½″ diam.;
covered bowl, 5″ h. × 6½″ diam.; covered bowl, 3⅜″ h. × 4⅜″ diam.; cup, 2¾″ h. × 3⅛″ diam.;
saucer, 5¾″ diam.

Ruodi Barth. *Zoologischer Garten Basel*. (1947).
Poster: offset lithograph, $49^5/_8 \times 34^3/_4''$

Fritz Bühler. *Film/Festival Congrès International Bâle*.
1945. Poster: offset lithograph, $50 \times 35^1/_2''$

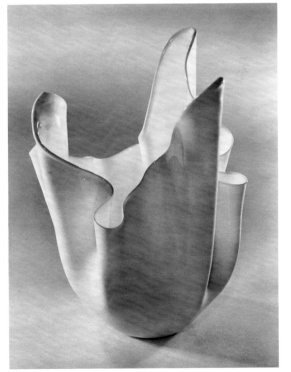

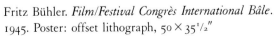

Fulvio Bianconi. Vase. (1949). Glass, $13^1/_4''$ h. $\times 8^3/_4''$ diam.

Marcello Nizzoli. "Lexikon 80" Manual Typewriter. (1948).
Gray enameled aluminum housing, 9 × 11 × 15"

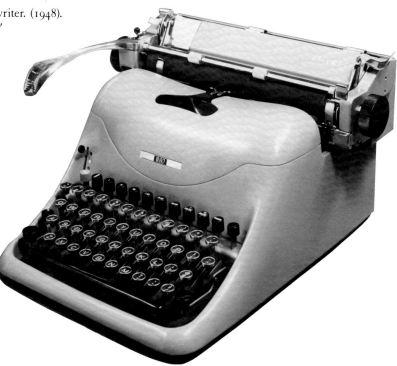

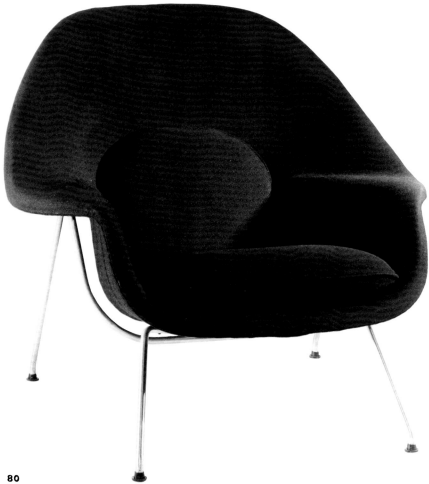

Eero Saarinen. "Womb" Chair. (1948). Upholstered
latex foam on fiberglass-reinforced plastic shell;
chrome-plated steel rod base, 36¹/₂ × 40 × 34"

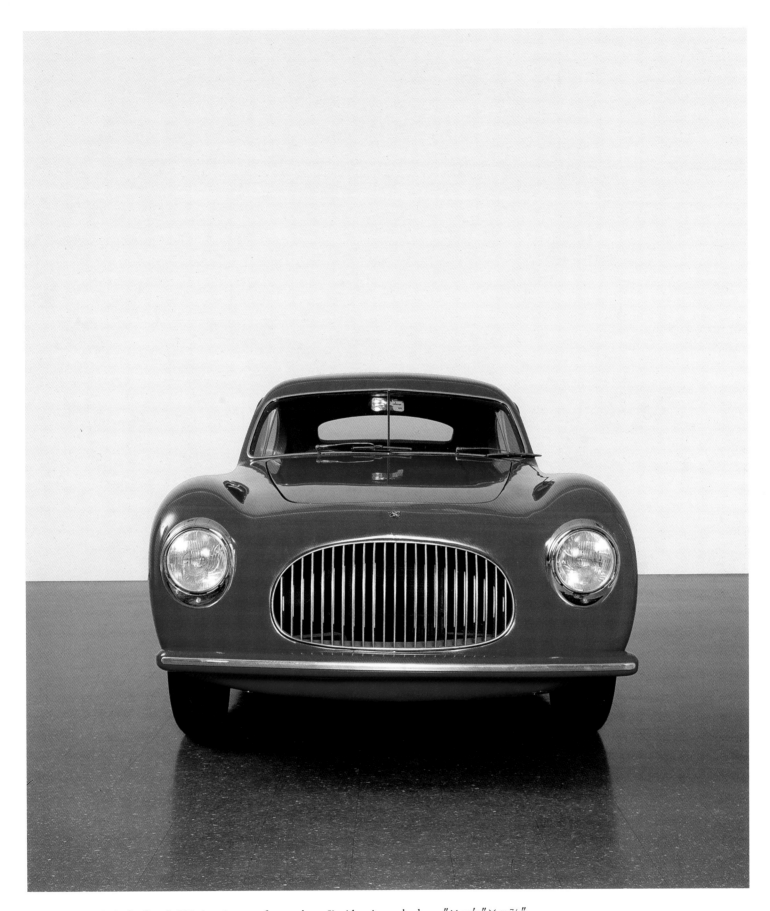

Pinin Farina. Cisitalia "202" GT. (1946; manufactured 1948). Aluminum body, $49'' \times 13' 2'' \times 57^{7/8}''$

Pablo Picasso. *Paris, July 14, 1942.* (begun 1942; this state probably printed 1945). Etching and engraving, 17¹⁄₂ × 25⁹⁄₁₆″

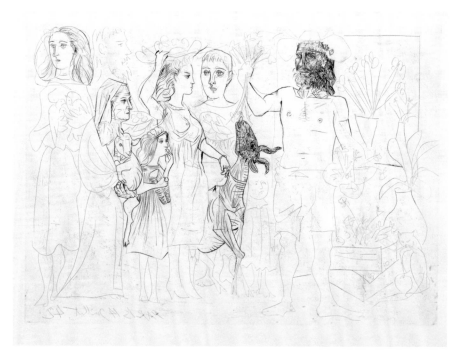

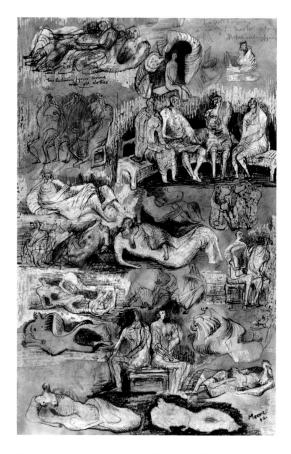

Henry Moore. *Seated and Reclining Figures.* 1942. Watercolor, pencil, wax crayon, black chalk, pen and India ink, 14 × 8⁷⁄₈″

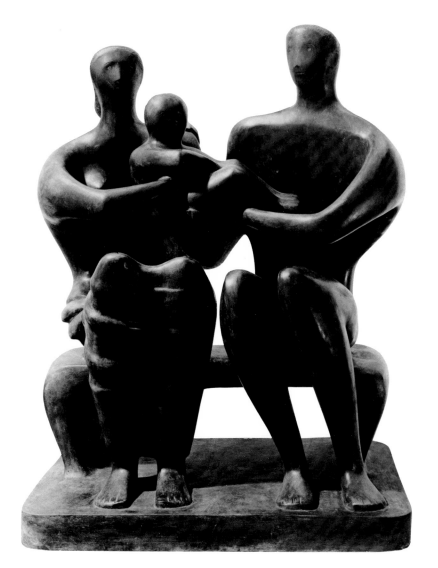

Henry Moore. *Family Group.* (1948–49; cast 1950). Bronze, 59¹⁄₄ × 46¹⁄₂ × 29⁷⁄₈″, including base

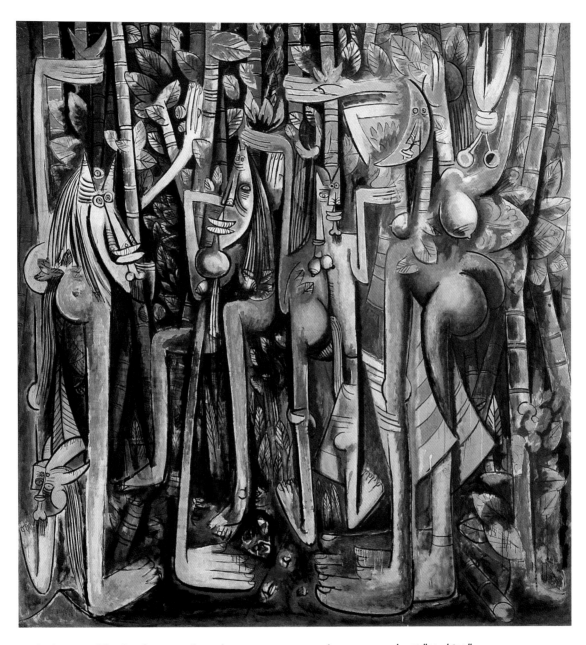

Wifredo Lam. *The Jungle*. 1943. Gouache on paper mounted on canvas, 7′10¼″×7′6½″

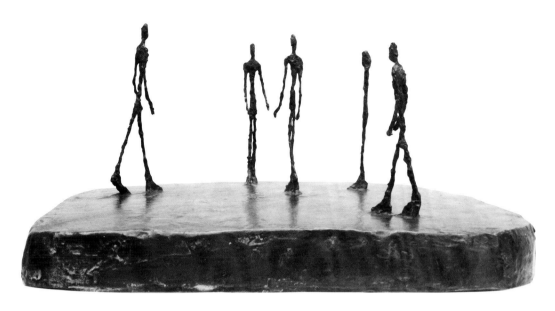

Alberto Giacometti. *City Square*. (1948). Bronze, 8¹/₂ × 25³/₈ × 17¹/₄″

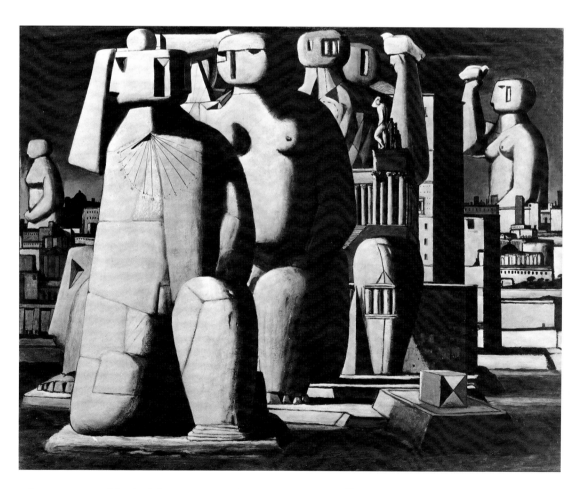

Salvatore Fiume. *Island of Statues*. 1948. Oil on canvas, 28 × 36¹/₄″

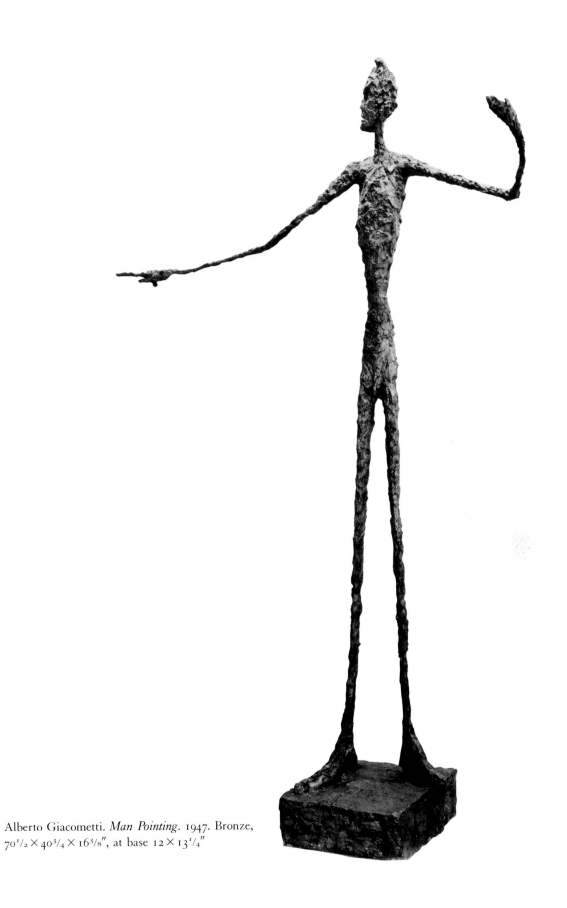

Alberto Giacometti. *Man Pointing*. 1947. Bronze,
70¹⁄₂ × 40³⁄₄ × 16³⁄₈″, at base 12 × 13¹⁄₄″

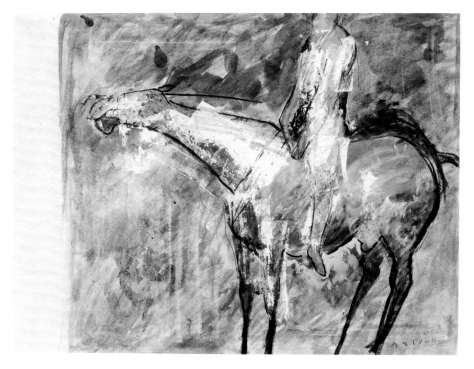

Marino Marini. *Boy on a Blue Horse*. (1947). Gouache,
wash, watercolor, and pen and ink, $11\frac{1}{2} \times 15\frac{5}{8}''$

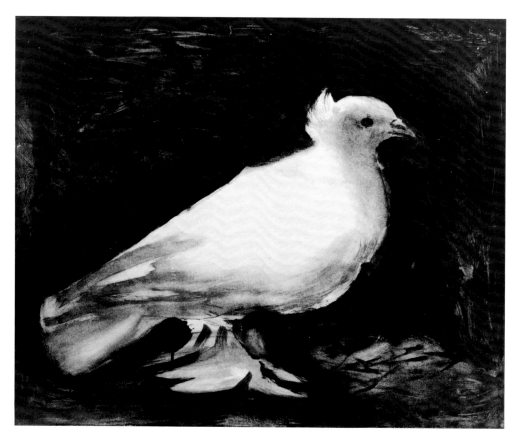

Pablo Picasso. *The Dove*. (January 9, 1949). Lithograph, $21\frac{1}{2} \times 27\frac{3}{16}''$, irreg.

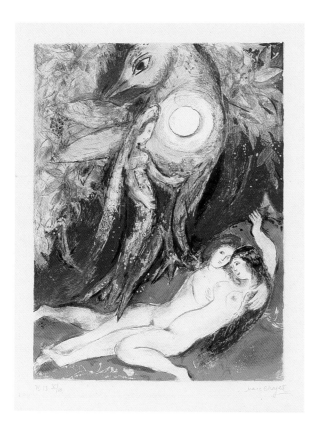

Marc Chagall. Plate 13, from *Four Tales
of the Arabian Nights*. 1948. Lithograph,
$16^{15}/_{16} \times 12^{15}/_{16}''$, irreg.

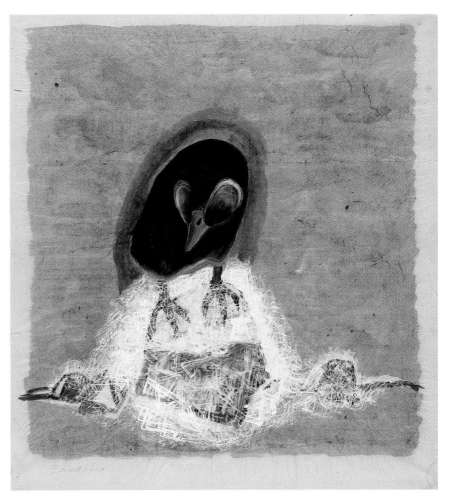

Morris Graves. *Blind Bird*.
(1940). Gouache and
watercolor on mulberry
paper, $30^1/_8 \times 27''$

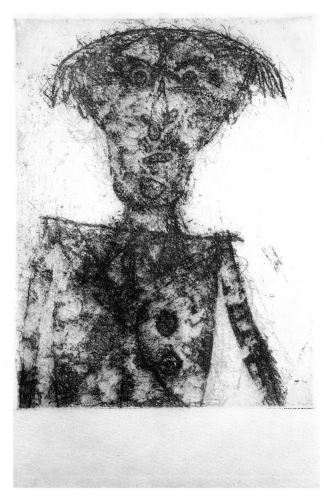

Jean Dubuffet. *Jean Paulhan*. (1946).
Hand photogravure, 12⁷/₁₆ × 9³/₄″

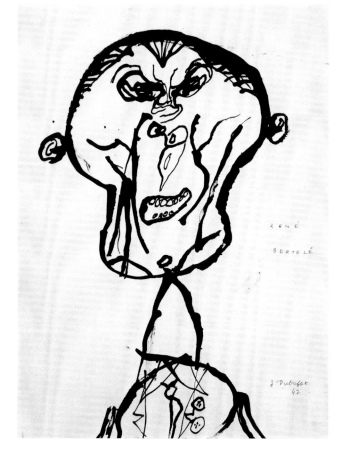

Jean Dubuffet. *René Bertelé*, from the More Beautiful
Than They Think: Portraits series. (July–August) 1947.
Reed pen and ink, 13¹/₄ × 9⁵/₈″

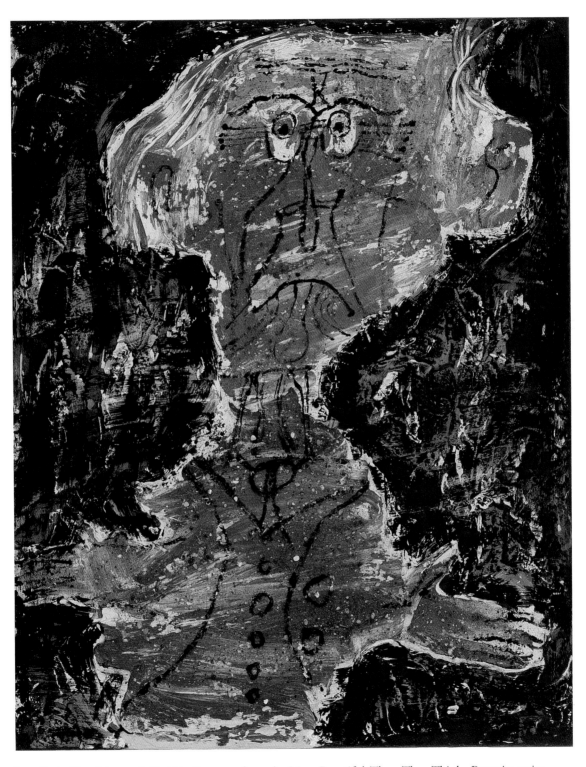

Jean Dubuffet. *Léautaud, Redskin Sorcerer*, from the More Beautiful Than They Think: Portraits series. (1946). Oil on canvas with pebbles, gravel, 36¹/₄ × 28³/₄″

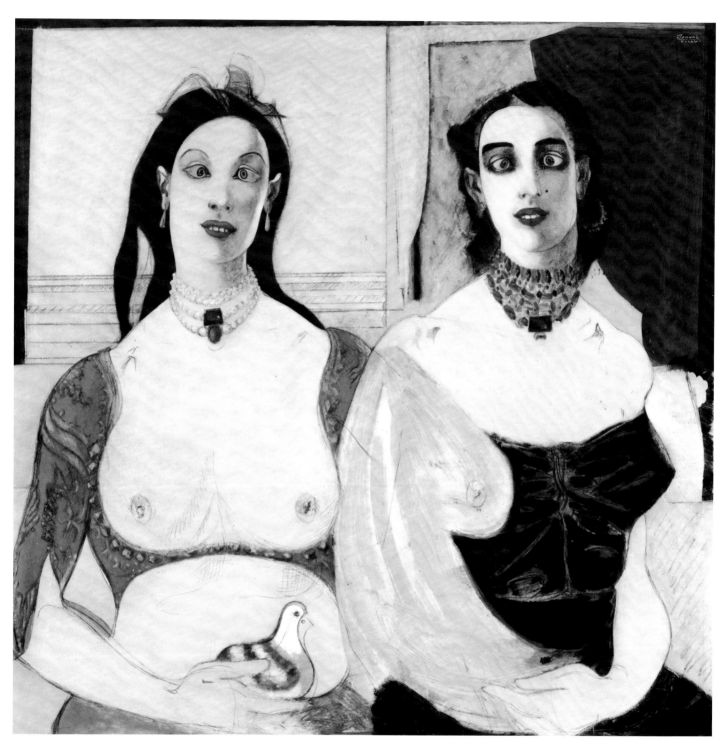

John D. Graham. *Two Sisters*. 1944. Oil, enamel, pencil, charcoal, and casein on composition board, 47⅞ × 48″

Lucian Freud. *Girl with Leaves*. (1948).
Pastel on gray paper, 18^{7}/$_{8}$ × 16^{1}/$_{2}$"

Édouard Boubat. *Lella*. 1948. Photograph:
gelatin-silver print, $8^{7}/_{16} \times 5^{7}/_{8}''$

Henri Cartier-Bresson. *M. and Mme. Joliot-Curie*. (1946).
Photograph: gelatin-silver print, 13¹/₂ × 9¹/₈″

Henri Cartier-Bresson. *Jean-Paul Sartre*. (1946).
Photograph: gelatin-silver print, 15¹/₈ × 10¹/₈″

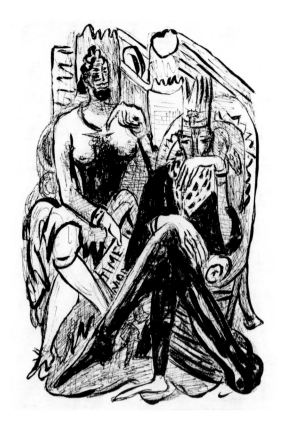

Max Beckmann. *King and Demagogue*, from the portfolio
Day and Dream. 1946. Lithograph, 14⁷/₈ × 10″

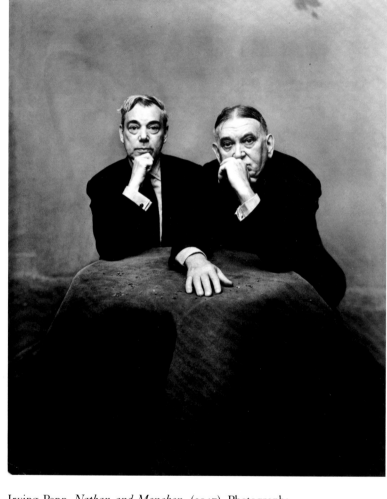

Irving Penn. *Nathan and Mencken*. (1947). Photograph:
gelatin-silver print, 19¹¹/₁₆ × 15⁹/₁₆″

Arnold Newman. *Robert Oppenheimer*. 1949.
Photograph: gelatin-silver print, 10¹/₁₆ × 8″

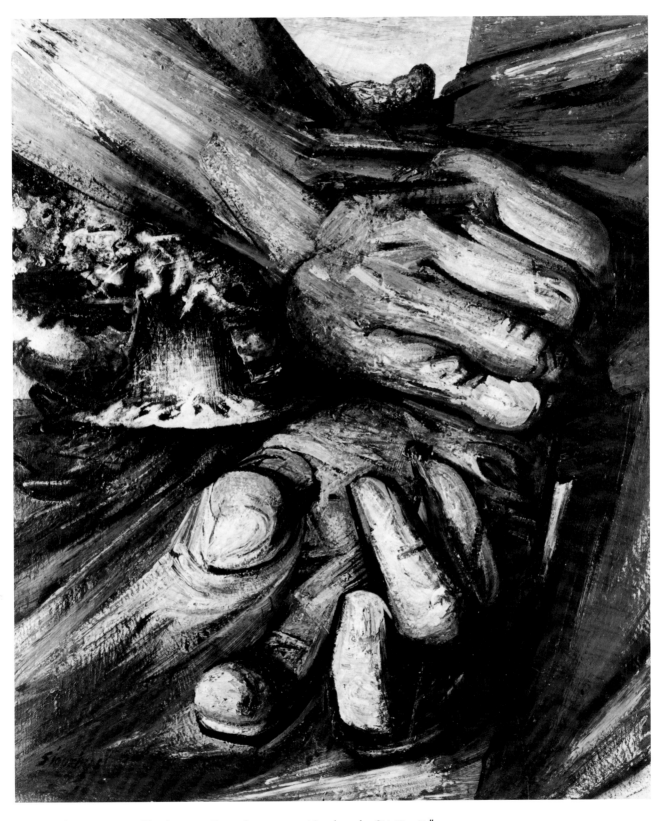

David Alfaro Siqueiros. *Hands*. 1949. Enamel on composition board, 48¹/₈ × 39³/₈″

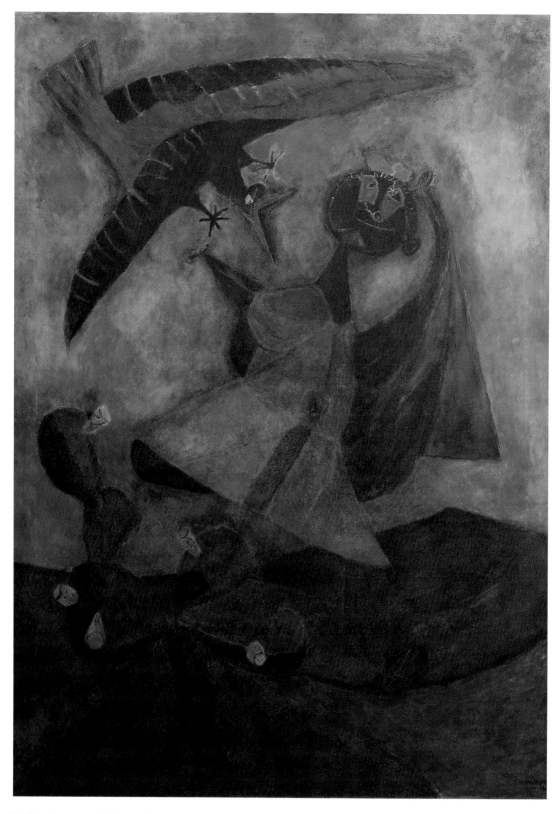

Rufino Tamayo. *Girl Attacked by a Strange Bird*. 1947. Oil on canvas, 70 × 50¹/₈″

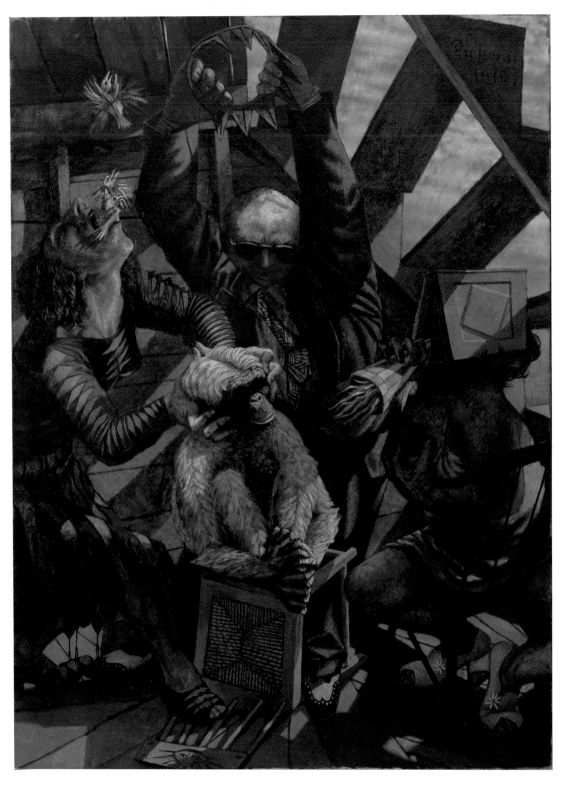

Alton Pickens. *Carnival*. 1949. Oil on canvas, 54⅝ × 40⅜″

Rico Lebrun. *Figure in Rain*. 1949. Enamel on
canvas over composition board, 48 × 30¹/₈″

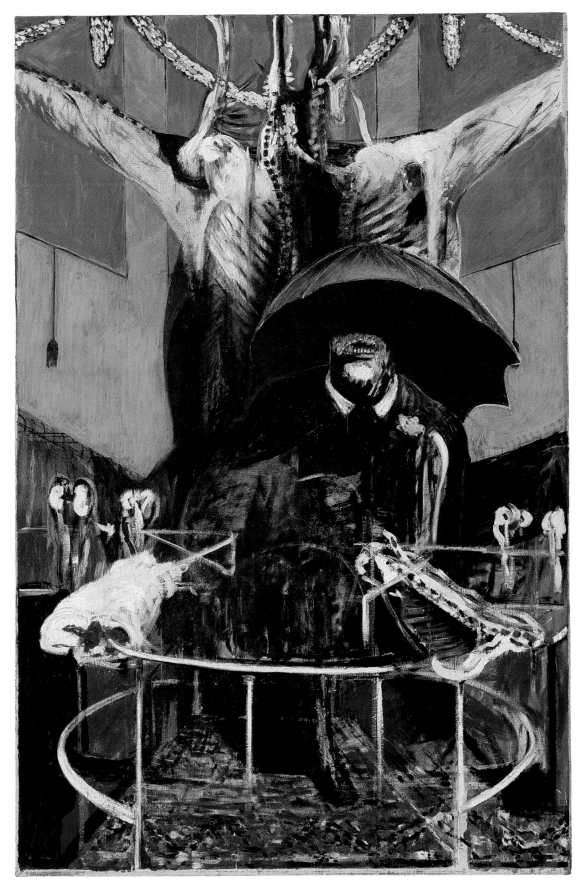

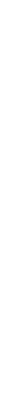

Francis Bacon. *Painting*. (1946). Oil and pastel on linen, $6'5^{7/8}'' \times 52''$

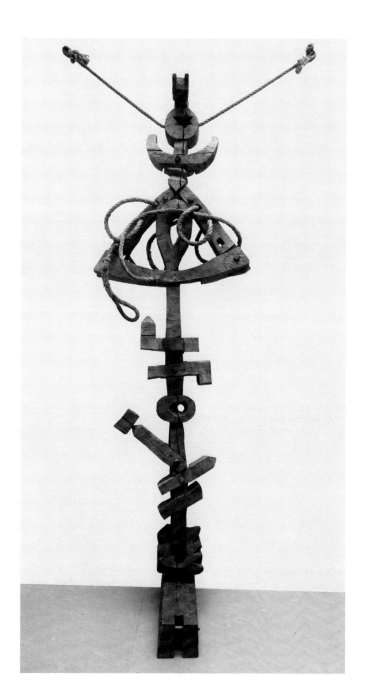

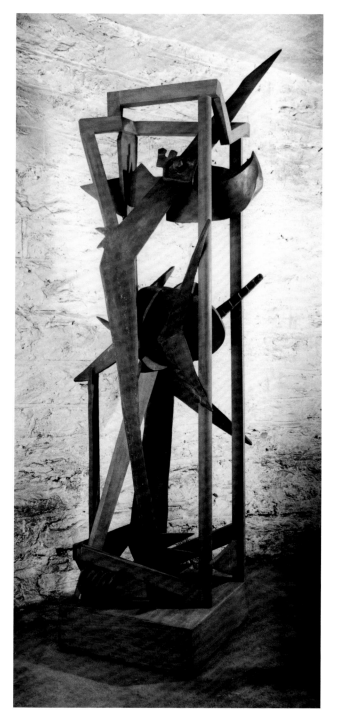

Left: Frederick J. Kiesler. *Totem for All Religions.* (1947). Wood and rope, 9′4¼″ × 34⅛″ × 30⅞″; upper rope extensions: left, 34¼″, and right, 33¼″

Right: Seymour Lipton. *Imprisoned Figure.* 1948. Wood and sheet-lead construction, 7′3¾″ × 30⅞″ × 23⅝″, including wood base, 6⅛ × 23⅛ × 20⅛″

Louise Bourgeois. *Quarantania, I.*
(1948–53). Painted wood on wood
base, 6'9¼" h., including base
6 × 27¼ × 27"

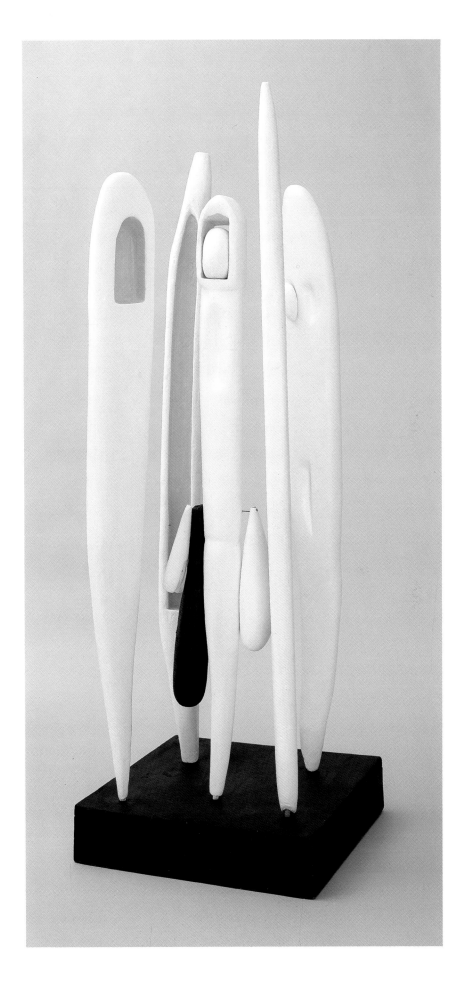

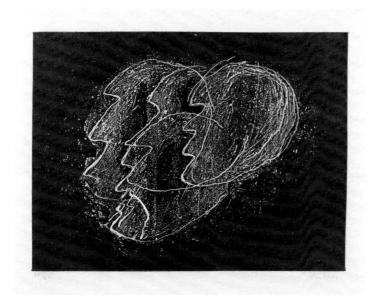

Jean Fautrier. *Hostages, Black Ground*. (1944–47; printed c. 1962).
Etching, 9¼ × 12⁹/₁₆″

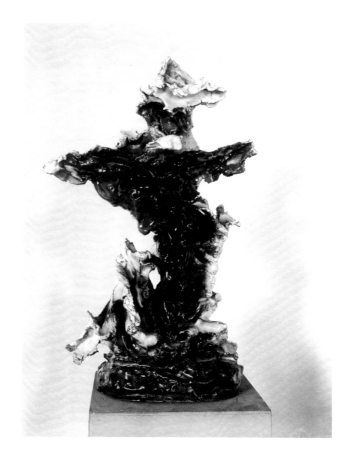

Lucio Fontana. *Crucifixion*. 1948.
Ceramic, 19¹/₈ × 12³/₈ × 9¹/₈″

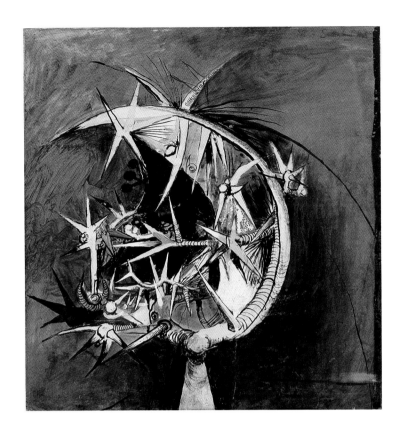

Graham Sutherland. *Thorn Head*. 1945.
Gouache, chalk, and ink, 21⁷/₈ × 20⁷/₈″

Wols. *Painting*. (1944–45).
Oil on canvas, 31⁷/₈ × 32″

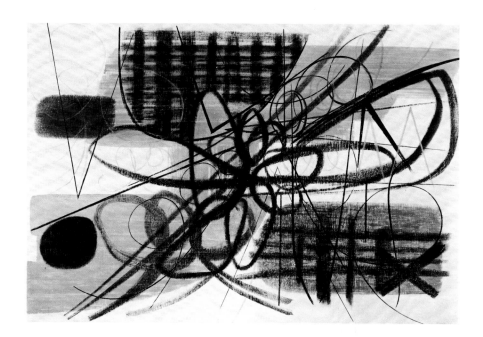

Hans Hartung. *Painting*. 1948.
Oil on canvas, 38¼ × 57½"

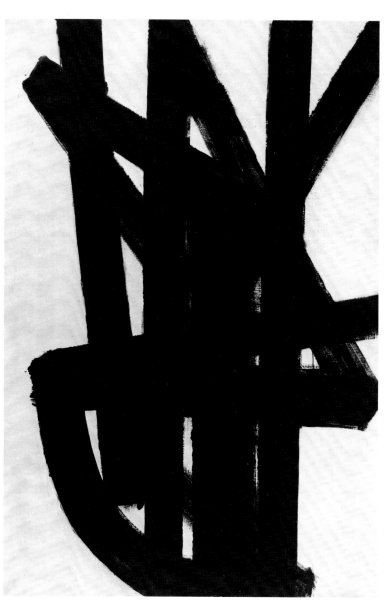

Pierre Soulages. *Painting*. 1948–49.
Oil on canvas, 6'4¼" × 50⅞"

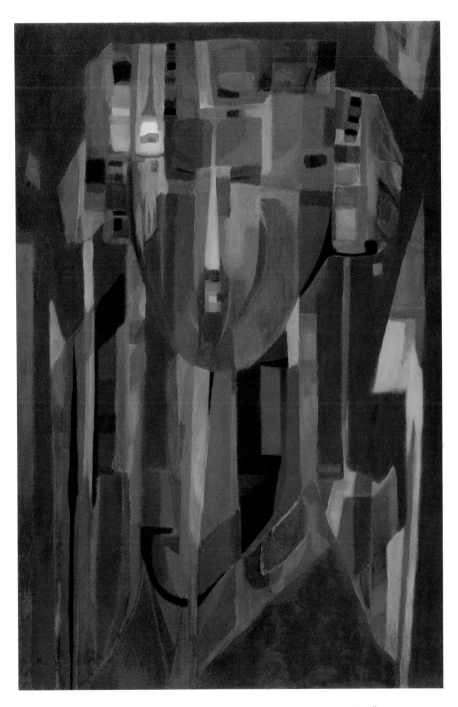

Alfred Manessier. *Figure of Pity*. 1944–45. Oil on canvas, 57³/₄ × 38¹/₄"

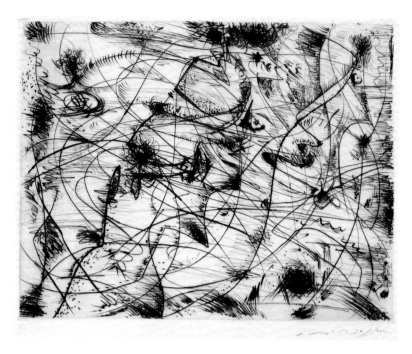

André Masson. *Abduction*. (c. 1946; printed in 1958).
Drypoint, 12^1/$_8$ × 16″

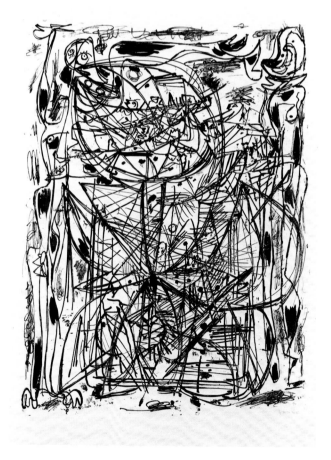

Asger Jorn. Plate from an untitled portfolio.
1945. Lithograph, 17^3/$_8$ × 12^3/$_4$″

Ad Reinhardt. *Newsprint Collage, 1940.* Dated 1940 and 1943. Cut-and-pasted construction paper and newsprint on gray cardboard, 16 × 20″

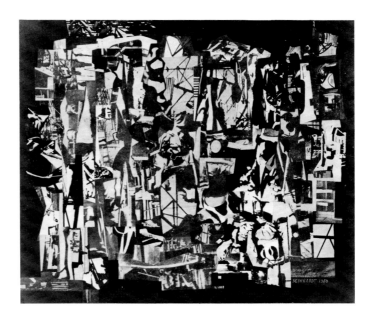

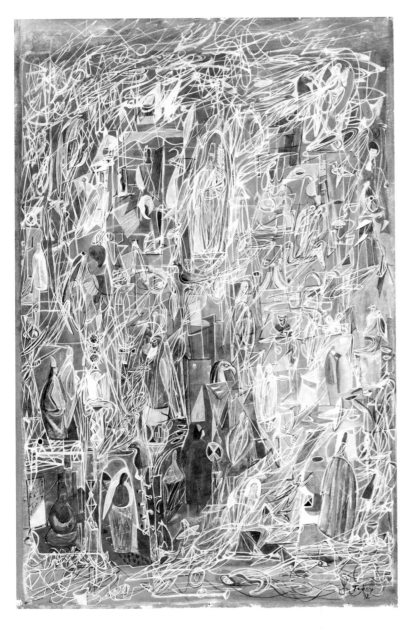

Mark Tobey. *Threading Light.* 1942.
Tempera on cardboard, 29¼ × 19¾″

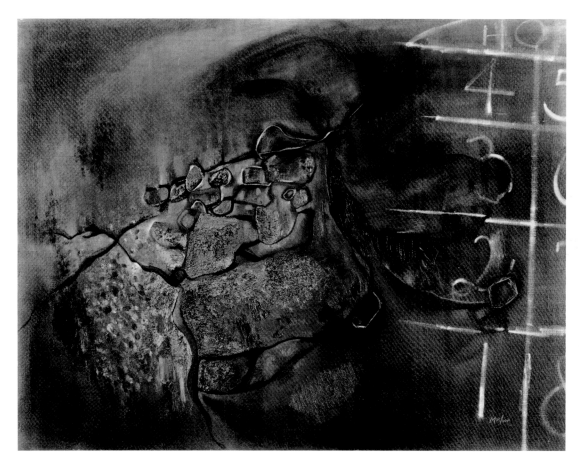

Loren MacIver. *Hopscotch*. (1940). Oil on canvas, 27 × 35⁷/₈″

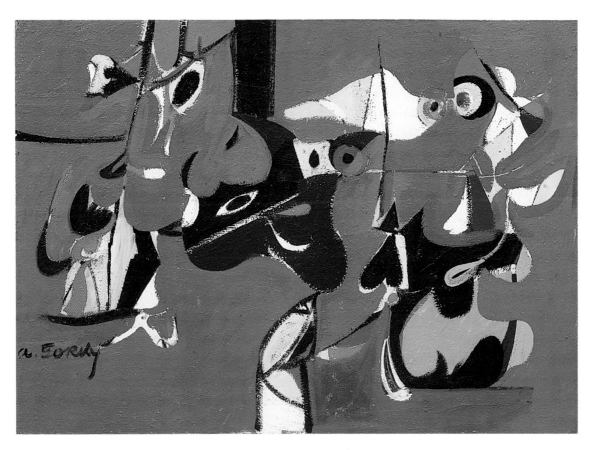

Arshile Gorky. *Garden in Sochi*. (1941). Oil on canvas, 44$^{1}/_{4}$×62$^{1}/_{4}$″

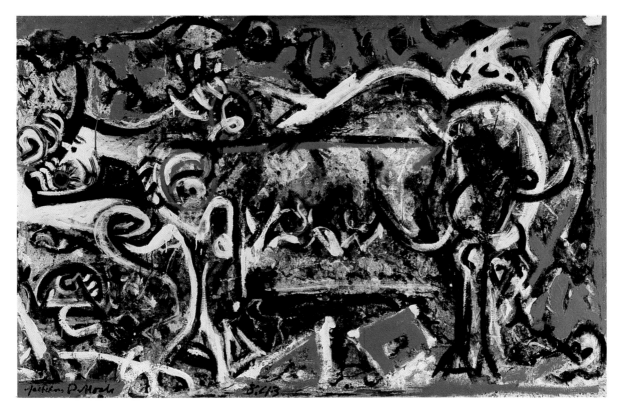

Jackson Pollock. *The She-Wolf*. 1943. Oil, gouache, and plaster on canvas, 41$^{7}/_{8}$×67″ **109**

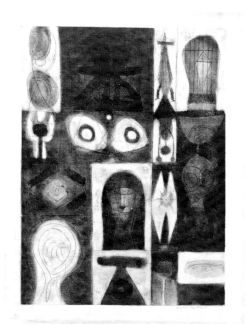

Adolph Gottlieb. *Apparition.* (1945).
Aquatint, 20¹/₈ × 15¹/₁₆″

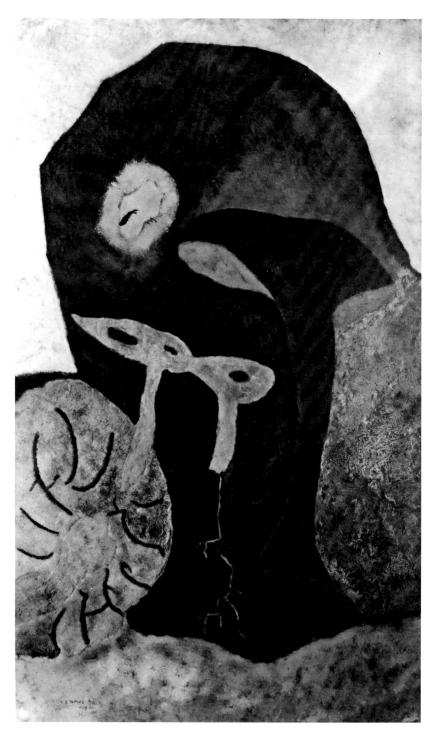

Theodoros Stamos. *Sounds in the Rock.* 1946.
Oil on composition board, 48¹/₈ × 28³/₈″

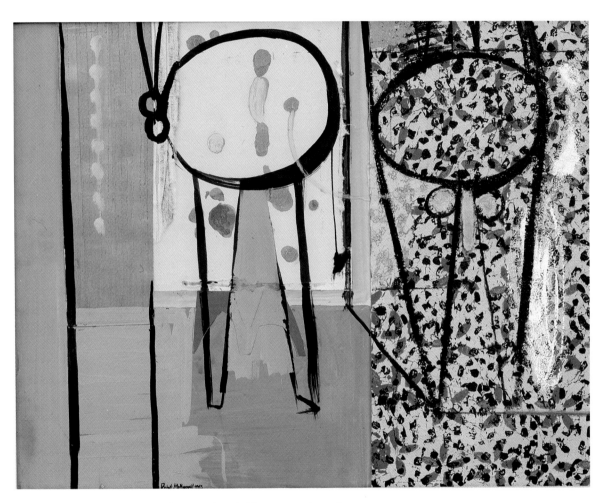

Robert Motherwell. *Pancho Villa, Dead and Alive.* 1943. Gouache,
oil, and cut-and-pasted papers on cardboard, 28¹/₄ × 35⁷/₈″

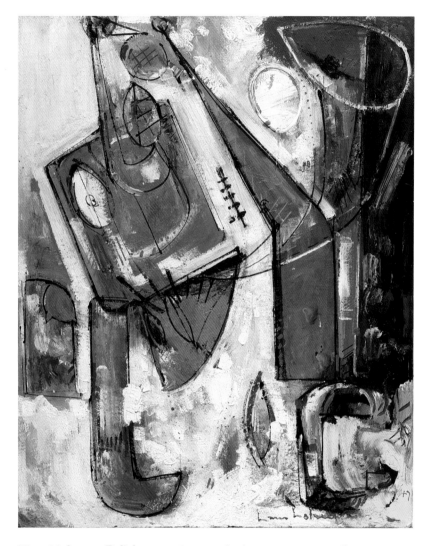

Hans Hofmann. *Delight*. 1947. Gesso and oil on canvas, 50 × 40″

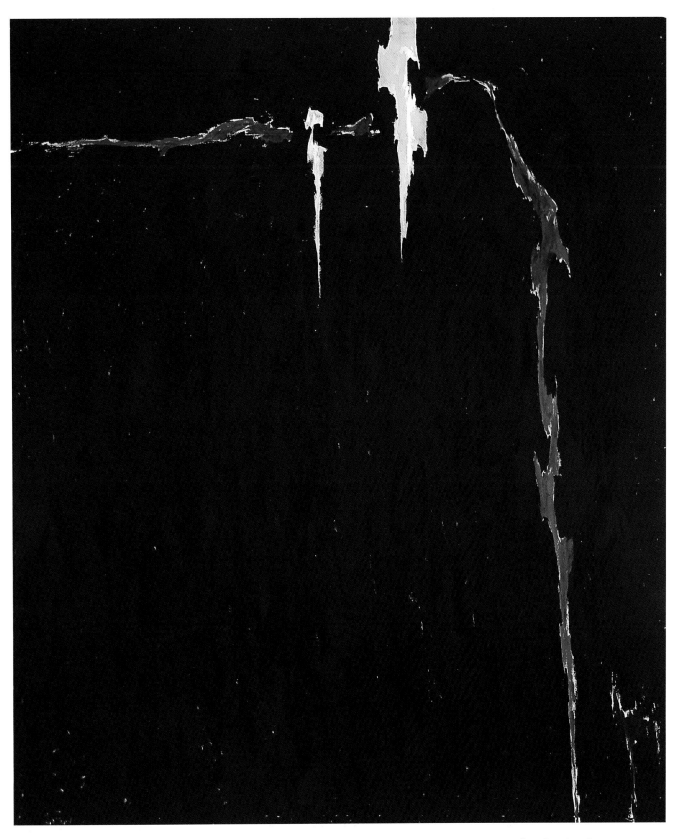

Clyfford Still. *Painting 1944-N*. (Inscribed on reverse by artist: *1944-N*). Oil on unprimed canvas, 8′8¼″ × 7′3¼″

Right: Herbert Ferber.
Jackson Pollock. 1949.
Lead, 17⅝ × 30 × 6½″

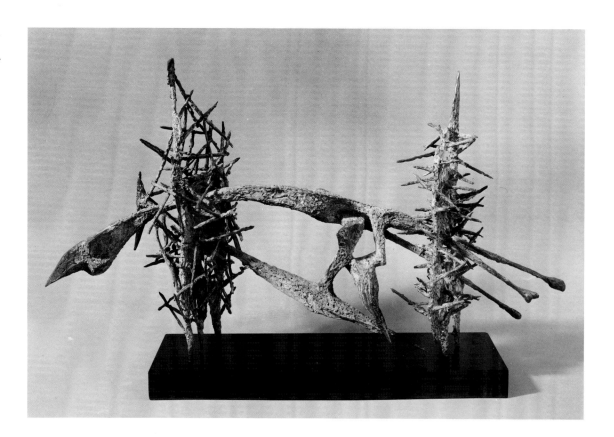

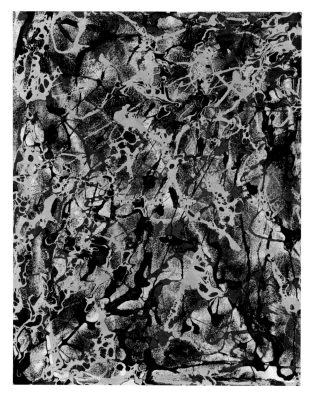

Above: Janet Sobel. Untitled. (c. 1946). Oil and
enamel on composition board, 18 × 14″

Right: Theodore J. Roszak. *Spectre of Kitty Hawk*.
(1946–47). Welded and hammered steel brazed with
bronze and brass, 40¼ × 18 × 15″

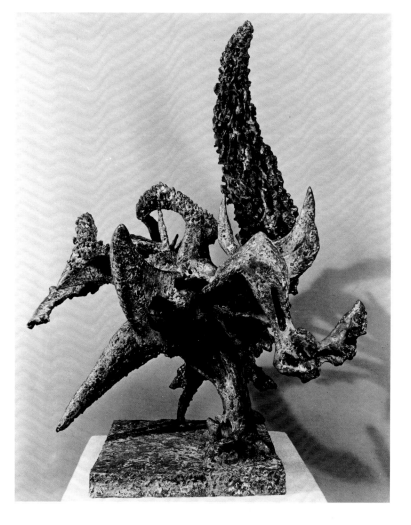

Edward Weston. *Point Lobos*. (1946). Photograph:
gelatin-silver print, $9^{1}/_{2} \times 7^{5}/_{8}''$

Frederick Sommer. *Arizona Landscape*. 1943.
Photograph: gelatin-silver print, $7^{5}/_{8} \times 9^{9}/_{16}''$

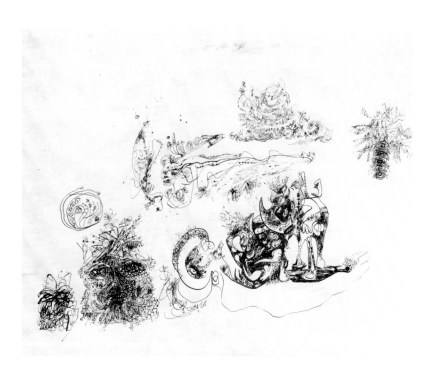

Jackson Pollock. Untitled. (1944). Pen and ink, 20⁷/₈ × 26″, irreg.

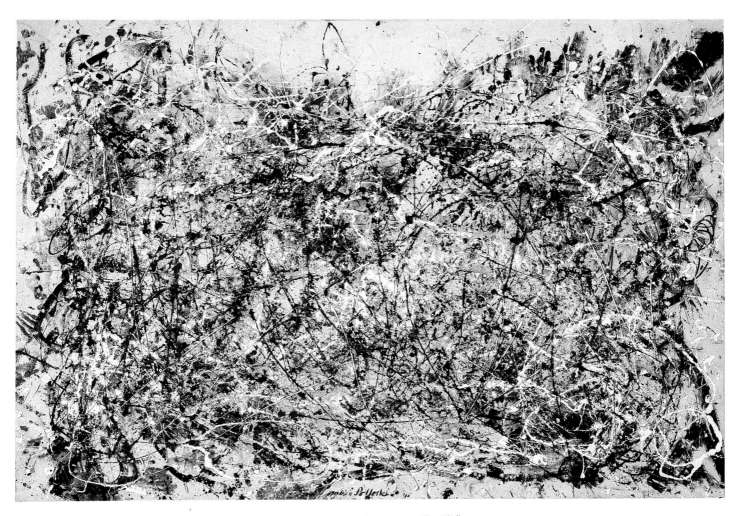

Jackson Pollock. *Number 1, 1948.* 1948. Oil and enamel on unprimed canvas, 68″ × 8′8″

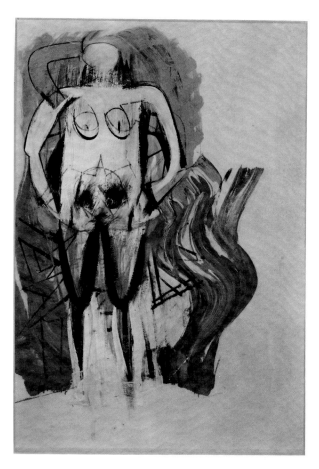

Willem de Kooning. *Woman*. (1947–49). Enamel and
charcoal on paper mounted on canvas, 23¹/₂ × 16¹/₄"

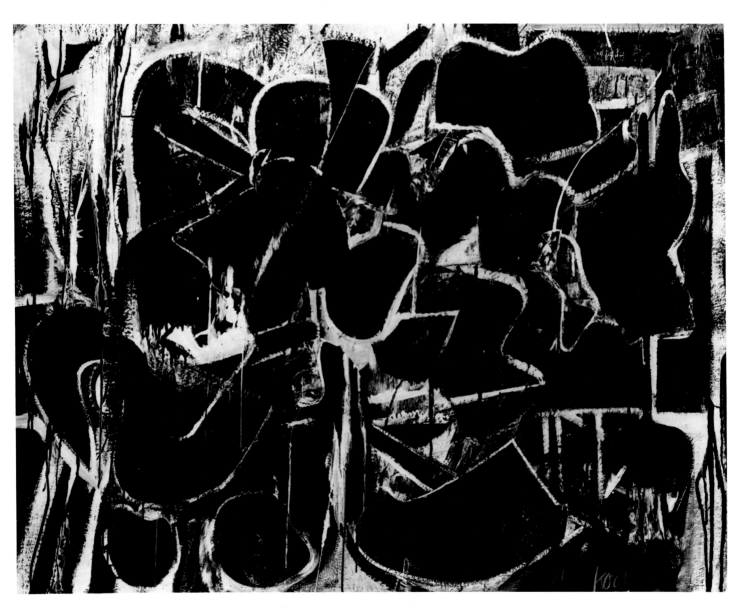

Willem de Kooning. *Painting*. (1948). Enamel and oil on canvas, 42⅝ × 56⅛″

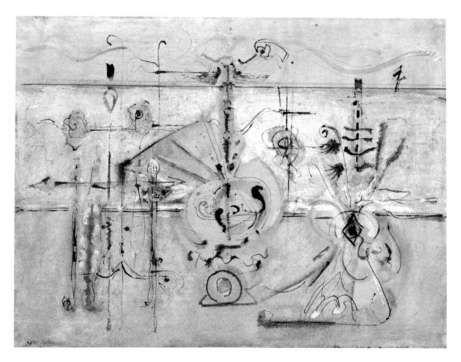

Mark Rothko. *Archaic Idol*. (1945). Wash, pen
and brush and ink, and gouache, $21^{7}/_{8} \times 30''$

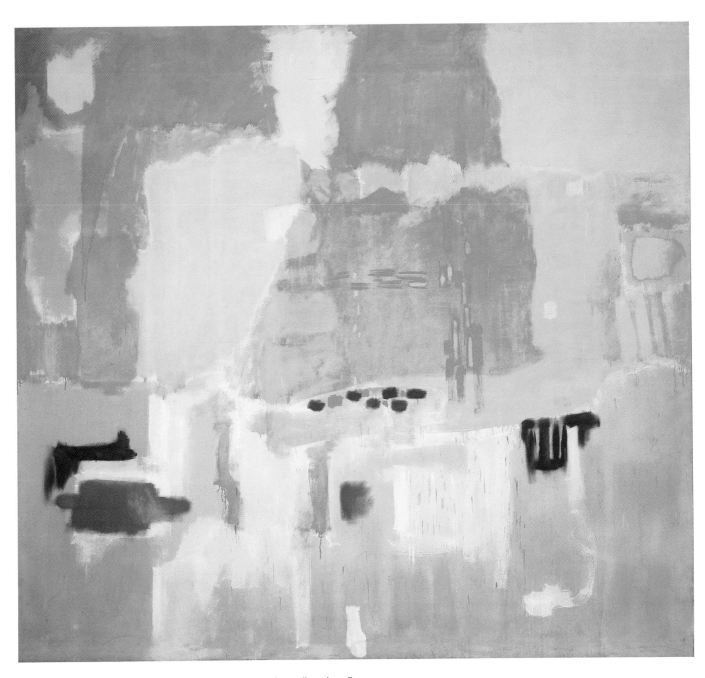

Mark Rothko. Untitled. (c. 1948). Oil on canvas, $8'10^{3}/8'' \times 9'9^{1}/4''$

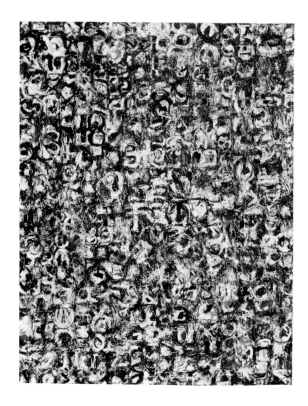

Lee Krasner. Untitled. 1949. Oil
on composition board, 48 × 37″

Bradley Walker Tomlin.
Number 20. (1949). Oil
on canvas, 7′2″ × 6′8¼″

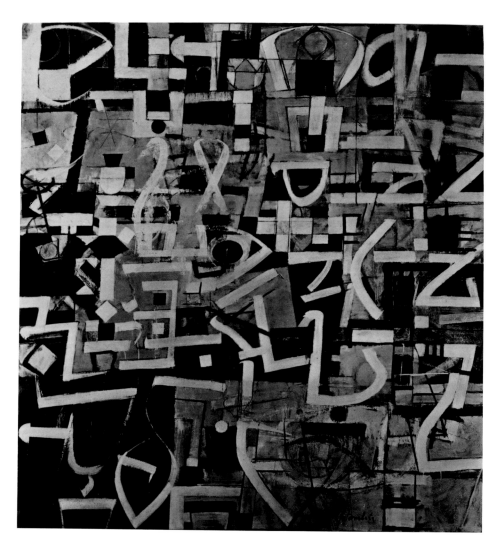

Barnett Newman. *Abraham*. 1949.
Oil on canvas, 6' 10¾" × 34½"

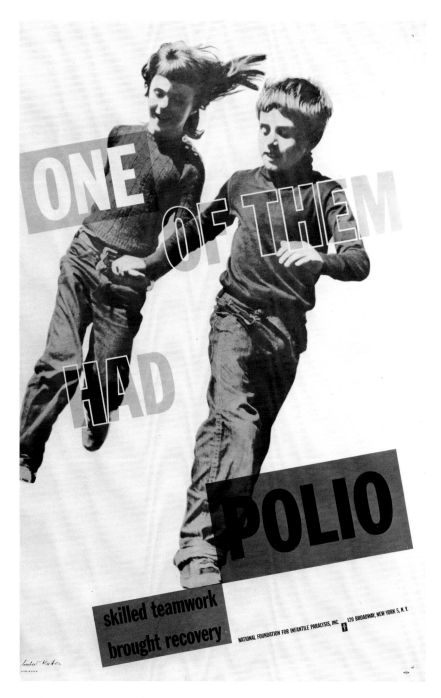

Herbert Matter. *One of Them Had Polio*. (1949).
Poster: offset lithograph, 45⅝ × 28⅞"

Andrew Wyeth. *Christina's World*. (1948). Tempera on gessoed panel, 32¹/₄ × 47³/₄"

List of Plate Illustrations

The works listed on the following pages are in the collection of The Museum of Modern Art unless otherwise noted. In the entries, titles appear in italics; dates enclosed in parentheses do not appear on the works. For drawings, prints, and illustrated books, the support is paper, unless otherwise noted. Dimensions are given in feet and inches, and in centimeters, height preceding width, and followed by depth for sculptures, constructions, and design objects. Composition or plate size is given for prints, and page size for illustrated books. Sheet size is given for other works on paper, unless otherwise specified. Entries for films are listed by director, and give title, date, nationality, medium, running time, and production company or producer. Page numbers for illustrations follow the entries.

For some works, additional information is given in texts selected from the Museum's Archives and publications or from other published sources, mostly contemporaneous with the works and events described.

ANSEL ADAMS
American, 1902–1984

Mt. Williamson, Sierra Nevada, from Manzanar, California. 1944. Photograph: gelatin-silver print, 15 1/8 × 18 3/4″ (38.4 × 47.6 cm). Purchase. *Page 44*

Moved by the human story unfolding in the encirclement of desert and mountains, and by the wish to identify my photography in some creative way with the tragic momentum of the times, I came to Manzanar with my cameras in the fall of 1943. . . . In these years of strain and sorrow, the grandeur, beauty, and quietness of the mountains are more important to us than ever before. I have tried to record the influence of the tremendous landscape of Inyo [County, California] on the life and spirit of thousands of people living by force of circumstance in the Relocation Center [for Japanese-Americans] of Manzanar. . . .

I believe that the acrid splendor of the desert, ringed with towering mountains, strengthened the spirit of the people of Manzanar. . . . Out of the jostling, dusty confusion of the first bleak days in raw barracks they have modulated to a democratic internal society and a praiseworthy personal adjustment to conditions beyond their control. The huge vistas and the stern realities of sun and wind and space symbolize the immensity and opportunity of America—perhaps a vital reassurance following the experiences of enforced exodus. (Ansel Adams, *Born Free and Equal: Photographs of the Loyal Japanese-Americans at Manzanar Relocation Center, Inyo County, California*, New York: U.S. Camera, 1944, pp. 7–9.)

JOSEF ALBERS
American, born Germany, 1888–1976. To U.S.A. 1933

Ascension, from the series *Graphic Tectonic*. 1942. Lithograph, 17 3/16 × 8 1/8″ (43.7 × 20.7 cm), irreg. Gift of the artist. *Page 52*

FRANCIS BACON
British, born 1909

Painting. (1946). Oil and pastel on linen, 6′5 7/8″ × 52″ (197.8 × 132.1 cm). Purchase. *Page 99*

Bacon painted . . . a man standing in what appears to be a butcher shop, before a battery of microphones. The man's face has no features except a gaping mouth. Over his head is an umbrella (Chamberlain's?); behind him hang a carcass of beef and Hitler's window-curtains with cords and tassels; two sides of beef are placed in the cagelike structure in

which he stands. The picture . . . was first entitled "Man with Microphones," and obviously instruments of public communication have had a profound symbolic significance for Bacon. The image's satirical impact is unforgettable. Its technical richness superb. (James Thrall Soby, in *The Saturday Review of Literature*, November 7, 1953, pp. 48–49.)

BALTHUS (Baltusz Klossowski de Rola)
French, born 1908

The Living Room. 1942. Oil on canvas, 45 1/4 × 57 7/8″ (114.8 × 146.9 cm). Estate of John Hay Whitney. *Page 36*

BARCALO MANUFACTURING COMPANY
American

Seven-in-one Tool. (1940). Metal, bronze finish, 6 1/4 × 2 1/2″ (15.9 × 6.4 cm). Manufacturer: Barcalo Manufacturing Company, New York. Gift of Lewis and Conger. *Page 57*

RUODI BARTH
Swiss, born 1921

Zoologischer Garten Basel. (1947). Poster: offset lithograph, 49 5/8 × 34 3/4″ (125.5 × 88.3 cm). Gift of the Swiss government. *Page 79*

WILLI BAUMEISTER
German, 1889–1955

African Play, IV. 1942. Oil on composition board, 14 1/8 × 18 1/8″ (35.7 × 45.9 cm). Gift of Mr. and Mrs. F. Taylor Ostrander. *Page 56*

HERBERT BAYER
American, born Austria, 1900–1985. To U.S.A. 1938

Our Allies Need Eggs. (1942). Poster: screenprint, 20 1/4 × 30″ (51.4 × 76.1 cm). Gift of the Rural Electrification Administration. *Page 43*

LESTER BEALL
American, born 1903

Cross Out Slums. 1941. Poster: offset lithograph, 39 1/2 × 29 1/8″ (100.3 × 74 cm). Gift of the U.S. Housing Authority. *Page 58*

MAX BECKMANN
German, 1884–1950. In Amsterdam 1936–47;
U.S.A. 1947–50

King and Demagogue, from the portfolio *Day and Dream*. New York, Curt Valentin, 1946. Lithograph, 14⁷/₈ × 10″ (37.9 × 25.4 cm). Abby Aldrich Rockefeller Fund. *Page 94*

FULVIO BIANCONI
Italian, born 1915

Vase. (1949). Glass, 13¹/₄″ h. × 8³/₄″ diam. (33.7 × 22.2 cm). Manufacturer: Venini S.p.A., Venice. Gift of Georg Jensen, Inc. *Page 79*

ANTONIO BONET
Spanish, 1913–1989

JUAN KURCHAN
Argentinian, 1913–1975

JORGE FERRARI-HARDOY
Argentinian, 1914–1977

"B.K.F." Chair. (1939–40). Leather seat, painted wrought-iron rod frame, 34³/₄ × 31 × 37″ (88.3 × 78.7 × 94 cm). Manufacturer: Artek-Pascoe, Inc., U.S.A. Edgar Kaufmann, Jr., Fund. *Page 58*

ÉDOUARD BOUBAT
French, born 1923

Lella. 1948. Photograph: gelatin-silver print, 8⁷/₁₆ × 5⁷/₈″ (21.5 × 15 cm). Gift of the photographer. *Page 92*

LOUISE BOURGEOIS
American, born France 1911. To U.S.A. 1938

Quarantania, I. (1948–53). Painted wood on wood base, 6′9¹/₄″ (206.4 cm) h., including base 6 × 27¹/₄ × 27″ (15.2 × 69.1 × 68.6 cm). Gift of Ruth Stephan Franklin. *Page 101*

Difficult Climb. (1945–50). Engraving, 6¹⁵/₁₆ × 4⁷/₈″ (17.6 × 12.4 cm). Gift of the artist. *Page 66*

BILL BRANDT
British, 1904–1983

Crowded Improvised Air-Raid Shelter in a Liverpool Street Tube Tunnel. (1940). Photograph: gelatin-silver print, 24¹/₈ × 20¹/₂″ (61.5 × 52.1 cm). Purchase. *Page 42*

ANDRÉ BRETON
French, 1896–1966. In New York 1941–46

Untitled, from the portfolio *VVV*. New York, VVV, 1943. Collage of paper, thread, and sequins with ink, 17¹⁵/₁₆ × 13¹⁵/₁₆″ (45.6 × 35.4 cm). The Louis E. Stern Collection. *Page 59*

FRITZ BÜHLER
Swiss, 1909–1963

Film/Festival Congrès International Bâle. 1945. Poster: offset lithograph, 50 × 35¹/₂″ (127.2 × 90.3 cm). Gift of the Lauder Foundation, Leonard and Evelyn Lauder Fund. *Page 79*

ALEXANDER CALDER
American, 1898–1976. Lived in France and U.S.A.

Constellation with Red Object. (1943). Painted wood and steel wire construction, 24¹/₂ × 15¹/₄ × 9¹/₂″ (62 × 38 × 24 cm). James Thrall Soby Fund. *Page 55*

HARRY CALLAHAN
American, born 1912

Chicago. (c. 1949). Photograph: gelatin-silver print, 6⁵/₈ × 8³/₈″ (16.8 × 21.3 cm). Gift of Robert and Joyce Menschel. *Page 50*

MARCEL CARNÉ
French, born 1909

Children of Paradise [*Les Enfants du paradis*]. (1945). France. Black-and-white film, 188 min. S.N. Pathé Cinéma. *Page 68*

HENRI CARTIER-BRESSON
French, born 1908

M. and Mme. Joliot-Curie. (1946). Photograph: gelatin-silver print, 13$^1/_2$ × 9$^1/_8$″ (34.3 × 23.2 cm). Gift of the photographer. *Page 93*

Jean-Paul Sartre. (1946). Photograph: gelatin-silver print, 15$^1/_8$ × 10$^1/_8$″ (38.6 × 25.9 cm). Gift of the photographer. *Page 93*

The novelist of *La Nauseé, du Mur*, and *Les Chemins de la Liberté*, Existentialist Philosopher, whose main work is *L'Être et le Néant*, director of the magazine *Les Temps Modernes*, is one of the undisputed leaders of contemporary thought. His stocky silhouette and round, peevish face haunts the streets around the Café de Flore, while he converses, like a Parisian Socrates, with the numerous readers and followers who come to him seeking advice. (Henri Cartier-Bresson, artist's statement, n.d., The Museum of Modern Art, collection records.)

MARC CHAGALL
French, born Russia, 1887–1985. In France 1910–14, 1923–41; U.S.A. 1941–48; France 1948–85

Plate 13, from *Four Tales of the Arabian Nights*, translated by Richard F. Burton. New York, Pantheon Books, 1948. Lithograph, 16$^{15}/_{16}$ × 12$^{15}/_{16}$″ (43.1 × 33 cm), irreg. The Louis E. Stern Collection. *Page 87*

JOSEPH CORNELL
American, 1903–1972

Untitled (*Bébé Marie*). (early 1940s). Papered and painted wood box, with painted corrugated cardboard floor, containing doll in cloth dress and straw hat with cloth flowers, dried flowers, and twigs, flecked with paint, 23$^1/_2$ × 12$^3/_8$ × 5$^1/_4$″ (59.7 × 31.5 × 13.3 cm). Acquired through the Lillie P. Bliss Bequest. *Page 36*

MICHAEL CURTIZ
American, born Hungary, 1888–1962. To U.S.A. 1926

Casablanca. (1942). U.S.A. Black-and-white film, 102 min. Hal B. Wallis, Warner Bros. Acquired from Warner Bros. *Page 69*

JEAN DUBUFFET
French, 1901–1985

Léautaud, Redskin Sorcerer [*Léautaud, Sorcier peau-rouge*], from the More Beautiful Than They Think: Portraits series. (1946). Oil on canvas with pebbles, gravel, 36$^1/_4$ × 28$^3/_4$″ (92.1 × 73 cm). William H. Weintraub Fund. *Page 89*

Jean Paulhan. (1946). Hand photogravure, 12$^7/_{16}$ × 9$^3/_4$″ (31.6 × 24.7 cm). The Associates Fund. *Page 88*

René Bertelé, from the More Beautiful Than They Think: Portraits series. (July–August) 1947. Reed pen and ink, 13$^1/_4$ × 9$^5/_8$″ (33.5 × 24.5 cm). Gift of Heinz Berggruen, William S. Lieberman, and Klaus Perls in memory of Frank Perls, art dealer. *Page 88*

CHARLES EAMES
American, 1907–1978

Study for a Glider Nose. (1943). Molded plywood, 10′5$^1/_2$″ × 6′8″ × 31$^1/_2$″ (318 × 203 × 80 cm). Manufacturer: Evans Products Company, U.S.A. Gift of Lucia Eames Demetrios and purchase. *Page 43*

In 1943 the glider designer Hawley Bowlus . . . designed an experimental glider . . . to be used for transporting military equipment and personnel. One prototype was built, and the Molded Plywood Division of Evans Products was contracted to produce "blisters" (compound-curved body units that formed part of the nose section) and other fuselage elements out of molded plywood . . . to replace components made of unobtainable metals.

Constructing a one-piece wooden section as large as the blister . . . was regarded as a nearly impossible task. New steel molding machines . . . were produced that required intricate engineering and a period of trial and error before production could begin. A mold for forming the plywood sheets . . . was developed using a technique devised for other, smaller plywood shapes. . . .

The company produced one set of two curved blisters—"ship sets"—for the nose section and other elements for the glider.

Although the large-scale aircraft work was of relatively short duration, the Molded Plywood Division gained invaluable skills and experience in producing the large pieces of molded plywood. (John Neuhart, Marilyn Neuhart, and Ray Eames, *Eames Design*, New York: Harry N. Abrams, 1989, p. 43.)

Side Chair. (1946). Molded plywood, ash, metal legs, 28³/₄ × 19¹/₂ × 20″ (73 × 49.5 × 50.8 cm). Manufacturer: Evans Products Company, U.S.A. Gift of Herman Miller Furniture Co. *Page 77*

Eames House, Santa Monica, California. (1949). *Page 53*. In the collection: Model, 24³/₈″ × 7′9″ × 39″ (61.9 × 236.1 × 99 cm). Made by K. Paul Zygas. Emilio Ambasz Fund

SERGEI EISENSTEIN
Soviet, born Latvia, 1898–1948

Ivan the Terrible [Ivan Grozny], Part I. (1944). U.S.S.R. Black-and-white film, 99 min. Alma-Ata Film Studio. Gift of Gosfilmofond, U.S.S.R. (by exchange) and gift of Janus Films. *Page 68*

MAX ERNST
French, born Germany, 1891–1976. To France 1922; in U.S.A. 1941–50

Alice in 1941. 1941. Oil on paper, mounted on canvas, 15³/₄ × 12³/₄″ (40 × 32.3 cm). James Thrall Soby Bequest. *Page 60*

During the early stages of the Second World War, Ernst, as a German, was confined for a time to a French concentration camp. The surrounding terrain was apparently mountainous, the military discipline not too severe for men like Ernst, whose devotion to France—their adopted homeland—was a matter of long and consistent record. In the camp Ernst began to paint *Alice in 1941*, its single human figure being an "imagined" portrait of a painter friend, Leonora Carrington, then a colleague in the Surrealist movement.

Presently Ernst was released by the French authorities and came to America where he was married to the celebrated patroness of the arts, Miss Peggy Guggenheim. For a time he and his wife lived in Arizona, whose arid, craggy landscape delighted the painter and where he completed *Alice in 1941*, making immensely skilled use of the decalcomania technique which had long interested him as one of the most versatile and inventive technicians in contemporary art. (*The James Thrall Soby Collection*, New York: The Museum of Modern Art, 1961, p. 43.)

The King Playing with the Queen. (1944; cast 1954). Bronze, 38¹/₂″ (97.8 cm) h., at base 18³/₄ × 20¹/₂″ (47.7 × 52.1 cm). Gift of D. and J. de Menil. *Page 65*

WALKER EVANS
American, 1903–1975

Subway Portrait. (1938–41). Photograph: gelatin-silver print, 3¹³/₁₆ × 5¹/₄″ (9.7 × 13.4 cm). Purchase. *Page 48*

PHILIP EVERGOOD
American, 1901–1973

Ice-Cream Cones for Three. (c. 1940). Etching, 11³/₄ × 10″ (29.9 × 25.5 cm). Abby Aldrich Rockefeller Fund (by exchange). *Page 46*

PININ FARINA
Italian, 1893–1966

Cisitalia "202" GT. (1946; manufactured 1948). Aluminum body, 49″ × 13′2″ × 57⁷/₈″ (124.5 × 401.3 × 147.3 cm). Manufacturer: Carrozzeria, Pininfarina, S.p.A., Italy. Gift of the manufacturer. *Page 81*

JEAN FAUTRIER
French, 1898–1964

Hostages, Black Ground. (1944–47; printed c. 1962). Etching, 9¹/₄ × 12⁹/₁₆″ (23.5 × 31.9 cm). Arthur B. Stanton Fund. *Page 102*

HERBERT FERBER
American, born 1906

Jackson Pollock. 1949. Lead, 17⁵/₈ × 30 × 6¹/₂″ (44.8 × 76.2 × 16.5 cm). Purchase. *Page 114*

SALVATORE FIUME
Italian, born 1915

Island of Statues. 1948. Oil on canvas, 28 × 36¹/₄″ (71.1 × 92.1 cm). Purchase. *Page 84*

LUCIO FONTANA
Italian, born Argentina, 1899–1968

Crucifixion. 1948. Ceramic, 19¹/₈ × 12³/₈ × 9¹/₈″ (48.6 × 31.4 × 23.2 cm). Purchase. *Page 102*

LUCIAN FREUD
British, born Germany, 1922

Girl with Leaves. (1948). Pastel on gray paper, 18⁷/₈ × 16¹/₂″ (47.9 × 41.9 cm). Purchase. *Page 91*

BUCKMINSTER FULLER
American, 1895–1983

Wichita House (Dymaxion Dwelling Machine). (1944–46). Model: aluminum and various mediums, 21¹/₄″ h. × 36″ diam. (54 × 91.5 cm). Gift of the architect. *Page 78*

It didn't look much like a house. It looked more like a big inverted top. When Wichita's Fuller Houses, Inc. unwrapped its new circular house this week, house-hungry U.S. citizens got an eyeful.

Those who remembered Designer Buckminster Fuller's [first] "Dymaxion Dwelling Machine" of 19 years ago could see basic similarities in his latest product. A 36-foot round aluminum shell was suspended on a central stainless steel mast, firmly anchored and capped by a rudderlike ventilator, which turns with the wind. Inside, the house was unexpectedly spacious: two bedrooms, two baths, a large living room with fireplace, kitchen and some built-in furniture. . . . Unlike other prefabricated houses, the Fuller unit can be made with mass production materials and techniques, notably those of the aircraft industry.

One of the prime attractions of the Fuller houses is its low price: not over $6,500 delivered. Its biggest drawback is the drawback of all such houses: building codes automatically bar them in most cities. Bucky Fuller's house has one more drawback. It stands out like a fat thumb among conventional houses. ("Fuller's Fancy," *Time Magazine*, March 26, 1946.)

NAUM GABO
American, born Russia, 1890–1977. Worked in Germany, France, and England. To U.S.A. 1946

Spiral Theme. (1941). Construction in plastic, 5¹/₂ × 13¹/₄ × 9³/₈″ (14 × 33.6 × 23.7 cm), on base 24″ (61 cm) square. Advisory Committee Fund. *Page 59*

A. E. GALLATIN
American, 1881–1952

Forms and Red. 1949. Oil on canvas, 30 × 23″ (76.2 × 58.4 cm). Purchase (by exchange). *Page 74*

ABRAM GAMES
British, born 1914

Your Talk May Kill Your Comrades. (1943). Poster: offset lithograph, 29 × 18³/₄″ (73.7 × 47.6 cm). Gift of the designer. *Page 43*

ALBERTO GIACOMETTI
Swiss, 1901–1966. To Paris 1922

Man Pointing. 1947. Bronze, 70¹/₂ × 40³/₄ × 16³/₈″ (179 × 103.4 × 41.5 cm), at base 12 × 13¹/₄″ (30.5 × 33.7 cm). Gift of Mrs. John D. Rockefeller 3rd. *Page 85*

City Square [La Place]. (1948). Bronze, 8¹/₂ × 25³/₈ × 17¹/₄″ (21.6 × 64.5 × 43.8 cm). Purchase. *Page 84*

These extraordinary figures, so completely immaterial that they often become transparent, so totally and fully real that they affirm themselves like a blow of the fist and are unforgettable, are they appearances or disappearances? Both at once. They seem sometimes so diaphanous that one no longer dreams of asking questions about their expression, one pinches oneself to be sure that they really exist. If one obstinately continues to watch them the whole picture becomes alive, a somber sea rolls over and submerges them, nothing remains but a surface daubed with soot; and then the wave subsides and one sees them again, nude and white, shining beneath the waters. But when they reappear, it is to affirm themselves violently.

They are entirely in action, and sinister, too, because of the void which surrounds them. These creatures of nothingness attain the fullness of existence because they elude and mystify us. (Jean-Paul Sartre, "Giacometti in Search of Space," *Art News*, September 1955, p. 65.)

JEAN GORIN
French, born 1899

Counterpoint Number 31. 1948. Painted wood relief, 22³/₄ × 35¹/₄ × 3³/₄″ (57.7 × 89.5 × 9.5 cm). The Riklis Collection of McCrory Corporation (fractional gift). *Page 52*

ARSHILE GORKY (Vosdanig Manoog Adoian)
American, born Armenia, 1904–1948. To U.S.A. 1920

Garden in Sochi. (1941). Oil on canvas, 44¹/₄ × 62¹/₄″ (112.4 × 158.1 cm). Purchase Fund and gift of Mr. and Mrs. Wolfgang S. Schwabacher (by exchange). *Page 109*

At least six works . . . relate to this theme. Although Gorky affixed to his title the name of Sochi, the Russian resort city on the north shore of the Black Sea, "The Garden of Wish Fulfillment" was in fact a part of his father's farm on the shore of Lake Van. It was an uncultivated orchard that had become overgrown and heavily shaded. In it, Gorky recalled, was a large dead tree, and a blue rock emerging from black earth and moss, both of which were believed by the villagers to have supernatural powers. On "The Holy Tree" were fastened strips which passers-by had torn from their clothing, and women came to rub their bared breasts against the rock—a means, it would appear, of inducing fertility.

The alchemy of Gorky's memory and imagination blended this romantic image with another from Renaissance art: large color reproductions of the three surviving panels of Paolo Uccello's *Battle of San Romano* hung on the wall of his Union Square studio. In *Garden in Sochi* he merged the multicolored ex-votos fluttering in the breeze, Uccello's heraldry of banners, lances, harnesses and costumes, the contact of yielding flesh against hard blue rock, the abstract patterns of a master he loved, and the sight and sound of rustling silver leaves, in a composite image. (William C. Seitz, *Arshile Gorky*, New York: The Museum of Modern Art, 1962, p. 26.)

ADOLPH GOTTLIEB
American, 1903–1974

Apparition. (1945). Aquatint, 20$^1/_8$ × 15$^1/_{16}$″ (51.1 × 38.2 cm). The Associates Fund. *Page 110*

JOHN D. GRAHAM (Ivan Dombrowski)
American, born Ukraine, 1881–1961. To U.S.A. 1920

Two Sisters [*Les Mamelles d'outre-mer*]. 1944. Oil, enamel, pencil, charcoal, and casein on composition board, 47$^7/_8$ × 48″ (121.4 × 121.8 cm). Alexander M. Bing Fund. *Page 90*

MORRIS GRAVES
American, born 1910

Blind Bird. (1940). Gouache and watercolor on mulberry paper, 30$^1/_8$ × 27″ (76.5 × 68.6 cm). Purchase. *Page 87*

PHILIPPE HALSMAN
American, born Latvia, 1906–1979. To U.S.A. 1940

Dali Atomicus. (c. 1948). Photograph: gelatin-silver print, 10$^3/_{16}$ × 13$^1/_8$″ (25.9 × 33.3 cm). Gift of the photographer. *Page 62*

DAVID HARE
American, born 1917

Magician's Game. (1944; cast 1946). Bronze, 40$^1/_4$ × 18$^1/_2$ × 25$^1/_4$″ (102.2 × 47 × 64.1 cm). Given anonymously. *Page 66*

HANS HARTUNG
French, born Germany, 1904–1989. To Paris 1935

Painting. 1948. Oil on canvas, 38$^1/_4$ × 57$^1/_2$″ (97.2 × 146 cm). Gift of John L. Senior, Jr. *Page 104*

STANLEY WILLIAM HAYTER
British, 1901–1988. In Paris 1926–39; U.S.A. 1939–50. To Paris 1950

Death by Water. 1948. Engraving, 13$^{13}/_{16}$ × 23$^{13}/_{16}$″ (35.1 × 60.5 cm). John S. Newberry Fund. *Page 66*

Through Hayter's particular usage [automatism] became one of the last remnants of Surrealist influence when he set up his Atelier in New York during World War II. . . . His shop drew many of the Surrealist group to it. As they discussed their common problems (most felt extremely dislocated in the English-speaking community, where they could barely communicate), some of them executed a few prints. A few American artists joined in the discussions or were attracted to try their hand at Hayter's methods of intaglio printmaking.

One of the Americans was Jackson Pollock. (Castleman, *Prints of the Twentieth Century*, p. 129.)

MORRIS HIRSHFIELD
American, born Russian Poland, 1872–1946. To U.S.A. 1890

Inseparable Friends. 1941. Oil on canvas, 60$^1/_8$ × 40$^1/_8$″ (152.6 × 101.9 cm). The Sidney and Harriet Janis Collection. *Page 71*

ALFRED HITCHCOCK
American, born Britain, 1899–1980. To U.S.A. 1939

Spellbound. (1945). U.S.A. Black-and-white film, 110 min. David O. Selznick. Gift of ABC Motion Pictures International Inc. *Page 68*

HANS HOFMANN
American, born Germany, 1880–1966. To U.S.A. 1932

Delight. 1947. Gesso and oil on canvas, 50 × 40″ (126.9 × 101.6 cm). Gift of Mr. and Mrs. Theodore S. Gary. *Page 112*

EDWARD HOPPER
American, 1882–1967

Gas. (1940). Oil on canvas, 26¼ × 40¼″ (66.7 × 102.2 cm). Mrs. Simon Guggenheim Fund. *Page 49*

His major expressive instrument . . . is light. He uses light variously, most often in bold chiaroscuro, but sometimes locally, as an almost invisible spray of highlighting. Light supplies the drama in most of his paintings, though typically it can be justified nearly always in the naturalistic terms of plausible source and reflecting surfaces. He is equally a master of the half-dark. Is there any living American painter able to suggest so well the huddled gloom of a grove of trees at evening?

If Hopper describes light with rare skill, he also records the density of air like the most delicate of barometers. A subtle gradation of atmospheric values is common to many of his finest works. In *Gas* . . . the air seems to thin out as the eye moves from the bright area of the service station toward the thick woods across the road, light and breeze waning together. The extremes of his atmosphere control are to be found in his depiction of absolute calm. . . . He can bring the summer air to a dead halt. (James Thrall Soby, *Contemporary Painters*, New York: The Museum of Modern Art, 1948, pp. 34, 36.)

NATHAN GEORGE HORWITT
American, 1898–1990

Wristwatch Face. (1947). Analogue watch, white gold, enameled dial, 1⁵⁄₁₆″ (3.3 cm) diam. Manufacturer: Vacheron & Constantin–Le Coultre Watches, Inc., Switzerland. Gift of the designer. *Page 78*

This [patent] application covers the design of a dial which reduces the number of indices to a single dot located where the numeral 12 normally occurs. This dial is so designed in the belief that all we require on a watch is the orientation supplied by indicating the starting point. The rest of the time-intelligence is adequately supplied by the hour and minute hand—the purpose of my design is to simplify the watch dial optically by eliminating all distracting and extraneous indices. (Nathan George Horwitt, statement to United States Patent Office, n.d., The Museum of Modern Art, collection records.)

ASGER JORN
Danish, 1914–1973

Plate from an untitled portfolio. 1945. Lithograph, 17³⁄₈ × 12³⁄₄″ (44.2 × 32.4 cm). Purchase. *Page 106*

FRIDA KAHLO
Mexican, 1910–1954

Self-Portrait with Cropped Hair. 1940. Oil on canvas, 15³⁄₄ × 11″ (40 × 27.9 cm). Gift of Edgar Kaufmann, Jr. *Page 71*

YOUSUF KARSH
Canadian, born Armenia, 1908. To Canada 1924

Winston Churchill. 1941. Photograph: gelatin-silver print. 19³⁄₄ × 15³⁄₄″ (50.2 × 40 cm). Gift of the photographer. *Page 42*

FREDERICK J. KIESLER
American, born Romania, 1890–1965. To U.S.A. 1926

Multi-use Rocker and Multi-use Chair. (1942). Oak and linoleum, 29¼ × 15⁵⁄₈ × 30³⁄₄″ (74.3 × 39.7 × 78.1 cm) and 33³⁄₈ × 15⁵⁄₈ × 35″ (84.8 × 39.7 × 88.9 cm). Edgar Kaufmann, Jr., Purchase Fund. *Page 57*

The Rest-Form of the two seats I designed for "Art of This Century" Gallery in 1942 had sprung up from my principle of "Continuous Tension." The seats were a kind of wave which curved down, surged up, and fell once more, thus forming an object without beginning or end: and in its convex curves the body could take ease. The Rest-Form had neither arms or legs and could be stood on either of its sides.

It could form itself into a chair, into the prop for sculpture or a painting, into a table or bench. In fact, this Rest-Form could fill eighteen different functions. I had foreseen only six of these, the others cropped up automatically as a result of their co-relation with the condition of the environment. That the Rest-Form is more practical, more economical, more functionally adequate than a chair, a sofa, or a stool is only too evident. (Frederick J. Kiesler, artist's statement, n.d., The Museum of Modern Art, collection records.)

Totem for All Religions. (1947). Wood and rope, 9′4¼″ × 34⅛″ × 30⅞″ (285.1 × 86.6 × 78.4 cm); upper rope extensions: left, 34¼″ (87 cm), and right, 33¼″ (84.4 cm). Gift of Mr. and Mrs. Armand P. Bartos. *Page 100*

PAUL KLEE
German, 1879–1940. Born and died in Switzerland

Lady Apart [*Dame Abseits*]. 1940. Tempera on paper mounted on cardboard, 25½″ × 19⅝″ (64.8 × 49.9 cm). A. Conger Goodyear Fund. *Page 70*

Klee, I think, more than any other artist, has given us the depths and reaches of his subjective life. Whoever knows his work well, knows him; knows what he thought and felt about life. Therein, of course, lies the preachment. For every artist, if he has nothing else — not even an Eames chair — has that thing: a wholly separate and individual self with its own dreams and passions, its unique landscape unmapped and unexplored — peopled with shapes and forms unknown to others. And that private, unknown self, wherever it has been realized well — in paint, sculpture, music or words — has been of unceasing value and wonder to others. (Ben Shahn, "Aspects of the Art of Paul Klee," *The Museum of Modern Art Bulletin*, Summer 1950, p. 6.)

WILLEM DE KOONING
American, born the Netherlands, 1904. To U.S.A. 1926

Woman. (1947–49). Enamel and charcoal on paper mounted on canvas, 23½″ × 16¼″ (59.8 × 41.4 cm). Gift of Ronald S. Lauder, R. L. B. Tobin, and A. Conger Goodyear (by exchange). *Page 118*

Painting. (1948). Enamel and oil on canvas, 42⅝″ × 56⅛″ (108.3 × 142.5 cm). Purchase. *Page 119*

LEE KRASNER
American, 1908–1984.

Untitled. 1949. Oil on composition board, 48 × 37″ (121.9 × 93.9 cm). Gift of Alfonso A. Ossorio. *Page 122*

WIFREDO LAM
Cuban, 1902–1982. Worked in France, Spain, and Italy from 1923

The Jungle. 1943. Gouache on paper mounted on canvas, 7′10¼″ × 7′6½″ (239.4 × 229.9 cm). Inter-American Fund. *Page 83*

In 1946, in a lecture on modern painting which André Breton gave in Port-au-Prince, Haiti, he spoke of that "secret of the unification of physical perception and mental representation" which formed, in the painting of Wifredo Lam, that "junction of the objective world and the world of magic." This is what he and his Surrealist colleagues and poets were constantly seeking, . . . And Breton saw a natural fusion of them in the work of Lam.

At that time Lam had already found his way from his early Paris work, marked by his admiration for Picasso, to *The Jungle* of 1943, painted after his return from Europe at the outbreak of World War II and his sojourn in Haiti. Here, recollections or suggestions of some phantasmagoric jungle ritual set the theme of terror. Human and animal figures flow in and out this jungle warp, the human suddenly becoming animal, the animal turning human and both in the end fixing themselves in our visual memory as masks, the paraphernalia of some nightmare sacrifice. (James Johnson Sweeney, *Wifredo Lam*, Terre Haute, Indiana: University of Notre Dame Art Gallery, 1961, pp. 3–4.)

DOROTHEA LANGE
American, 1895–1965

Migratory Cotton Picker, Eloy, Arizona. (1940). Photograph: gelatin-silver print, 10½″ × 13½″ (26.7 × 34.2 cm). Gift of the photographer. *Page 48*

The photograph . . . for example, of a young man with his hand, palm out, across the lower part of his face: it was the lens, not the photographer's eye, that caught this exact instant. Not even in the view finder could she have seen all that we see here in this print. These are greys, that was in color. Doubtless he was in motion, speaking, gesturing, looking about; she could not have known the exact relationship of his hand to his face as it would seem in a photograph. . . .

What she could see, as she there on the ranch was preparing her camera to do its special glancing, was potentials. She knew and felt that it was possible for the light to catch him just right—the sadness we see in the eyes is an effect of shadow. She knew and felt that there was an unconscious gesture he could make from his own being which could reveal to the camera's glance something essential about that being. She kept stepping about in the hope that these possibilities would collect themselves in one unselfconscious revelation while the lens was ready. She made herself accessible to the operations of grace. (George P. Elliott, *Dorothea Lange*, New York: The Museum of Modern Art, 1966, p. 13.)

San Francisco. (c. 1942). Photograph: gelatin-silver print. 9¹/₂ × 9³/₈″ (24.2 × 23.8 cm). Purchase. *Page 44*

CLARENCE JOHN LAUGHLIN
American, 1905–1985

The Eye that Never Sleeps. 1946. Photograph: gelatin-silver print, 12³/₈ × 8³/₄″ (31.4 × 22.2 cm). Purchase. *Page 59*

JACOB LAWRENCE
American, born 1917

The Migration of the Negro. (1940–41). Eight from a series of 60 works (30 in the Museum): tempera on gesso on composition board, each 18 × 12″ (45.7 × 30.5 cm), vert. or horiz. Gift of Mrs. David M. Levy. *Page 47*

4. The Negro was the largest source of labor to be found after all others had been exhausted.

16. Although the Negro was used to lynching, he found this an opportune time for him to leave where one had occurred.

22. Another of the social causes of the migrants' leaving was that at times they did not feel safe, or it was not the best thing to be found on the streets late at night.

28. The labor agent who had been sent South by northern industry was a very familiar person in the Negro counties.

46. Industries attempted to board their labor in quarters that were oft times very unhealthy. Labor camps were numerous.

52. One of the largest race riots occurred in East St. Louis.

56. Among the last groups to leave the South was the Negro professional who was forced to follow his clientele to make a living.

58. In the North the Negro had better educational facilities.

Painted in 1940–41 on a grant from the Rosenwald Foundation [these works] depict the poverty-stricken, fear-ridden existence of many negroes in the South; their hopeful migration to the labor-starved markets of the North in World War I; and the conditions they met there—disillusionment because of segregated, overcrowded districts, fear because of occasional race riots, yet on the whole a step forward because they could exercise their right to the ballot and their children's right to an education.

The Migration pictures were shown in May 1943 at the Portland (Oregon) Art Museum at a time when there were severe racial difficulties in the Kaiser shipyards. With the aid of a prominent Negro organization, the Portland Museum arranged a forum for discussion of the immediate problems of World War II against the background of pictures which so understandingly portrayed the same problems during World War I. The forum produced good results. ("Jacob Lawrence," *The Museum of Modern Art Bulletin*, November 1944, p. 11.)

RICO LEBRUN
American, born Italy, 1900–1964. To U.S.A. 1924

Figure in Rain. 1949. Enamel on canvas over composition board, 48 × 30¹/₈″ (121.9 × 76.5 cm). Gift of Mrs. Robert Woods Bliss. *Page 98*

FERNAND LÉGER
French, 1881–1955. In U.S.A. 1940–45

Studies I and V for a Cinematic Mural. (1939–40). Gouache, pencil, and pen and ink on cardboard, each approx. 20 × 15″ (50.7 × 38 cm). Given anonymously. *Cover*

Big Julie [*La Grande Julie*]. 1945. Oil on canvas, 44 × 50¹/₈″ (111.8 × 127.3 cm). Acquired through the Lillie P. Bliss Bequest. *Page 72*

HELEN LEVITT
American

Untitled. (c. 1940). Photograph: gelatin-silver print, 6⁵/₈ × 9³/₄″ (16.8 × 24.8 cm). Gift of Edward Steichen. *Page 36*

Helen Levitt seems to walk invisible among the children. She is young, she has the eye of a poet, and she has not forgotten the strange world which tunnels back through thousands of years to the dim beginnings of the human race. With her camera to her eye, she watches a group playing; she seizes the split second when the dark world rises visible into the light. She understands the magic of metamorphoses— how a mask invests the wearer with the power of the enigma, how a discarded mirror or an empty house may engender a hundred improvisations full of danger and destruction. Reverently she records the occult symbols drawn on walls and sidewalks.

The children of the poor are not starched and supervised. Roaming in tribes through the streets and empty lots, they inherit to the full the magic and terror of the inscrutable world. Joyous, vicious, remote, or sad, these photographs arouse in adults a swift and poignant succession of emotions. (N[ancy] N[ewhall], "Helen Levitt, Photographs of Children," *The Museum of Modern Art Bulletin*, April 1943, n.p.)

JACQUES LIPCHITZ
American, born Lithuania, 1891–1973. In France 1909–41. To U.S.A. 1941

Rape of Europa IV. 1941. Chalk, gouache, brush and ink, 26 × 20″ (66 × 50.8 cm). Purchase. *Page 38*

I made drawings for the new *Rape of Europa*, 1941, . . . in which Europa is fighting against her rapist (Hitler) and trying to kill him. There are a number of drawings of this, very intense in feeling, almost like a prayer, in which Europa is overcoming the monster. These works of the period around 1940 take on a new kind of violence with broken contours and dramatic gestures, perhaps the result of the emotions I felt in relation to the war and the disruption of my entire life. The earlier version of Europa and the bull is a rather simple and lyrical interpretation of the classic myth in which Zeus carries the nymph off to Crete; but in the later version Europa has become specifically modern Europe threatened by the powers of evil and fighting for her life against them. (Jacques Lipchitz with H. H. Arnason, *My Life in Sculpture*, New York: Viking Press, 1972, p. 151.)

SEYMOUR LIPTON
American, 1903–1986

Imprisoned Figure. 1948. Wood and sheet-lead construction, 7′3³/₄″ × 30⁷/₈″ × 23⁵/₈″ (215.2 × 78.3 × 59.9 cm), including wood base, 6¹/₈ × 23¹/₈ × 20¹/₈″ (15.3 × 58.6 × 51 cm). Gift of the artist. *Page 100*

LOREN MACIVER
American, born 1909

Hopscotch. (1940). Oil on canvas, 27 × 35⁷/₈″ (68.6 × 91.1 cm). Purchase. *Page 108*

ALFRED MANESSIER
French, born 1911

Figure of Pity [*Grande figure de pitié*]. 1944–45. Oil on canvas, 57³/₄ × 38¹/₄″ (146.7 × 97.2 cm). Gift of Mr. and Mrs. Charles Zadok. *Page 105*

I cannot speak of painting: words are too far removed from colors! When I reread what I have said or what someone has been able to make me say, I nearly always have a feeling of regret, and an impression of total inexactness.

I prefer by far the painter of a good picture to the author of many volumes of theories on the problems of modern art. Let the critics and art historians do their work and let us do ours; our job is to paint, not to explain.

I feel the unity of a certain blue and a certain red, that's all; this is what is important and this is what can't be explained. It is in the realm of feeling. The domain of the intelligence is of another order. . . .

I paint in response to my desire for harmony and unity, to a renewal of self, reconstructed step by step, towards this world lost from grace. . . .

We are living in the time of the Apocalypse, in the time of the end of the world, but we must not be discouraged. We must continue to hope and to work. (Alfred Manessier, in Andrew Carnduff Ritchie, ed., *The New Decade: 22 European Artists and Sculptors*, New York: The Museum of Modern Art, 1955, pp. 26–27.)

MARINO MARINI
Italian, 1901–1980

Boy on a Blue Horse. (1947). Gouache, wash, watercolor, and pen and ink, 11¹/₂ × 15⁵/₈″ (29 × 39.6 cm). Gift of Mrs. John D. Rockefeller 3rd. *Page 86*

ANDRÉ MASSON
French, 1896–1987. In U.S.A. 1941–45

Pasiphaë. 1945. Pastel, 27¹/₂ × 38¹/₈″ (69.8 × 96.8 cm). Gift of the artist. *Page 67*

Abduction. (c. 1946; printed in 1958). Drypoint, 12¹/₈ × 16″ (30.8 × 40.6 cm). Lent anonymously. *Page 106*

My idea of America, like that of so many French, was, and perhaps still is, rooted in Chateaubriand. Nature: the might of nature—the savagery of nature—the feeling that nature may one day recover its strength and turn all back to chaos. . . .

Fundamentally I am more a sympathizer with surrealism, than a surrealist or a non-surrealist. In the beginning I tried to satisfy myself with the automatist approach. It was I who became the severest critic of automatism. I still cannot agree with the unconscious approach. I do not believe you can arrive by this means at the intensity essential for a picture. I recognize that there are intense expressions to be obtained through the subconscious, but not without selection. And in that I am not orthodox. . . .

Now on the eve of my departure [October 1945]—and one never sees so clearly as on the eve of a departure—my work in the United States seems to form a definite cell with walls: studies after nature accepting any object whatever without any a priori intentions, without an attempt at analysis, without any esthetic preconceptions—in short an application of the automatic approach to whatever object comes up. . . . Fernand Leger had tried to do this. In contrast to Leger's approach I feel that to be pure one must respond freely to sensations, and discipline them later. (André Masson, in James Johnson Sweeney, "Eleven Europeans in America," *The Museum of Modern Art Bulletin*, 1946, pp. 3–5.)

HENRI MATISSE
French, 1869–1954

Le Cirque, from *Jazz*. Paris, Tériade, 1947. Pochoir, 16⅝ × 25⅝″ (42.2 × 65.6 cm). Gift of the artist. *Page 73*

Monsieur Loyal, from *Jazz*. Paris, Tériade, 1947. Pochoir, 16⅝ × 25⅝″ (42.2 × 65.6 cm). Gift of the artist. *Page 73*

MATTA (Sebastian Antonio Matta Echaurren)
Chilean, born 1911. In U.S.A. 1939–48; Paris 1955–69. To Italy 1969

Listen to Living [*Écoutez vivre*]. 1941. Oil on canvas, 29½ × 37⅜″ (74.9 × 94.9 cm). Inter-American Fund. *Page 63*

By 1941, the scattered and uneven brilliance of his earlier canvases had gathered into one impressive whole.

Perhaps a trip to Mexico in 1941 hastened his development. Late in 1940 he had begun to vary the candy-stick

tonality of his previous paintings by sometimes using a dark, over-all ground, green or blue or red, in which bloomed sudden vivid crocuses of color. . . . The heavens in his pictures now exploded in a shower of volcanic sparks and spiraling lava. At the same time, the landscape of Mexico seems to have taught him a more rhythmic relationship between earth and sky, as in the Museum of Modern Art's fine canvas, *Listen to Life* [sic]. His burning stones plunged deeper and deeper into an ethereal maze, and he extended space by a labyrinth of diaphanous screens, tissue behind tissue, the light reflecting back and forth, through and between. (Soby, *Contemporary Painters*, pp. 63–64.)

I Want to See It to Believe It, plate V from the *Brunidor Portfolio, No. 1*. New York, Brunidor Editions, 1947. Lithograph, 12⅛ × 12⅞″ (30.9 × 32.6 cm). Purchase Fund. *Page 62*

HERBERT MATTER
American, born Switzerland, 1907–1984. In Paris 1928–32. To U.S.A. 1936

One of Them Had Polio. (1949). Poster: offset lithograph, 45⅝ × 28⅞″ (116 × 73.3 cm.) Gift of the National Foundation for Infantile Paralysis. *Page 124*

LUDWIG MIES VAN DER ROHE
American, born Germany, 1886–1969. To U.S.A. 1938

Farnsworth House, Plano, Illinois. (1946–51). *Page 53*. In the collection: Model, 30¼ × 60 × 42″ (76.8 × 152.3 × 106.7 cm). Made by Paul Bonfilio with Edith Randel and Leon Kaplan. Purchase

The only American building by Mies with the poetic intensity of the Barcelona Pavilion is the house for Dr. Edith Farnsworth, on the Fox River near Plano, Illinois.

The flat site and its beautiful trees are regularly flooded, and the floor level of the house is therefore five feet above ground. The composition consists of the floor and roof of the house, and a low platform, suspended between columns welded to the fascias.

Mies's standards of craftsmanship for the building required the sandblasting of the steel and numerous layers of paint to achieve a finish normally associated with furniture. Although its exterior walls are entirely of glass the Farnsworth House reads as a steel building, because its steel structure is so powerfully articulated and because it is painted white. . . .

Notwithstanding its unresolved problems, the Farnsworth House remains a superlative essay in the clarification of structure. The floating horizontal planes and the two flights of steps, leading to open space and trees beyond, make a serene and unforgettable image. (Arthur Drexler, wall text for *Mies van der Rohe Centennial Exhibition*, The Museum of Modern Art, 1986.)

JOAN MIRÓ
Spanish, 1893–1983. In Paris 1919–40

The Escape Ladder [*L'Échelle de l'évasion*]. (1940). Gouache, watercolor, and brush and ink, 15³/₄ × 18³/₄″ (40 × 47.6 cm). Bequest of Helen Acheson. *Page 55*

The Beautiful Bird Revealing the Unknown to a Pair of Lovers. 1941. Gouache and oil wash, 18 × 15″ (45.7 × 38 cm). Acquired through the Lillie P. Bliss Bequest. *Page 54*

His beautiful bird (in the upper right, with yellow eye) is deciphering the unknown to: a huge woman (below the bird) with a white eye, targetlike breasts, black and red vulva, and buttocks in the form of a black double crescent (these latter three features also combining to suggest a face); and to the left of the woman, her little blue-eyed lover. Above the man's head, a worm-bodied snail approaches a crescent moon. Above and below the bird, a star and ladder can be found. But the rest of the signs refuse deciphering. They are the unknown. (John Elderfield, *The Modern Drawing*, New York: The Museum of Modern Art, 1983, p. 170.)

Plate XXIII, from the *Barcelona Series*. Barcelona, Joan Prats, 1944. Transfer lithograph, 24³/₈ × 18⁹/₁₆″ (61.9 × 47.3 cm). Purchase Fund. *Page 56*

LÁSZLÓ MOHOLY-NAGY
American, born Hungary, 1895–1946. In Germany 1921–34; U.S.A. 1937–46

Double Loop. 1946. Plexiglass, 16¹/₄ × 22¹/₄ × 17¹/₂″ (41.1 × 56.5 × 44.5 cm). Purchase. *Page 74*

PIET MONDRIAN
Dutch, 1872–1944. In Paris, 1912–14, 1919–38. To New York 1940

Broadway Boogie Woogie. 1942–43. Oil on canvas, 50 × 50″ (127 × 127 cm). Given anonymously. *Page 51*

True Boogie Woogie I conceive as homogeneous in intention with mine in painting: destruction of melody which is the equivalent of destruction of natural appearance; and construction through the continuous opposition of pure means—dynamic rhythm.

I think the destructive element is too much neglected in art. (Piet Mondrian, in Sweeney, "Eleven Europeans in America," pp. 35–36.)

HENRY MOORE
British, 1898–1986

Seated and Reclining Figures. 1942. Watercolor, pencil, wax crayon, black chalk, pen and India ink, 14 × 8⁷/₈″ (35.4 × 22.5 cm). James Thrall Soby Bequest. *Page 82*

Family Group. (1948–49; cast 1950). Bronze, 59¹/₄ × 46¹/₂ × 29⁷/₈″ (150.5 × 118 × 75.9 cm), including base. A. Conger Goodyear Fund. *Page 82*

When Walter Gropius was working in England before the war he was asked by Henry Morris, Director for Education in Cambridgeshire to design a large school at Impington, near Cambridge. It was called a Village College and was meant to be different from other Elementary schools because it was meant to put into practice lots of Henry Morris's ideas on education. Such as, that the children's parents should be the center of social life of the surrounding villages. The school had . . . even sleeping accommodation for parents if they were held up there in winter evenings. . . . Gropius asked me to do a piece of sculpture for the school. We talked about it and I suggested that a Family Group would be the right subject. However, it never got further than that because there was no money. . . . Gropius left England for Harvard University [in 1937]—Later the war came and I heard no more about it until about 1944, Henry Morris told me that he now thought he could get enough money together for the sculpture. . . .

I must have worked for nine months or so on the "Family Group" themes and ideas, but again Henry Morris found it difficult to raise money for the sculpture, and also my maquettes were not liked by the local Education authorities, and again nothing materialized.

About two years later, 1947, John Newsom, the Director of Education in Hartfordshire, . . . having similar progressive ideas on education, told me of a large school . . . built by Hartfordshire Education authorities. . . . Newsom and Yorke knew of the projected Impington sculpture and now said as that had fallen through would I be prepared to

do a piece of sculpture at their new school at Stevenage. . . . I went to see the school and chose from my previous ideas the one which I thought would be right for Stevenage and also one which I had wanted most to carry out on a life size scale. This was a bronze idea (the one which the Museum bought from my exhibition in 1945). (Henry Moore, letter to Dorothy C. Miller, January 31, 1951, The Museum of Modern Art Archives, Dorothy C. Miller Papers.)

BARBARA MORGAN
American, born 1900

Martha Graham, Letter to the World (Kick). 1940. Photograph: gelatin-silver print, 14¹/₂ × 18¹/₄" (36.8 × 46.4 cm). John Spencer Fund. *Page 45*

ROBERT MOTHERWELL
American, born 1915

Pancho Villa, Dead and Alive. 1943. Gouache, oil, and cut-and-pasted papers on cardboard, 28¹/₄ × 35⁷/₈" (71.7 × 91.1 cm). Purchase. *Page 111*

The art of our period vacillates between exclusive concentration on the strictly aesthetic (with the implied rejection of the other values of our society), and a consequent impoverishment of art; and an effort to enrich art by the only inspiring content now available (because it represents the greatest need), revolutionary content. This tends to be frustrated by the (seeming) inappropriateness of the cubist style . . . for a revolutionary content, and there is a consequent inability of the artist to associate himself with those with whom he would, i.e., the working class. This is the dilemma of Picasso, Masson and perhaps Miró and preoccupies many lesser artists, consciously or not, including myself. Most of my paintings are preoccupied with strictly aesthetic problems; *Pancho Villa* with the revolutionary problem, whatever its faults as aesthetic or as revolutionary.

The picture represents Pancho Villa dead, on the left, with bloodstains, bullet holes, etc. and Pancho Villa alive, on the right, with a Mexican "wall paper" behind him and pink genitals. The personal and topical and symbolic significance are evident to anyone who sees it as I do; I have tried to "objectify" . . . these values; i.e., make a picture. If I were French I would have called it "Le Tombeau de Pancho Villa," following a convention. (Robert Motherwell, artist's statement, May 1945, The Museum of Modern Art, collection records.)

GERTRUD NATZLER
American, born Austria, 1908–1971. To U.S.A. 1939

OTTO NATZLER
American, born Austria, 1908. To U.S.A. 1939

Two Vases and a Bowl. (1942–46). Glazed ceramic: spherical vase (1942), 5¹/₂" h. × 6¹/₂" diam. (14 × 16.5 cm); vase (1945), 7¹/₂" h. × 5¹⁵/₁₆" diam. (18.4 × 14.6 cm); bowl (1943–46), 4¹/₄" h. × 12¹/₄" diam. (10.8 × 31.1 cm). Gift of Edgar Kaufmann, Jr. *Page 76*

ARNOLD NEWMAN
American, born 1918

Robert Oppenheimer. 1949. Photograph: gelatin-silver print, 10¹/₁₆ × 8" (25.6 × 20.3 cm). Gift of the photographer. *Page 94*

BARNETT NEWMAN
American, 1905–1970

Abraham. 1949. Oil on canvas, 6' 10³/₄" × 34¹/₂" (210.2 × 87.7 cm). Philip Johnson Fund. *Page 123*

MARCELLO NIZZOLI
Italian, 1887–1969

"Lexikon 80" Manual Typewriter. (1948). Gray enameled aluminum housing, 9 × 11 × 15" (22.8 × 38.1 × 38.1 cm). Manufacturer: Ing. C. Olivetti & C., S.p.A., Italy. Gift of Olivetti Corporation of America, New York. *Page 80*

ISAMU NOGUCHI
American, 1904–1988. Worked in U.S.A., Japan, and Italy

Table. (1944). Ebonized birch (base) and glass (top), 15⁵/₈ × 50 × 36" (39.7 × 127 × 91.4 cm). Manufacturer: Herman Miller, Inc., U.S.A. Gift of Robert Gruen. *Page 75*

I went to Hawaii in 1939 to do an advertisement (with Georgia O'Keeffe and Pierre Roy). As a result of this I had met Robsjohn Gibbings, the furniture designer, who . . .

asked me to do a coffee table for him. (I had already done a table for Conger Goodyear.) I designed a small model in plastic and heard no further before I went west.

While interned in Poston [Relocation Center, Arizona] I was surprised to see a variation of this published as a Gibbings advertisement. When, on my return I remonstrated, he said anybody could make a three-legged table. In revenge, I made my own variant of my own table, articulated as in the Goodyear Table, but reduced to rudiments. . . . This is the *Coffee Table* that was later sold in such quantity by the Herman Miller Furniture Company. (Isamu Noguchi, *A Sculptor's World*, New York and Evanston: Harper & Row, 1968, pp. 25, 27.)

JOSÉ CLEMENTE OROZCO
Mexican, 1883–1949. In U.S.A. 1917–18, 1927–34, 1940, 1945–46

Dive Bomber and Tank. 1940. Fresco, 9 × 18′ (275 × 550 cm), on six panels, each 9 × 3′ (275 × 91.4 cm). Commissioned through the Abby Aldrich Rockefeller Fund. *Page 40*

Orozco's mural *Dive Bomber and Tank* was painted two months after Dunkirk. His mind, like ours, was full of the shock of the mechanical warfare which had just crushed western Europe. But instead of picturing an actual incident with technically accurate details he makes us feel the essential horror of modern war—the human being mangled in the crunch and grind of grappling monsters "that tear each other in their slime." We can see suggestions of the bomber's tail and wings, of tank treads and armor plate and human legs dangling from the jaws of shattered wreckage. Beneath emerge three great sightless masks weighted with chains which hang from pierced lips or eyes. These ancient symbols of dramatic agony and doom are fused with the shapes of modern destruction to give the scene a sense of timeless human tragedy. (Alfred H. Barr, Jr., *What Is Modern Painting?* New York: The Museum of Modern Art, 1946, p. 10.)

IRVING PENN
American, born 1917

Nathan and Mencken. (1947). Photograph: gelatin-silver print, 19¹¹⁄₁₆ × 15⁹⁄₁₆″ (50 × 39.5 cm). Gift of the photographer. *Page 94*

IRENE RICE PEREIRA
American, 1907–1971

Shadows with Painting. (1940). Outer surface, oil on glass, 1¼″ (3.2 cm) in front of inner surface, gouache on cardboard, 15 × 12⅛″ (38.1 × 30.8 cm). Gift of Mrs. Marjorie Falk. *Page 52*

PABLO PICASSO
Spanish, 1881–1973. To France 1904

Woman Dressing Her Hair. June 1940. Oil on canvas, 51¼ × 38¼″ (130.2 × 97.2 cm). Promised gift of Mrs. Bertram Smith. *Page 35*

Woman Dressing Her Hair was painted in Royan in mid-June 1940, by which time the town had been overrun by the invading Germans. The sense of oppression and constraint Picasso must have felt in the face of the curfew, the restrictions on travel and, above all, the presence of the alien occupying army doubtless played a role in motivating it. But this anguished image of a human being unable to cope transcends its immediate context to become a universal image of dilemma. Although the animalistic elements in the figuration—the hooflike hands and snoutlike nose—have led to an interpretation of the protagonist as a "ruthless" being, she seems rather more brutalized than brute, a person whose predicament has reduced her to a less than human state. (William Rubin, *Picasso in the Collection of The Museum of Modern Art*, New York: The Museum of Modern Art, 1972, p. 158.)

Paris, July 14, 1942. (begun 1942; this state probably printed 1945). Etching and engraving, 17½ × 25⁹⁄₁₆″ (44.5 × 64.9 cm). Purchased in part with funds from Mrs. Melville Wakeman Hall, Jeanne C. Thayer, Brook Berlind, Nelson Blitz, Jr., William K. Simpson, Philip and Lynn Straus. *Page 82*

The Charnel House. Paris (1944–45; dated 1945). Oil and charcoal on canvas, 6′6⅝″ × 8′2½″ (199.8 × 250.1 cm). Mrs. Sam A. Lewisohn Bequest (by exchange), Mrs. Marya Bernard Fund in memory of her husband Dr. Bernard Bernard, and anonymous funds. *Page 41*

The *Charnel House* is a very large canvas, one of the largest Picasso has painted since *Guernica*. And like *Guernica* it was obviously inspired by the day's atrocious news. The *Guernica* was a modern Laocoon, a Calvary, a doom picture. Its symbols transcend the fate of the little Basque city to proph-

esy Rotterdam and London, Kharkov and Berlin, Milan and Nagasaki—our dark age.

In the *Charnel House* there are no symbols and, perhaps, no prophecy. Its figures are facts—the famished, waxen cadavers of Buchenwald, Dachau and Belsen. The fury and shrieking violence which make the agonies of *Guernica* tolerable are here reduced to silence. For the man, the woman, and the child this picture is a *pietà* without grief, an entombment without mourners, a requiem without pomp.

"No, painting is not done to decorate apartments. It is an instrument of war. . . ." against "brutality and darkness." Twice in the past decade Picasso has magnificently fulfilled his own words. (Alfred H. Barr, Jr., *Picasso: Fifty Years of His Art*, New York: The Museum of Modern Art, 1946, p. 250.)

The Dove. (January 9, 1949). Lithograph, 21$^1/_2$ × 27$^3/_{16}$" (54.6 × 69.1 cm), irreg. Gift of the Estate of Mrs. George Acheson. *Page 86*

ALTON PICKENS
American, born 1917

Carnival. 1949. Oil on canvas, 54$^5/_8$ × 40$^3/_8$" (138.7 × 102.6 cm). Gift of Lincoln Kirstein. *Page 97*

A city of people is the source from which I make a picture; these pictures are taken from parts of the every-day existence of the people around me. . . .

For instance, the children of the streets seem to be children, but they are also aged, brutalized. And the aged, with years of existence, are, in a sense, still children. . . .

It is easier perhaps to visualize the tragedy of the ghettos of Europe than to see the wasting of human bodies all about us. And then how could one see these things without a modicum of incredulous humor?

All paintings, even those which are most abstract, are provided by the observer with meaning—as story, if you like. I try to compose material upon which the observer may build. In the larger sense he provides the significance when there is any. (Alton Pickens, in Dorothy C. Miller, ed., *Fourteen Americans*, New York: The Museum of Modern Art, 1946, p. 49.)

JACKSON POLLOCK
American, 1912–1956

Untitled. (c. 1938–41). Screenprint with hand additions, 17 × 21$^{13}/_{16}$" (43.2 × 55.4 cm), slightly irreg. Purchase. *Page 40*

Bird. (1941). Oil and sand on canvas, 27$^3/_4$ × 24$^1/_4$" (70.5 × 61.6 cm). Gift of Lee Krasner in memory of Jackson Pollock. *Page 39*

The She-Wolf. 1943. Oil, gouache, and plaster on canvas, 41$^7/_8$ × 67" (106.4 × 170.2 cm). Purchase. *Page 109*

Untitled. (1944). Pen and ink, 20$^7/_8$ × 26" (52.7 × 65.8 cm), irreg. Gift of Samuel I. Rosenman (by exchange). *Page 116*

Number 1, 1948. 1948. Oil and enamel on unprimed canvas, 68" × 8'8" (172.7 × 264.2 cm). Purchase. *Page 117*

In *Number 1* of 1948, Pollock used no brush but, laying his canvas on the floor, trickled the fluid paint on it from above, his hand weaving the thick stream of color back and forth and around until he created a rhythmic, variegated, transparent labyrinth.

Number 1 presents an extraordinary adventure for the eye—an adventure which involves excitement and discovery, pitfalls, fireworks, irritations and delights. As your eye wanders, a mysterious sense of depth and internal light develops in the shuttling maze of lines. Then, when your eye escapes again to the edge of the vortex, you find that the artist has vividly restored the flat reality of his huge canvas by slapping it with his own paintcovered hands. (Alfred H. Barr, Jr., ed., *Masters of Modern Art*, New York: The Museum of Modern Art, 1954, p. 178.)

JAMES L. PRESTINI
American, born 1908

Two Bowls and a Platter. (c. 1945). Bowl: Cuban mahogany, 3$^3/_4$ h. × 9$^5/_8$" diam. (9.5 × 24.5 cm). Gift of the designer, San Francisco. Footed bowl: ash, 1$^3/_4$ h. × 4$^1/_2$" diam. (4.4 × 11.4 cm). Gift of Dorothy Liebes. Platter: Macassar ebony, 7$^1/_8$" (18 cm) diam. Gift of Dorothy Liebes. *Page 76*

AD REINHARDT
American, 1916–1967

Newsprint Collage, 1940. Dated 1940 and 1943. Cut-and-pasted construction paper and newsprint on gray cardboard, 16 × 20" (40.6 × 50.8 cm). Gift of the artist. *Page 107*

HANS RICHTER
American, born Germany, 1888–1976. To
U.S.A. 1941

Dreams That Money Can Buy. (1947). U.S.A. Color
film, 80 min. Hans Richter. Gift of Frida Richter.
Page 69

THEODORE J. ROSZAK
American, born Poland, 1907–1981. To U.S.A. 1909

Spectre of Kitty Hawk. (1946–47). Welded and
hammered steel brazed with bronze and brass,
40¹/₄ × 18 × 15″ (102.2 × 45.7 × 38.1 cm). Purchase.
Page 114

A million years after the last pterodactyl flapped to the
cretaceous earth, forty-three years after the Wrights first
flew their contraption over the Carolina sands, one year after
the bomb fell on Hiroshima, a sculptor set to work.
Thoughts of these disparate events haunted his mind along
with the recollection that Daedalus' ingenuity had led to his
own son's fatal crash and that even Orville Wright, before he
died, had suffered some misgivings. Imagining the con-
vulsed forms of the great flying reptile, he welded and
hammered this image in steel, then braised [sic] it with
bronze and brass. (Alfred H. Barr, Jr., "Will This Art
Endure?" *The New York Times Magazine*, December 1, 1957,
p. 48.)

MARK ROTHKO
American, born Latvia, 1903–1970. To U.S.A. 1913

Archaic Idol. (1945). Wash, pen and brush and ink,
and gouache, 21⁷/₈ × 30″ (55.6 × 76.2 cm). The Joan
and Lester Avnet Collection. *Page 120*

The experience of surrealism proved a liberating instrument
for Rothko as it did for so many other American artists of his
generation. He has always admired Dali, de Chirico, Miro,
and Max Ernst. The impact of surrealism led to an explora-
tion of myth. But his archaic mythological beings of the early
forties, his soothsayers and oracles, are generalized and not
recognizable. They appear to inhabit an imaginary world
below the sea, and the familiar identity of things is destroyed
by these organic biomorphic beings made up of elements
partly human, animal, or vegetable. The symbolic ab-
stractions are muted in color and always dominated by a
swirling calligraphic line. (Peter Selz, *Mark Rothko*, London:
Fosh & Cross Ltd., n.d., p. 14.)

Untitled. (c. 1948). Oil on canvas, 8′10³/₈″ × 9′9¹/₄″
(270.2 × 297.8 cm). Gift of the artist. *Page 121*

EERO SAARINEN
American, born Finland, 1910–1961. To
U.S.A. 1923

"Womb" Chair. (1948). Upholstered latex foam on
fiberglass-reinforced plastic shell; chrome-plated
steel rod base, 36¹/₂ × 40 × 34″ (92.7 × 101.6 ×
86.4 cm). Manufacturer: Knoll Associates, Inc.
Gift of the manufacturer. *Page 80*

I designed the "womb" chair because there seemed to be a
need for a large and really comfortable chair to take the
place of the old overstuffed chair. These dreadnoughts dis-
appeared from modern interiors, partly because they were
designed for an era which tried to impress by sheer mass,
partly because their manufacture depended upon hundreds
of hand-labor operations and costs became too high. But the
need for such chairs has not passed. More than ever before,
we need to relax. . . .

The "womb" chair . . . attempts to achieve a psycho-
logical comfort by providing a great big cup-like shell into
which you can curl up and pull up your legs. . . . A chair . . .
should not only look well as a piece of sculpture in the room
when no one is in it, it should also be a flattering background
when someone is in it—especially the female occupant.
(Eero Saarinen, in Aline B. Saarinen, ed., *Eero Saarinen on
His Work*, New Haven and London: Yale University Press,
1962, p. 68.)

ST. REGIS PAPER COMPANY
American

Propeller Blade. (c. 1943). Panelyte (composite of
plastic and paper), 62¹/₄ × 14¹/₂ × 3¹/₂″ (158.1 ×
36.8 × 9 cm). Manufacturer: St. Regis Paper
Company, U.S.A. Gift of the manufacturer. *Page 42*

PETER SCHLUMBOHM
American, born Germany, 1896–1962. To
U.S.A. 1931

"Chemex" Coffee Maker (quart size). (1941).
Borosilicate glass, wood collar handle, rawhide
string, 9¹/₂ × 6¹/₈″ diam. (24.2 × 15.5 cm).
Manufacturer: Chemex Corporation, New York.
Gift of Lewis and Conger. *Page 58*

KURT SELIGMANN
American, born Switzerland, 1900–1962. Worked
in Paris. To U.S.A. 1939

Acteon, plate VI from the *Brunidor Portfolio, No. 1*.
New York, Brunidor Editions, 1947. Etching,
11³/₄ × 8¹³/₁₆″ (29.8 × 22.4 cm). Purchase Fund.
Page 64

BEN SHAHN
American, born Lithuania, 1898–1969. To
U.S.A. 1906

This Is Nazi Brutality. (1943). Poster: offset
lithograph, 38¹/₄ × 27⁷/₈″ (97.2 × 70.8 cm). Gift
of the Office of War Information. *Page 38*

Shahn had been trained as a commercial lithographer and
lettering artist, but had long since abandoned this for paint-
ing and drawing when depression and then war gripped
the country. . . . In the 1940s came a series of posters for the
CIO Political Action Committee and for the war effort in
which Shahn used his skill as an illustrator to create memo-
rable bold designs that are notable for their incorporation of
the painter's direct brushwork into images as arresting as the
polished forms of Kauffer and Cassandre, but with more
passion and personal engagement.

With his interest in lettering, it is not surprising that
Shahn should have investigated alternatives to the sans-serif
letter, which had become almost obligatory. In *This Is Nazi
Brutality* the strips of the teletype printer contribute a sense
of authenticity and immediacy. (Alan Fern, in Mildred
Constantine, ed., *Word and Image: Posters from the Collection
of The Museum of Modern Art*, New York: The Museum of
Modern Art, 1968, p. 62.)

Welders. (1943). Tempera on cardboard mounted on
composition board, 22 × 39³/₄″ (55.9 × 100.9 cm).
Purchase. *Page 46*

HONORÉ SHARRER
American, born 1920

Workers and Paintings. (1943; dated 1944). Oil on
composition board, 11⁵/₈ × 37″ (29.5 × 94 cm). Gift
of Lincoln Kirstein. *Page 45*

The subject matter of *Workers and Paintings* stems from the
idea that Springfield, a small industrial town was going to
have a mural in its Museum of Fine Arts Building. The
sketch shows workers' reactions to different types of paint-

ings. They admire the portrait of the Puritan founder. They
are sympathetic to Daumier, Breughel, Millet, Rivera, and
Grant Wood because in these they recognize themselves.
The people are quizzical and uncertain in their approach to
Picasso's painting but more frequently there is jeering. The
women grouped around Fragonard's picture regard it with
envy; the little girl just loves the beautiful lady, but the
reaction for the onlooker is intended to evoke irony. The
butterfly on the little boy's head is one he has made at school
out of paper.

My program as an artist is to be a pictorial recorder of
the misgivings, struggles and glories of the American work-
ers and farmers through an intimate approach to such things
as the folk ways of miners and seamen, country fairs, picket
lines, trade unions, and the wisdom of farm wives. (Honoré
Sharrer, artist's statement, n.d., The Museum of Modern
Art, collection records.)

DAVID ALFARO SIQUEIROS
Mexican, 1896–1974

Hands. 1949. Enamel on composition board,
48¹/₈ × 39³/₈″ (122.2 × 100 cm). Gift of Henry R.
Luce. *Page 95*

AARON SISKIND
American, born 1903

Chicago. 1949. Photograph: gelatin-silver print,
14 × 17¹³/₁₆″ (35.6 × 45.3 cm). Gift of Robert and
Joyce Menschel. *Page 74*

DAVID SMITH
American, 1906–1965

Death by Gas, from the Medals for Dishonor series.
1939–40. Bronze medallion, 11³/₈″ (28.9 cm) diam.,
irreg. Given anonymously. *Page 39*

The spectre sprays heavy gas—the mother has fallen—
flaming and eaten lungs fly to space where planets are
masked. Two bare chickens escape in the same apparatus.
The death venus on wheels holds aloft the foetus who, from
environment, will be born masked.

The immune goddess in the boat hangs to the handle of
a tattered umbrella . . . She wears a chastity mask and blows
her balloon. The peach pits were saved in the last war.
(David Smith, in *Medals for Dishonor*, New York: Willard
Gallery, November 1940, n.p.)

JANET SOBEL
American, born Russia, 1894–1968. To U.S.A. 1908

Untitled. (c. 1946). Oil and enamel on composition board, 18 × 14″ (45.5 × 35.5 cm). Gift of William Rubin. *Page 114*

FREDERICK SOMMER
American, born Italy, 1905. To U.S.A. 1931

Arizona Landscape. 1943. Photograph: gelatin-silver print, 7⁵/₈ × 9⁹/₁₆″ (19.4 × 24.3 cm). Purchase. *Page 115*

PIERRE SOULAGES
French, born 1919

Painting. 1948–49. Oil on canvas, 6′4¹/₄″ × 50⁷/₈″ (193.4 × 129.1 cm). Acquired through the Lillie P. Bliss Bequest. *Page 104*

THEODOROS STAMOS
American, born 1922

Sounds in the Rock. 1946. Oil on composition board, 48¹/₈ × 28³/₈″ (122.22 × 72.1 cm). Gift of Edward W. Root. *Page 110*

CLYFFORD STILL
American, 1904–1980

Painting 1944-N. (Inscribed on reverse by artist: *1944–N*). Oil on unprimed canvas, 8′8¹/₄″ × 7′3¹/₄″ (264.5 × 221.4 cm). The Sidney and Harriet Janis Collection. *Page 113*

That pigment on canvas has a way of initiating conventional reactions for most people needs no reminder. Behind these reactions is a body of history matured into dogma, authority, tradition. The totalitarian hegemony of this tradition I despise, its presumptions I reject. Its security is an illusion, banal, and without courage. Its substance is but dust and filing cabinets. The homage paid to it is a celebration of death. We all bear the burden of this tradition on our backs but I cannot hold it a privilege to be a pallbearer of my spirit in its name.

From the most ancient times the artist has been expected to perpetuate the values of his contemporaries. The record is mainly one of frustration, sadism, superstition, and the will to power. What greatness of life crept into the story came from sources not yet fully understood, and the temples of art which burden the landscape of nearly every city are a tribute to the attempt to seize this elusive quality and stamp it out. (Clyfford Still, in Dorothy C. Miller, ed., *15 Americans,* New York: The Museum of Modern Art, 1952, pp. 20–21.)

PAUL STRAND
American, 1890–1976. To France 1951

Church. (1944). Photograph: gelatin-silver print, 9¹/₂ × 7⁵/₈″ (24.2 × 19.3 cm). Gift of Mrs. Armand P. Bartos. *Page 50*

GRAHAM SUTHERLAND
British, 1903–1980

Thorn Head. 1945. Gouache, chalk, and ink, 21⁷/₈ × 20⁷/₈″ (55.4 × 53 cm). The James Thrall Soby Bequest. *Page 103*

About my thorn pictures; I can only give a clue, since the process of becoming involved with one's subject is always mysterious and not easy to explain. . . .

I had been thinking of the Crucifixion (as you know I hope to attempt this subject for [the church of] St. Matthew, Northampton [England]) and my mind became preoccupied with the idea of thorns (the crown of thorns) and wounds made by thorns.

Then on going into the country I began to notice thorn trees and bushes. Especially against the sky . . . all kinds of ideas for pictures started to come into my mind . . . I had several ideas for "Thorn Heads." A sort of "pricking" and demarcation of a hollow headshaped space enclosed by the points. . . . (Graham Sutherland, letter to Curt Valentin, January 24, 1946, The Museum of Modern Art, collection records.)

RUFINO TAMAYO
Mexican, born 1899. In New York 1935–48; Paris 1949–54

Girl Attacked by a Strange Bird. 1947. Oil on canvas, 70 × 50¹/₈″ (177.8 × 127.3 cm). Gift of Mr. and Mrs. Charles Zadok. *Page 96*

YVES TANGUY
American, born France, 1900–1955. To U.S.A. 1939

Slowly Toward the North [*Vers le nord lentement*]. 1942. Oil on canvas, 42 × 36″ (106.7 × 91.4 cm). Gift of Philip Johnson. *Page 61*

Untitled. 1947. Gouache, brush and ink, and pencil, 13⅝ × 9⅞″ (34.6 × 25.1 cm). James Thrall Soby Bequest. *Page 64*

Here in the United States the only change I can distinguish in my work is possibly in my palette. What the cause of this intensification of color is I can't say. But I do recognize a considerable change. Perhaps it is due to the light. I also have a feeling of greater space here—more "room." But that was why I came. (Yves Tanguy, in Sweeney, "Eleven Europeans in America," p. 23.)

PAVEL TCHELITCHEW
American, born Russia, 1898–1957. In Western Europe and England from 1921; U.S.A. 1938–52

Hide-and-Seek [*Cache-cache*]. 1940–42. Oil on canvas, 6′6½″ × 7′3¾″ (199.3 × 215.3 cm). Mrs. Simon Guggenheim Fund. *Page 37*

To see in a subject another subject—to create two moments of different time in one—was the problem. This occupied me since 1928 . . . culminating in "Hide-and-Seek." . . . There I discovered that the change of one subject into another occurs by an equal interval of time which I called "rhythmical time." . . .

[Afterwards] I surprisingly discovered that all the circular rotation of this picture occurred by the same "rhythmical time," by the same continuity in interchangeable images which appeared and disappeared organically—not mechanically. (Stravinsky, who is very interested in rhythms [and] stayed 2½ hours counting with his chronometer the rhythms of the appearances and disappearances of the images, said, "The whole picture beats like a human heart with the blood pressure of 110.") (Pavel Tchelitchew, letter to Dr. James E. Lasry, July 11, 1956, The Museum of Modern Art, collection records.)

MARK TOBEY
American, 1890–1976

Threading Light. 1942. Tempera on cardboard, 29¼ × 19¾″ (74.5 × 50.1 cm). Purchase. *Page 107*

The earth has been round for some time now, but not in man's relations to man nor in the understanding of the arts of each as a part of that roundness. As usual we have occupied ourselves too much with the outer, the objective, at the expense of the inner world wherein the true roundness lies.

There has been some consciousness of this for a very long time, but only now does the challenge to make the earth one place become so necessarily apparent. Ours is a universal time and the significances of such a time all point to the need for the universalizing of the consciousness and the conscience of man. It is in the awareness of this that our future depends unless we are to sink into a universal dark age.

America more than any other country is placed geographically to lead in this understanding, and if from past methods of behavior she has constantly looked toward Europe, today she must assume her position, Janus-faced, toward Asia, for in not too long a time the waves of the Orient shall wash heavily upon her shores.

All this is deeply related to her growth in the arts, particularly upon the Pacific slopes. Of this I am aware. Naturally my work will reflect such a condition and so it is not surprising to me when an Oriental responds to a painting of mine as well as an American or European. (Mark Tobey, in Miller, ed., *Fourteen Americans*, p. 70.)

BRADLEY WALKER TOMLIN
American, 1899–1953

Number 20. (1949). Oil on canvas, 7′2″ × 6′8¼″ (218.5 × 203.9 cm). Gift of Philip Johnson. *Page 122*

EARL S. TUPPER
American, 1907–1983

"Tupperware." (c. 1945). Flexible plastic: bowl, 2⅞″ h. × 5½″ diam.; covered bowl, 3⅜″ h. × 4⅜″ diam.; covered bowl, 5″ h. × 6½″ diam.; cup, 2¾″ h. × 3⅛″ diam.; saucer, 5¾″ diam. Manufacturer: Tupper Corporation, U.S.A. Gift of the manufacturer. *Page 78*

During most of his adult life, easy-going Earl S. Tupper, 40, has described himself as "a ham inventor and Yankee trader." By last week, one of his inventions—an unbreakable, flexible, shape-retaining plastic which can be moulded into all sorts of containers—was forcing him to temper the "ham" and drop the "trader" entirely.

Along with the new material, which he calls simply Poly-T ("There have been too many bum articles called plastic"), Tupper has developed machinery to press it into 25

pastel-shaded houseware items. . . . Some of the bowls have close-fitting caps which, upon slight pressure, create a partial vacuum, form an air-tight container. All of them can be squeezed to form a spout which disappears when the bowl is set down. A Massachusetts insane asylum found Tupperware an almost ideal replacement for its noisy, easily battered aluminum cups and plates; patients could damage Tupperware only by persistent chewing. ("Tupperware," *Time Magazine*, September 8, 1947.)

UNKNOWN PHOTOGRAPHER (U.S. Navy)

Gunners of the U.S.S. Hornet Score a Direct Hit on Japanese Bomber—18 March 1945. (1945). Photograph: gelatin-silver print. $13^{1}/_{2} \times 10^{3}/_{4}''$ (34.3×27.3 cm). Gift of Edward Steichen. *Page 43*

WEEGEE (Arthur Fellig)
American, born Poland. 1899–1968. To U.S.A. 1909

Woman Shot from Cannon. 1943. Photograph: gelatin-silver print, $13^{7}/_{8} \times 11^{1}/_{4}''$ (35.3×28.6 cm). Purchase. *Page 62*

ORSON WELLES
American, 1915–1985

Citizen Kane. (1941). U.S.A. Black-and-white film, 119 min. Orson Welles, RKO. Acquired from RKO Radio Pictures. *Page 69*

EDWARD WESTON
American, 1886–1958

Quaker State Oil, Arizona. (1941). Photograph: gelatin-silver print, $7^{5}/_{8} \times 9^{5}/_{8}''$ (19.4×24.5 cm). Purchased as the gift of Mrs. Armand P. Bartos. *Page 48*

Point Lobos. (1946). Photograph: gelatin-silver print, $9^{1}/_{2} \times 7^{5}/_{8}''$ (24.1×19.4 cm). Gift of David McAlpin. *Page 115*

In 1941 he was asked to photograph through America for an edition of Walt Whitman's *Leaves of Grass*. His aim was not to illustrate but to counterpoint Whitman's vision by his own. During the journey through the South and up the East Coast he found the land and the people weary, the civilization more strongly rooted in a quieter earth; he saw blatant power in industry everywhere, strength still standing in old

barns and houses. In Louisiana he worked intensely on the decay and beauty of swamps, sepulchers, ruins of plantation houses. A miasma of gray light and smoke obscures the cities. In New York it seemed to wall him in.

The trip was cut short by Pearl Harbor. The Westons returned to Carmel, joined civilian watchers of the headlands. All Edward's sons were swept into the war. Lobos was occupied by the Army. (Beaumont and Nancy Newhall, manuscript, [January 5, 1946], The Museum of Modern Art, collection records.)

WOLS (Otto Alfred Wolfgang Schulze)
German, 1913–1951. To France 1932

Painting. (1944–45). Oil on canvas, $31^{7}/_{8} \times 32''$ (81×81.1 cm). Gift of D. and J. de Menil Fund. *Page 103*

ANDREW WYETH
American, born 1917

Christina's World. (1948). Tempera on gessoed panel, $32^{1}/_{4} \times 47^{3}/_{4}''$ (81.9×121.3 cm). Purchase. *Page 125*

EVA ZEISEL
American, born Hungary, 1906. To U.S.A. 1938

"Museum" Dinner Service. (c. 1942–45). Glazed porcelain, various dimensions. Manufacturer: Castleton China Company, U.S.A. Gift of the manufacturer. *Page 76*

The first fine china dinner service in this country to take on new and modern shapes . . . represents the culmination of a project talked over back in 1942 by Eliot Noyes, director of the [Museum of Modern Art's] department of design, and Louis B. Hellman, president of Castleton. . . .

The new china is a pale ivory color that looks bone white in certain lights. It is translucent at the edges, thinning out delicately from a substantial base. The twenty-five pieces in the first collection are all completely undecorated. . . .

"I wanted to design a service of real elegance," Mrs. Zeisel said, . . . "That's why I gave all the pieces an erect, uplift look, as if they were growing up from the table." . . .

Introduced for the first time into any dinner service is an oversize salad bowl because, according to the designer, salad is becoming an increasingly important part of the American diet. (Eugenia Sheppard, "China Service Is Displayed in Modern Shapes," *New York Herald Tribune*, April 17, 1946.)

Chronology

1940 Discovery of paleolithic paintings in caves at Lascaux, France

International Surrealist exhibition in Mexico City

Piet Mondrian, Fernand Léger, and Stanley William Hayter arrive in New York; Hayter opens his Atelier 17 at New School for Social Research

Charles Henri Ford publishes first issue of *View* magazine

Hermann Goering's collection of stolen art shown in Paris

Guernica shown in *Picasso: Forty Years of His Art* at The Museum of Modern Art (remains at Museum until 1981)

MODERN ART: Constantin Brancusi, final version of *Bird in Space*; Joan Miró, first works in Constellation series; Henry Moore begins *Shelter Drawings* in London air-raid shelters; Léger commissioned to decorate Radio City Music Hall

ARCHITECTURE AND DESIGN: Eliel and Eero Saarinen, Church of Christ, Columbus, Indiana; Charles and Ray Eames begin experiments with molded plywood

FILM: Charlie Chaplin, *The Great Dictator*; Walt Disney, *Fantasia*; John Ford, *The Grapes of Wrath*; Fritz Hippler, *Campaign in Poland*; Humphrey Jennings and Harry Watt, *London Can Take It*; Len Lye, *Musical Poster No. 1*

THE MUSEUM OF MODERN ART: *Twenty Centuries of Mexican Art*, *Frank Lloyd Wright: American Architect*, *D. W. Griffith: American Film Master*, and *War Comes to the People: A Story Written With the Lens* exhibitions; Department of Photography established under direction of Beaumont Newhall; Department of Industrial Design formed under direction of Eliot Noyes

LITERATURE: Graham Greene, *The Power and the Glory*; Lillian Hellman, *Watch on the Rhine*; Ernest Hemingway, *For Whom the Bell Tolls*; Upton Sinclair, *World's End*; Richard Wright, *Native Son*

MUSIC: Igor Stravinsky, *Symphony in C*

POPULAR SONGS: *You Are My Sunshine*; *The Last Time I Saw Paris*; *When You Wish Upon a Star*

THEATER: Joseph A. Fields and Jerome Chodorov, *My Sister Eileen*; Elliott Nugent and James Thurber, *The Male Animal*; Richard Rodgers and Moss Hart, *Pal Joey*; Robert Sherwood, *There Shall Be No Night*

1941 National Gallery of Art opens in Washington, D.C.

André Breton, Marc Chagall, Max Ernst, Wifredo Lam, Jacques Lipchitz, and André Masson arrive in New York; Robert Motherwell meets some of them through Meyer Schapiro, his professor at Columbia University

MODERN ART: Henri Matisse, recovering from two operations, begins series of drawings, *Themes et variations*, and development of cut-paper compositions

FILM: John Ford, *How Green Was My Valley*; Howard Hawks, *Sergeant York*; John Huston, *The Maltese Falcon*; Michael Powell, *49th Parallel*; Preston Sturges, *Sullivan's Travels*; Orson Welles, *Citizen Kane*

THE MUSEUM OF MODERN ART: *Indian Art of the United States*, *Understanding Modern Art*, *Paul Klee*, *Joan Miró*, *Salvador Dali*, and *Organic Design in Home Furnishings* exhibitions; National Defense Poster Competition; Buckminster Fuller's Dymaxion Deployment Unit shown in Museum garden; Vincent van Gogh's *The Starry Night* enters collection

LITERATURE: Louis Aragon, *Le Creve-coeur*; A. J. Cronin, *The Keys of the Kingdom*; Arthur Koestler, *Darkness at Noon*; Alberto Moravia, *The Fancy Dress Party*; Budd Schulberg, *What Makes Sammy Run*; Franz Werfel, *The Song of Bernadette*

MUSIC: Dmitri Shostakovich, *Symphony No. 7*; William Walton, *Scapino* overture

POPULAR SONGS: *Bewitched, Bothered and Bewildered*; *Chattanooga Choo-Choo*; *Deep in the Heart of Texas*

THEATER: Bertolt Brecht, *Mother Courage, A Chronicle of the Thirty Years' War*; Noel Coward, *Blithe Spirit*; Ira Gershwin and Kurt Weill, *Lady in the Dark*

1941: Eleanor Roosevelt with artists Dooley Shorty, Elsie Bonser, and Nellie Starboy Buffalo Chief at the exhibition *Indian Art of the United States*

1940 Columbia University team isolates isotope uranium 235
Karl Landsteiner discovers Rh factor in blood
RCA demonstrates electron microscope
Discovery of freeze-drying process for food
First helicopter flight in U.S. by Vought-Sikorsky Corp.
Production of MIG-1 and Mustang fighter planes
Karl K. Pabst designs Jeep automobile
Initiation of Social Security payments
Nylon stockings appear on market in U.S.
BOOKS: Carl G. Jung, *The Interpretation of Personality*; Carl
Sandburg, *Abraham Lincoln: The War Years* (Pulitzer Prize);
George Santayana, *The Realms of Being*

Germany invades Norway and Denmark, the Netherlands,
 Luxembourg, and Belgium (Blitzkrieg)
Winston Churchill succeeds Neville Chamberlain as prime
 minister of Great Britain
France signs armistice with Germany
Battle of Britain begins
Leon Trotsky assassinated in Mexico
Axis alliance formed by Germany, Italy, and Japan
Franklin D. Roosevelt reelected U.S. president for third term
Fulgencio Batista elected president of Cuba

1940: José Clemente
Orozco at work in
The Museum of
Modern Art on
his mural *Dive
Bomber and Tank*,
commissioned for
the exhibition
*Twenty Centuries
of Mexican Art*

1941 "Manhattan Project," for atomic research, begins
Edwin McMillan and Glenn T. Seaborg discover plutonium
John R. Whinfield invents Dacron (Terylene)
BOOKS: Benedetto Croce, *History as the Story of Liberty*; Erich
Fromm, *Escape from Freedom*; Reinhold Niebuhr, *The Nature
and Destiny of Man*; William L. Shirer, *Berlin Diary*

Lend-Lease Act provides American aid to Allies
Germany invades U.S.S.R; October, siege of Leningrad begins
Nazis massacre more than 50,000 Ukrainians at Babi Yar
Japan attacks U.S. at Pearl Harbor and the Philippines on
 December 7, "a date that will live in infamy," says President
 Roosevelt; December 8, U.S. declares war on Japan, Ger-
 many, and Italy
Adolph Hitler orders the systematic genocide of Jews in Europe

1941: Edgar
Kaufmann, Jr.,
Eliot Noyes, Marcel
Breuer (standing),
Frank Parrish,
Alfred H. Barr, Jr.,
Catherine Bauer,
and Edward Stone
(seated) planning
the exhibition
*Organic Design in
Home Furnishings*

1942 Peggy Guggenheim opens Art of This Century gallery
First Papers of Surrealism exhibition organized by Marcel Duchamp and André Breton, who also begin *VVV* magazine with Max Ernst and David Hare in New York
Artists in Exile exhibition at Pierre Matisse Gallery
Musée d'Art Moderne, Paris, opens
ARCHITECTURE: Oscar Niemeyer, Church of St. Francis of Assisi, Pampulha, Brazil; Frank Lloyd Wright, preliminary design for Solomon R. Guggenheim Museum, New York (completed 1957)
FILM: Frank Capra, first two documentaries in *Why We Fight* series; Noel Coward and David Lean, *In Which We Serve*; Michael Curtiz, *Casablanca*; Leo Hurwitz and Paul Strand, *Native Land*; Ernst Lubitsch, *To Be or Not To Be*; Irving Rapper, *Now, Voyager*; Orson Welles, *The Magnificent Ambersons*
THE MUSEUM OF MODERN ART: first "Americans" exhibition; *Road to Victory* and *Tchelitchew: Paintings and Drawings* exhibitions; *Painting and Sculpture in The Museum of Modern Art*, the first catalog of the collection; Lincoln Kirstein appointed consultant for Latin American Art, and with Alfred H. Barr, Jr., and Edgar Kaufmann, Jr., acquires fifty-eight works with special Inter-American Fund; Max Beckmann's first triptych, *Departure*, Peter Blume's *The Eternal City* (portraying Mussolini), Pavel Tchelitchew's *Hide-and-Seek*, and Oskar Schlemmer's *Bauhaus Stairway* acquired

LITERATURE: Albert Camus, *The Stranger*; John Steinbeck, *The Moon is Down*
MUSIC: Aaron Copland, *Rodeo*; Aram Khatchaturian, *Gayeneh*; Heitor Villa-Lobos, *Bachianas Brasileiras No. 9*
POPULAR SONGS: *I Left My Heart at the Stage Door Canteen*; *White Christmas*; *Praise the Lord and Pass the Ammunition*
THEATER: Jean Anouilh, *Antigone*; George Balanchine, *Metamorphoses;* Irving Berlin, *This Is the Army*; Thornton Wilder, *The Skin of Our Teeth*

1943 Jackson Pollock's first exhibition at Art of This Century
Clyfford Still's first exhibition at San Francisco Museum of Art
Destruction of Kurt Schwitters's *Merzbau* during an air raid in Hannover
MODERN ART: Mondrian, *Broadway Boogie Woogie*; Picasso, *Man with a Sheep*; Jean Dubuffet makes first *"brut"* works; Rufino Tamayo paints mural at Smith College; scarcity of metal leads Alexander Calder to work with new forms, called Constellations by Duchamp and James Johnson Sweeney
FILM: Henri-Georges Cluzot, *The Raven*; Maya Deren and Alexander Hammid, *Meshes of the Afternoon*; Carl-Theodor Dreyer, *Day of Wrath*; Humphrey Jennings, *Fires Were Started*; Frank Launder and Sidney Gilliat, *Millions Like Us*; Michael Powell and Emeric Pressburger, *The Life and Death of Colonel Blimp*
THE MUSEUM OF MODERN ART: *Occupational Therapy: Its Function and Purpose*, *The Paintings of Morris Hirshfield*, *Young Negro Art*, *Alexander Calder*, and *Romantic Painting in America* exhibitions; Alfred H. Barr, Jr., director, is asked to resign, relinquishes administrative duties; Barr's *What Is Modern Painting?* published; René d'Harnoncourt named director of new Department of Manual Industry; James Thrall Soby named director of Department of Painting and Sculpture; Marc Chagall's *Time Is a River Without Banks* and Mondrian's *Broadway Boogie Woogie* acquired

LITERATURE: T. S. Eliot, *Four Quartets*; Robert Frost, *A Witness Tree*; Ayn Rand, *The Fountainhead*; Antoine de Saint-Exupéry, *The Little Prince*; Upton Sinclair, *Dragon's Teeth*; Betty Smith, *A Tree Grows in Brooklyn*; Franz Werfel and S. N. Behrman, *Jacobowsky and the Colonel*
MUSIC: Aaron Copland, *A Lincoln Portrait*; Ralph Vaughan Williams, *Symphony No. 5 in D*
POPULAR SONGS: *Mairzy Doats*; *I'll Be Seeing You (in All the Old, Familiar Places)*; *Do Nothin' Till You Hear from Me*
THEATER: James Gow and Arnaud d'Usseau, *Tomorrow the World*; Richard Rodgers and Oscar Hammerstein, II, *Oklahoma!*; John Van Druten, *The Voice of the Turtle*

1942　First nuclear reactor built in Chicago
Development of first automatic computer in U.S.
K-rations, instant coffee developed as food products for war
Cultivation of "Victory Gardens" in U.S.
BOOKS: R. G. Collingwood, *The New Leviathan*; C. S. Lewis,
The Screwtape Letters; Maurice Merleau-Ponty, *The Structure of
Behavior*; Hans Reichenbach, *Philosophic Foundations of Quantum Mechanics*

Japan occupies the Philippines, Malaya, Burma, and the Netherlands East Indies
U.S. defeats Japan in the battles of Coral Sea and Midway
British victory at El Alamein checks progress of Axis in Africa
Over 110,000 Japanese-Americans placed in internment camps
Congress of Racial Equality (CORE) founded

1942: Installation
view of exhibition
Road to Victory

1943　Russell Marker pioneers synthetic hormone production and
　　　oral contraceptives
Albert Hofmann in Switzerland accidentally discovers that
　　　LSD has hallucinogenic properties
Introduction of DDT in U.S.
G.I. Bill of Rights offers free education to U.S. war veterans
Completion of the Pentagon, the world's largest office building
Liberty ships built in four days by Henry Kaiser
J. M. Keynes proposes an international currency union
BOOKS: Arnold L. Gesell and Frances Ilg, *The Infant and Child
in the Culture of Today*; Walter Lippmann, *U.S. Foreign Policy*;
Jean-Paul Sartre, *Being and Nothingness*

Casablanca Conference appoints Dwight D. Eisenhower Allied
　　　commander in North Africa
U.S. victory at Guadalcanal
Soviet victory at Stalingrad
Allied forces invade Italy
Teheran Conference plans Allied landing at Normandy
Race riots in Detroit and New York

1943: Party in the
Museum's garden
for enlisted men

1944 Kodacolor introduced

William Baziotes, Hans Hofmann, and Robert Motherwell have individual exhibitions at Art of This Century gallery

Abstraction and Surrealist Art in the U.S. exhibition organized by art dealer Sidney Janis, shown at Cincinnati Art Museum and several western U.S. museums

Picasso exhibits 74 paintings in the Salon d'Automne (Salon of Liberation); joins the Communist Party

Jean Dubuffet has first exhibition at Galerie René Drouin, Paris

László Moholy-Nagy founds Institute of Design in Chicago

MODERN ART: Henri Matisse begins paper cut-outs for *Jazz* (published 1947); Henry Moore, first Family Group sculptures

FILM: Maya Deren, *At Land*; Sergei Eisenstein, *Ivan the Terrible*, Part I; Emilio Fernandez, *Maria Candelaria*; Vicente Minnelli, *Meet Me in St. Louis*; Laurence Olivier, *Henry V*; Otto Preminger, *Laura*; Billy Wilder, *Double Indemnity*

THE MUSEUM OF MODERN ART: *Art in Progress*, *Paintings by Jacob Lawrence*, *Marsden Hartley*, *Modern Drawings*, and *Hayter and Studio 17: New Ways of Gravure* exhibitions; War Veterans' Art Center established; Pollock's *The She-Wolf*, the first painting by the artist to be collected by a museum, enters the collection

LITERATURE: Isak Dinesen, *Winter's Tales*; John Hersey, *A Bell for Adano*; W. Somerset Maugham, *The Razor's Edge*; Lillian Smith, *Strange Fruit*

MUSIC: Béla Bartók, *Violin Concerto*; Walter Piston, *2nd Symphony, Washington, D.C.*; Sergei Prokofiev, *War and Peace*

POPULAR SONGS: *Accentuate the Positive*; *Don't Fence Me In*; *I'll Walk Alone*; *Rum and Coca-Cola*

THEATER: Betty Comden, Adolph Green, and Leonard Bernstein, *On the Town*; Jean Giraudoux, *The Mad Woman of Chaillot*; Jean-Paul Sartre, *No Exit*; John Van Druten, *I Remember Mama*; Tennessee Williams, *The Glass Menagerie*; Philip Yordan, *Anna Lucasta*

1945 Trial of Hans van Meegren, forger of Vermeer and other artists

Mark Rothko's first exhibition at Art of This Century

Arshile Gorky's first exhibition at Julien Levy Gallery

Jean Fautrier and Wols exhibit at Galerie René Drouin

André Masson and Léger return to France; Léger joins Communist Party

MODERN ART: Picasso begins to make lithographs at workshop of Fernand Mourlot, Paris

ARCHITECTURE: Le Corbusier begins design of L'Unité d'Habitation, Marseilles (completed 1952)

FILM: Robert Bresson, *Les Dames du Bois de Boulogne*; Marcel Carné, *The Children of Paradise*; René Clement, *Battle of the Rails*; Alfred Hitchcock, *Spellbound*; David Lean, *Brief Encounter*; Jean Renoir, *The Southerner*; Roberto Rossellini, *Rome, Open City*; Billy Wilder, *The Lost Weekend*

THE MUSEUM OF MODERN ART: *Piet Mondrian*, *Georges Rouault*, *Paul Strand: Photographs 1915–1945*, and *Stuart Davis* exhibitions; James Johnson Sweeney named director of Department of Painting and Sculpture; Georges Braque's *Man with a Guitar*, Wifredo Lam's *The Jungle*, and Léger's *Big Julie* enter collection

LITERATURE: Hermann Hesse, *Der Glasperlenspiel*; Carlo Levi, *Christ Stopped at Eboli*; George Orwell, *The Animal Farm: A Fairy Story*; Evelyn Waugh, *Brideshead Revisited*

MUSIC: Benjamin Britten, *Peter Grimes*; Sergei Prokofiev, *Cinderella*; Richard Strauss, *Metamorphosen*

POPULAR SONGS: *It's Been a Long, Long Time*; *La Mer*

THEATER: Howard Lindsay and Russel Crouse, *State of the Union*; Richard Rodgers and Oscar Hammerstein, II, *Carousel*

1944
Quinine synthesized

DNA shown to carry hereditary characteristics

First automatic, general-purpose digital computer completed at Harvard University

World Bank (International Bank for Reconstruction) established at conference in Bretton Woods, New Hampshire

BOOKS: William Beveridge, *Full Employment in a Free Society*; Julian Huxley, *On Living in a Revolution*; Gunnar Myrdal, *An American Dilemma*; Sumner Welles, *The Time for Decision*

Siege of Leningrad ends

Rome liberated

Allies, under the command of Eisenhower, land in Normandy (D-Day)

Russians enter Romania, Poland, and Hungary

Dumbarton Oaks Conference in Washington, D.C., produces framework for organization of United Nations

Paris liberated

German V-1 and V-2 rockets ("buzz bombs") hit Great Britain

Roosevelt reelected U.S. president for fourth term

U.S. Supreme Court upholds right of all races to vote

1944: Jacob Lawrence and young visitors to the exhibition *Paintings by Jacob Lawrence*

1945
First atomic bomb detonated near Alamogordo, New Mexico

Vitamin A synthesized

Penicillin and streptomycin introduced commercially

State religion (Shintoism) abolished in Japan

Parallel between "incidence of cancer of the lung and the sale of cigarettes" stated by Alton Ochsner, M.D.

"Bug bombs," aerosol spray insecticides, put on market

CARE (Cooperative for American Remittances to Europe), a private relief organization is founded

The name "Coke" registered as trademark for Coca-Cola

BOOK: Martin Buber, *For the Sake of Heaven*

Yalta Conference outlines terms for entry of U.S.S.R. into Japanese war

League of Arab States organized

Roosevelt dies; Harry S. Truman becomes U.S. president

Benito Mussolini captured and executed

Hitler commits suicide in Berlin

Germany surrenders

Potsdam Conference agrees on demilitarized, democratic Germany

Nuremburg trials of Nazis begin

United Nations charter signed in San Francisco

U.S.S.R. declares war on Japan

U.S. drops atomic bombs on Nagasaki and Hiroshima

Japan surrenders

Republic of Vietnam proclaimed

French women obtain right to vote

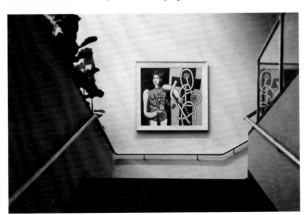

1945: Installation in the Museum's stairwell of Fernand Léger's *Big Julie* (1945), soon after it entered the collection

1946 First Salon des Réalités Nouvelles founded by Auguste Herbin, Albert Gleizes, Jean Gorin, and others in Paris

Alberto Giacometti's first exhibition since 1932 at Galerie Pierre, Paris

Betty Parsons Gallery opens

Naum Gabo moves to U.S.

Term "abstract expressionism" first applied to the work of New York painters by Robert M. Coates of *The New Yorker*

MODERN ART: Picasso begins to make ceramics in Vallauris, France; Jean Dubuffet begins More Beautiful than They Think: Portraits series; Lucio Fontana issues his "White Manifesto" in Buenos Aires and other spatial manifestos in Milan; Acrylic paint, made available to artists as "Magna" by Bocour Artist Colours, first used by Jackson Pollock, Barnett Newman, Ad Reinhardt, and Morris Louis

ARCHITECTURE: Buckminster Fuller, Witchita House; Ludwig Mies van der Rohe begins design of Farnsworth House, Plano, Illinois (completed 1951)

FILM: Frank Capra, *It's A Wonderful Life*; Jean Cocteau, *Beauty and the Beast*; Alfred Hitchcock, *Notorious*; Roberto Rossellini, *Paisan*; Wolfgang Staudte, *The Murderers Are Among Us*; William Wyler, *The Best Years of Our Lives*

THE MUSEUM OF MODERN ART: *Arts of the South Seas*, *The Photographs of Edward Weston*, *New Furniture Designed by Charles Eames*, *Marc Chagall*, *Georgia O'Keeffe*, and *Henry Moore* exhibitions; Matisse's *Piano Lesson* enters collection

LITERATURE: Christopher Isherwood, *The Berlin Stories*; Nikos Kazantzakis, *Zorba the Greek*; Dylan Thomas, *Deaths and Entrances*; Robert Penn Warren, *All the King's Men*
MUSIC: Benjamin Britten, *The Rape of Lucretia*; Gian-Carlo Menotti, *The Medium*
POPULAR SONGS: *Come Rain or Come Shine*; *(Get Your Kicks on) Route 66*; *La Vie en rose*; *To Each His Own*
THEATER: Irving Berlin, *Annie Get Your Gun*; Lillian Hellman, *Another Part of the Forest*; Eugene O'Neill, *The Iceman Cometh*

1947 The Polaroid Land Camera patented by Edwin H. Land

Institute of Contemporary Arts founded in London

First Cannes International Film Festival

William Baziotes is first Abstract Expressionist to win an important prize (at Thirty-eighth Annual Exhibition at Art Institute of Chicago)

Max Beckmann settles in U.S.

Last international Surrealist exhibition organized by Breton and Duchamp at Galerie Maeght, Paris

Venice International Film Festival (established 1934) resumes

MODERN ART: Miró arrives in Cincinnati to paint mural in Terrace-Hilton hotel; Pollock creates first drip paintings; de Kooning begins second series of Women paintings

ARCHITECTURE: Wallace K. Harrison and associates, United Nations Secretariat Building, New York

FILM: Kenneth Anger, *Fireworks*; James Broughton, *Mother's Day*; Charlie Chaplin, *Monsieur Verdoux*; Elia Kazan, *Gentleman's Agreement*; Sidney Peterson, *The Cage*; Carol Reed, *Odd Man Out*; Hans Richter, *Dreams that Money Can Buy*

THE MUSEUM OF MODERN ART: *The Photographs of Henri Cartier-Bresson*, *Mies van der Rohe*, and *Ben Shahn* exhibitions; Barr named director and Dorothy C. Miller curator of new Department of Museum Collections; Edward Steichen appointed director of Department of Photography

LITERATURE: Albert Camus, *The Plague*; Malcolm Lowry, *Under the Volcano*; Thomas Mann, *Doktor Faustus*; James Michener, *Tales of the South Pacific*
MUSIC: Arthur Honegger, *Symphony No. 4*; Darius Milhaud, *Suite for Harmonica and Orchestra*; Maria Callas makes her opera debut
POPULAR SONGS: *Open the Door, Richard*; *Almost Like Being in Love*
THEATER: Burton Lane and E. Y. Harburg, *Finian's Rainbow*; Alan Jay Lerner and Frederick Loewe, *Brigadoon*; Arthur Miller, *All My Sons*; Tennessee Williams, *A Streetcar Named Desire*

1946 Xerography invented by Chester Carlson
Fulbright awards for international exchange of students begin
Vespa motor scooters introduced in Italy
Bikini swimsuit introduced in Paris
BOOKS: John Hersey, *Hiroshima*; Benjamin Spock, *The Common Sense Book of Baby and Child Care*

First United Nations general assembly opens in London; New York selected as permanent headquarters at second meeting
Churchill refers to U.S.S.R. domination of Eastern Europe as an "iron curtain . . . across the Continent"
Philippines granted independence from U.S.
Beginning of French war in Vietnam
Juan D. Peron elected president of Argentina
First civilian president, Miguel Aleman, elected in Mexico
Charles de Gaulle elected president of France
British establish free health service (socialized medicine)
Atomic Energy Commission established
Indian Claims Commission established by Congress

1946: René d'Harnoncourt installing the exhibition *Arts of the South Seas*

1947 First supersonic flight
Isotope Carbon 14 discovered by W. F. Libby (carbon 14 dating)
First commercial microwave oven introduced using electronic tube developed for radar
"Flying saucers" first seen by Kenneth Arnold in western U.S.
Dead Sea Scrolls discovered
Thor Heyerdahl crosses Pacific Ocean on raft *Kon-Tiki*
BOOKS: Theodor Heuss, *Deutsche Gestalten*; Guido Ruggiero, *Existentialism*; H. R. Trevor-Roper, *The Last Days of Hitler*

India and Pakistan become independent states
The Truman Doctrine of aid to countries threatened by Communism
Central Intelligence Agency (CIA) authorized by U.S. Congress
First "black list" compiled of Hollywood writers, directors, and actors who used fifth amendment rights in U.S. Congressional hearings on "Un-American Activities"
Taft-Hartley Act curbs union rights in U.S.

1947: Philip Johnson and Ludwig Mies van der Rohe at the exhibition *Mies van der Rohe*

1948

Georges Braque wins grand prize at Venice Biennale

Hans Hofmann exhibition at Addison Gallery of American Art, Andover, Massachusetts, is the first individual retrospective for an Abstract Expressionist

Willem de Kooning's first exhibition at Egan Gallery, New York

The Subjects of the Artist school formed by Baziotes, David Hare, Motherwell, and Still in New York

Concrete art movement begins in Italy

MODERN ART: Motherwell makes automatic drawing which is first *Elegy to the Spanish Republic*; Pollock paints *Number 1, 1948*; Barnett Newman paints *Onement I*

FILM: Jules Dassin, *The Naked City*; Vittorio de Sica, *The Bicycle Thief*; Robert Flaherty, *Louisiana Story*; Howard Hawks, *Red River*; John Huston, *The Treasure of the Sierra Madre*; Max Ophuls, *Letter from an Unknown Woman*; Michael Powell and Emeric Pressburger, *The Red Shoes*

THE MUSEUM OF MODERN ART: *International Competition for Low-cost Furniture Design*, *Gabo-Pevsner*, *Pierre Bonnard*, and *In and Out of Focus: A Survey of Today's Photography* exhibitions as well as several exhibitions devoted to children's work; de Kooning's *Painting*, acquired by the Museum, is first work by the artist to enter a museum collection; War Veterans' Art Center becomes People's Art Center

LITERATURE: W. H. Auden, *Age of Anxiety*; Truman Capote, *Other Voices, Other Rooms*; William Faulkner, *Intruder in the Dust*; Norman Mailer, *The Naked and the Dead*; Alan Stewart Paton, *Cry, the Beloved Country*; Ezra Pound, *The Pisan Cantos*

MUSIC: Benjamin Britten, *The Beggar's Opera*; Oliver Messiaen, *Turangalila Symphony*

POPULAR SONGS: *Nature Boy*; *Tennessee Waltz*; *Enjoy Yourself—It's Later than You Think*

THEATER: Bertolt Brecht, *The Caucasian Chalk Circle*; Jean Cocteau, *Les Parents terribles*; Cole Porter, *Kiss Me, Kate*; Jean-Paul Sartre, *Les Mains sales*

1949

International exhibition of contemporary prints at Petit Palais

First CoBrA exhibition, Amsterdam

First exhibition of Matisse's *papiers découpes* in America at Pierre Matisse Gallery, New York

Louise Bourgeois has first exhibition at Peridot Gallery

The Eighth Street Club is founded

ARCHITECTURE: Alvar Aalto, Massachusetts Institute of Technology Senior Dormitory, Baker House, Cambridge, Massachusetts; Ludwig Mies van der Rohe, 860–880 Lake Shore Drive apartments, Chicago

FILM: Georges Franju, *Le Sang des bêtes*; Robert Hamer, *Kind Hearts and Coronets*; Norman McLaren and Evelyn Lambart, *Begone Dull Care*; Sidney Meyers and Helen Levitt, *The Quiet One*; Yasujiro Ozu, *Banshun*; Carol Reed, *The Third Man*; Robert Rossen, *All the King's Men*; Raoul Walsh, *White Heat*

THE MUSEUM OF MODERN ART: *From Le Corbusier to Niemeyer: 1929–1949*, *Twentieth Century Italian Art*, *The House in the Museum Garden*, *Georges Braque*, *Oskar Kokoschka*, and *Paul Klee* exhibitions; René d'Harnoncourt named director of Museum; Philip Johnson named chairman of Department of Architecture and Design; The Abby Aldrich Rockefeller Print Room opens; Brancusi's *Fish*, Picasso's *Three Musicians*, and Andrew Wyeth's *Christina's World* enter collection

LITERATURE: Nelson Algren, *The Man with the Golden Arm*; Graham Greene, *The Third Man*; George Orwell, *Nineteen Eighty-four*

MUSIC: Carl Orff, *Antigonae*

POPULAR SONGS: *Rudolph, the Red-Nosed Reindeer*; *Some Enchanted Evening*; *Mona Lisa*; *Bonaparte's Retreat*

THEATER: Carson McCullers, *The Member of the Wedding*; Arthur Miller, *Death of a Salesman*; Leo Robin and Jules Styne, *Gentlemen Prefer Blondes*; Richard Rodgers and Oscar Hammerstein, II, *South Pacific*

1948

Cortisone synthesized by P. S. Hench and E. C. Kendell
Bell Laboratories develops the first transistor
Long-playing record invented by Peter Goldmark
Michelin introduces first radial tires
200-inch telescope at Mount Palomar dedicated
International Planned Parenthood Federation founded by Margaret Sanger
BOOKS: Winston Churchill, *The Gathering Storm*; Alfred C. Kinsey, *Sexual Behavior in the Human Male*; André Malraux, *Psychologie de l'art*; Thomas Merton, *The Seven Story Mountain*; Fairfield Osborne, *Our Plundered Planet*; Norbert Wiener, *Cybernetics*

Mahatma Gandhi assassinated in India
Communists seize power in Czechoslovakia
Marshall Plan for European aid enacted
State of Israel proclaimed; David Ben-Gurion named prime minister
Organization of American States (OAS) formed
Republic of Korea and People's Democratic Republic in northern Korea formed
U.S.S.R. breaks with Yugoslavia
U.S. and British airlifts counter Soviet blockade of Berlin
Situation between U.S.S.R. and U.S. termed "cold war" by presidential advisor Bernard Baruch
Truman elected U.S. president

1949

First non-stop flight around the world made by U.S. Air Force
"Silly Putty," a failed attempt to make synthetic rubber, marketed as a toy
U.S.S.R. tests its first atomic bomb
U.S. launches first long-range guided missile
BOOKS: Simone de Beauvoir, *The Second Sex*; J. D. Bernal, *The Freedom of Necessity*; Albert Schweitzer, *Hospital in the Jungle*; Paul Tillich, *The Shaking of the Foundations*

North Atlantic Treaty Organization (NATO) formed
Germany divided; separate governments established
Konrad Adenauer elected chancellor of Federal Republic of Germany
Chiang Kai-shek moves nationalist forces to Formosa (Taiwan)
Communist People's Republic of China proclaimed with Mao Ze Dong as chairman and Zhou En Lai as premier
Apartheid policy established in South Africa
Republic of Eire proclaimed in Dublin
Hungarian Cardinal Mindszenty sentenced for "high treason," takes refuge in U.S. Embassy in Budapest
Berlin airlift ends
Radio Free Europe begins to broadcast behind Iron Curtain
Leaders of American Communist Party convicted of conspiracy to overthrow U.S. government

1949: *The House in the Museum Garden* exhibition, featuring a single-family home designed by Marcel Breuer

Trustees of

The Museum of Modern Art

Acknowledgments

The exhibition which this volume accompanies was selected by the following members of the Museum's curatorial staff: Kirk Varnedoe, Director, Department of Painting and Sculpture; John Szarkowski, Director, Department of Photography; Stuart Wrede, Director, Department of Architecture and Design; Laurence Kardish, Curator, Department of Film; Robert Evren, Curatorial Assistant, Department of Drawings; and by the writer in her capacity as Director, Department of Prints and Illustrated Books. Advice and assistance were provided by Kynaston McShine, Senior Curator, Carolyn Lanchner, Curator, Cora Rosevear, Associate Curator, and Anne Umland, Assistant to the Director, Department of Painting and Sculpture; John Elderfield, Director, and Bernice Rose, Senior Curator, Department of Drawings; Wendy Weitman, Assistant Curator, Department of Prints and Illustrated Books; Christopher Mount, Curatorial Assistant, Department of Architecture and Design; Tony Troncale, Study Center Supervisor, Department of Photography; and Mary Corliss, Assistant Curator, Department of Film. Samantha Dunham, Assistant Registrar, and Eleanor Belich, Traffic Manager, Department of Registration, provided additional assistance. Conservators Karl Buchberg, James Coddington, and Patricia Houlihan revived and refurbished a number of objects. Jerry Neuner, Production Manager, Exhibition Program, designed the exhibition galleries with considerable understanding of the period.

I am particularly grateful to Richard E. Oldenburg, Director of the Museum, for his essential support in the conception and planning of the entire project. James S. Snyder, Deputy Director for Planning and Program Support; Sue B. Dorn, Deputy Director for Development and Public Affairs; Ellen Harris, Deputy Director for Finance and Auxiliary Services; Richard L. Palmer, Coordinator of Exhibitions; Jeanne Collins, Director, and Jennifer Carlson, Senior Press Representative, Department of Public Information; Clive Phillpot, Director, Library; Emily Kies Folpe, Museum Educator; and Richard L. Tooke, Supervisor, Mikki Carpenter, Archivist, and Mali Olatunji, Fine Arts Photographer, Department of Rights and Reproductions, all made valuable contributions to this endeavor. These and other knowledgeable and skillful members of the staff have joined together in a remarkable camaraderie to produce in less than a year this exceptional perspective of the collection. I am extremely grateful to them all.

This volume is the result of the informed and excellent guidance of the Museum's Managing Editor, Harriet Schoenholz Bee, who has played a fundamental role in its planning and execution, and of the intensive

research of the Museum's Archivist, Rona Roob. Michael Hentges, Director, Graphics, has supervised its superb designer, Lisa Govan; and Osa Brown, Director, Tim McDonough, Production Manager, Vicki Drake, Associate Production Manager, and Nancy Kranz, Manager of Promotion and Special Services, have carried on the fine tradition of the Museum's Department of Publications, which was formally established in 1939. Their thoughtful suggestions and excellent work more than deserve my warmest thanks.

Appreciative acknowledgment is also owed the following, who have been extremely generous with advice and support: Walter Bareiss, Nelson Blitz, Jr. and Catherine Woodard, Annie Cohen-Solal, Gabrielle Kopelman, Jo Carole Lauder, and Marian Skedgell. Finally, I am most deeply indebted to my superb staff in the Department of Prints and Illustrated Books, who have borne the brunt of the daily toil of preparation, for their good will and understanding, and to Deborah Goldberg, Special Curatorial Assistant, who is owed my unqualified gratitude for her astuteness and unstinting help in coordinating the entire project.

Riva Castleman

Photograph Credits

Courtesy Amon Carter Museum, Fort Worth, Texas: 26. Oliver Baker: 110 right. Walter Civardi: 76 bottom left. Geoffrey Clements: 66 bottom left, 100 right. Colten Photos: 40. Charles Eames: 53 left. Courtesy Office of Charles and Ray Eames, Venice, California: 43 bottom right. Eliot Elisofon: 149 top. Albert Fenn: 148, 149 bottom, 151 bottom. Gottscho: 151 top. International News: 153 top. Seth Joel: 75, 81. Courtesy Barbara King: 153 bottom. William Leftwich: 155 top and bottom. Jon Miller, Hedrich-Blessing, Chicago: 53 right. The Museum of Modern Art, New York — David Allison: 40 top, 55 top, 73 top and bottom, 76 top left, 105, 112, 121; George Barrows: 58 bottom left, 76 right, 79 bottom right, 80 bottom, 114 bottom left; Tom Griesel: 88 top left; Kate Keller: 36 top and bottom right, 39 top, 47 top and bottom, 64 left, 78 bottom left, 79 left, 82 left and top right, 97, 99, 101, 102 top, 103 bottom, 104 bottom, 106, 110 top left, 111, 118, 125; James Mathews: 56 top, 58 top right, 71 left, 79 top right, 84 top, 86 top, 100 left, 107 top and bottom, 119, 122 top; Mali Olatunji: 37, 40 bottom, 43 bottom left, 46 bottom, 49, 51, 52 top, 55 bottom, 56 bottom, 57 top and bottom, 63, 64 right, 66 top, 67, 74 right, 76 top left, 77, 78 top and bottom right, 86 bottom, 87 top and bottom, 89, 91, 96, 103 top, 106 bottom, 109 top, 116, 120, 123, 124; Rolf Petersen: 52 bottom left, 59 top left, 62 top right, 88 bottom right; Adolph Studley: 38 left; Soichi Sunami: 17, 38 right, 39 bottom, 42 right, 43 top right, 45 top, 52 bottom right, 59 bottom, 67, 70, 71 right, 72, 74 bottom left, 80 top, 82 bottom right, 84 bottom, 85, 94 top left, 95, 98, 102 bottom, 104 top, 108, 114 top and bottom right, 122 bottom. Philips/Schwab, courtesy Robert Miller Gallery, New York: 66 bottom right. Sandak: 41, 49, 60, 61, 83, 109 bottom, 113. Ezra Stoller © Esto: 157. Underwood & Underwood Illustration Studios, Inc.: 58 top left. Malcolm Varon: 35, 90. © Wadsworth Atheneum, Hartford: 16